CW00661824

COUNTIES OF CONTENTION

CHARITY PROVOKES CHARITY
Inscription on the tomb of Lord Craigavon,
at Stormont, Belfast

COUNTIES OF CONTENTION

*A study of the origins and implications
of the Partition of Ireland*

BENEDICT KIELY

MERCIER PRESS

MERCIER PRESS
Douglas Village, Cork
www.mercierpress.ie

Trade enquiries to COLUMBA MERCIER DISTRIBUTION,
55a Spruce Avenue, Stillorgan Industrial Park, Blackrock, Dublin

© Ben Kiely, 1945, 2004
First published in May 1945 – this edition 2004

1 85635 430 X

10 9 8 7 6 5 4 3 2 1

This book is sold subject to the condition that it shall not, by way of trade or otherwise, be lent, resold, hired out or otherwise circulated without the publisher's prior consent in any form of binding or cover other than that in which it is published and without a similar condition being imposed on the subsequent purchaser.

Printed in Ireland by Colour Books Ltd.

Contents

Publisher's Note

Mercier Press is the longest established independent Irish publishing house and has published books in the fields of history, literature, folklore, music, art, humour, drama, politics, current affairs, law and religion. It was founded in 1944 by John and Mary Feehan whose vision for the company is still prevalent at Mercier today – to explore our culture and bring it alive to people.

Over our 60 years in business, we have endeavoured to publish books that we hope play a part in forming public opinion about controversial subjects, as we believe that all sides need to be heard. We believe that our books are effective ambassadors to send abroad as they can help to build up mutual understanding and respect between cultures.

On the occasion of our sixtieth anniversary, we are proud to reissue a facsimile edition of Ben Kiely's *Counties of Contention* which Mercier Press originally published in May 1945.

Introduction

JOHN HUME

The publication of a new edition of this book is a welcome and timely contribution to the process of political development and reconciliation on our island.

Ben Kiely wrote this book in an era when Nationalist doctrine in Ireland was dominated by the 'fourth green field' approach. This focused on territory at the expense of people. At the same time, Europe was suffering from the previously unimaginable horrors of the Second World War. This too had come about from division between people.

Of course, for Ireland the lesson of the decades since this book was first published is that violence only deepens division among people.

Written at that time, still only two decades after the partition of Ireland, this book contended that the Irish situation had arisen not out of agreement but disagreement and misunderstanding. This was a forward-looking analysis. Of course, we now have an Agreement, which finally came over four decades and much strife later. This work was, therefore, in many ways ahead of its time.

The author declares modestly that the work was not intended as a resolution or remedy, but as a recording of thoughts and observations which may help the 'task of the new generation'.

That generation was the generation that endorsed the Good Friday Agreement and it now has the task of implementing it.

The book is clearly written from a Nationalist perspective, but the author is upfront and honest about this and about any prejudices he may hold. He makes clear that people must not live in history and must see reason override passion if our ancient quarrel is to be addressed.

Written six decades ago, the book concentrates on partition, that enclosing wall, as the problem to be resolved. Partition was, of course, a vivid memory at the time of writing and was still a shock and hurt in Nationalist Ireland. Even so, the author recog-

x

nises that reunification has to come about with the consent of the Unionist community in the North.

Despite that hurt, the author saw the real need for co-operation and friendship to help build a new Ireland. This was stressed as much for civil society and what we would now call non-governmental organisations as for politicians. It is clear that the author hoped that the work of Fr. Finlay, S.J., who helped Orangemen farmers improve their industries would be but one example of this new solidarity expressed through working together in common interest.

The overriding message that one has to understand the rights and identity of the other side while respecting one's own principles and rights remains important.

This pride in one's own identity is neatly matched by a modesty on the part of the author which plays down the value of this work. For Ben Kiely, this book reveals a political robustness matching a writer's robustness which serves the purpose of honestly addressing the challenge of division.

This reflection on our ancient quarrel is firmly rooted in wider perspectives. There are numerous references to literature and to the artistic and the author also makes use of various historical contexts from Lincoln to Washington.

For me, as a past teacher of History and French, this is particularly interesting now when set beside his citing of a passage from Y. M. Goblet's *'La frontière de l'Ulster'*. Ben Kiely was already viewing our situation in the wider European context, and time has shown that instinct to be right with the development of the European Union and its positive impact on Ireland.

As Europe emerged from war, the author hoped for a time when Ireland would see a peace in which homes are built through a resolution that would respect the rights and aspirations of all the people.

In looking back to the time when this book was written which longed for such an agreement, we must now look forward again to the building up of a new Ireland where the new generation will unleash the potential which that agreement provides for all of our people.

FOREWORD

THE general thesis of this book is that the present position in Ireland, two governments and a customs-barrier in one country, is the result of a compromise based, not on a common agreement, but on disagreement and misunderstanding with an origin that sentimentally does not go back beyond William of Orange, and actually does not go back much beyond Edward Carson. The separate chapters approach or attempt to approach that compromise from several different angles by studying some ideas, influences and incidents almost all within the last half-century of Irish history. The aim is to point the way towards the removal of a compromise forced on the people of Ireland by circumstances and the battle of conflicting sentiments, towards the establishment of a compromise that will, in peace and mutual understanding, make for the good of all the people of a united Ireland, and for improved relations with the people and government of Great Britain.

The attempt to appreciate Unionist sentiment will possibly offend a few Nationalist Irishmen; while the inevitable result of the writer's Nationalist breeding and background will eventually drive away all but the most impartial and persevering Unionist readers . . . if it is not being too optimistic to hope that any Unionist will ever open the book. It is not very easy to be impartial about everything and to keep it up all the time. The most that can be hoped for is that all Irishmen will some day learn to view the past without passion, to approach the present in the practical way that the artist or the craftsman approaches the material out of which he is to make something permanent and durable and essentially one.

The book is not a scientifically-documented account giving

in chronological order everything that happened between 1911 and 1935. Several good books have already covered that ground.

It does not offer any foolproof remedy for present ills. The finding of that remedy and its proper application will be the task of the new generation in Ireland. One man of that generation here gives the jumbled reflections and ideas that may suggest something to some more lucid and capable contemporary.

Finally : there are difficulties with certain terms such as *Ulster, Unionist, Loyalist,* and so on. No amount of reservation can prevent occasional inexactitude. The discerning reader will naturally do a little interpreting, now and again, not to impose his own meaning on those terms, but to arrive at the meaning that the author intended to convey.

PREFACE TO SECOND EDITION

A REVIEWER in a Scottish newspaper, by no means as wordy and violently abusive as the proverbial Scottish or Scotch reviewer, said when he had read the first edition of this book that : " The author's historical narrative is lively and will entertain or exasperate his reader according to his political ideas." That was a generous, pleasantly neutral remark, and I may have an uneasy fear that, in spite of all my efforts, it may be quite true. I say " in spite of all my efforts " because, as a man remembering his native places with much joy and some sorrow, I wrote this book as an attempt to soothe men and settle differences, not to exasperate men and provide them only with matter for further controversy. The material for disagreement already exists and I imagined, and still imagine, that a popular review of the origins of that disagreement in the past might show the infernal tomfoolery of continuing that disagreement in the present.

There is gratifying evidence that the effort has not been unsuccessful. Obviously a large proportion of my fellow-countrymen and many interested people outside Ireland do not need to be helped towards that realisation. Men such as Captain Denis Ireland or Mr. Aodh de Blacam knew all about it when the present writer was doing sums on a slate, but they have generously added their voices to support his testimony. And I can think of two reviews written by younger, more impatient, less experienced men that show clearly enough that my own contemporaries know what the main problem is and are well enough informed about the lesser problems it creates.

One of these young men was impatient with me because anyone who writes a book about a problem is *ipso facto* expected to put forward a solution. It does not, by any means, follow ; and it may be worth while pointing out

3

again that the purpose of this book is to review origins and consider implications, not to write a prescription for a pink pill. Given a certain understanding of the disunifying accidents of the past, a certain appreciation of the material and spiritual benefits to be gained from unity in the present, men of goodwill in Belfast, Dublin, London and New York may find the basis for common agreement. The phrase *men of goodwill* may for young, impatient, tingling ears have unhappy associations with nondenominational food-kitchens. It has also a happier, nobler association with the greatest message of peace ever given to and left unheeded in this unfortunate world. And I make the whole thing a tale not of two cities but of four, because international events since this book was first published have made it more obvious that that amazing, twenty year old line is of importance not only to Ireland and England but to the United States of America.

I mention this point here not in a backhanded attempt to utilise a second edition for the business of answering reviewers, but because the same difficulty has occurred to other readers and may still occur to future readers. Answering reviewers is one of the interesting, useless things that for several good reasons is never done ; and my own feelings towards the reviewers of this book are amicable and pleasant and worthy of being left in peace. With two or possibly with only one exception, for the comment of *The Belfast News-Letter* is as understandable and as worthy of an answer as the roll of a drum. This paper pointed out, with no reference to the pages in which I had already touched on the point, that the differences that created partition were " fundamentally racial " and went right back to A.D. 1500. Unfortunately the documents that, according to *The News-Letter* proved this point were destroyed in the burning of the Public Record Office in Dublin in 1922. The scholarly reviewer did not mention any of his authorities. He went on to say that : " The spirit of Sinn Féin is ' ourselves alone,' and in that spirit the author seems to live. Against such a spirit may be invoked the teaching of Edmund Burke, who taught us that the approach to the outlook of the future of the

world is from kin to kind—that is, we love our own people of Ulster, and proceed to widen our sphere to the people of England and Scotland, and then to the people of the Empire."

Now, not for one moment do I question the sincerity of this scholar without authorities whose world-vision takes in everybody except his own fellow-countrymen. Possibly, it might be in order to wonder what he means by " our own people of Ulster," to contrast that with his common enough misinterpretation of the two words *Sinn Féin* as a theory of life not very far different from the two lines in which Wordsworth interpreted Rob Roy MacGregor in particular and robbery in general.* What place in that world-vision would *The News-Letter* find for that Catholic minority in the Six Counties ?

Still, if this book answers anything it answers the naïve arguments of that Belfast reviewer, and his statement is of interest largely because it leads on to another review in the Dublin *Irish Times*, a paper popularly supposed on the strength of one excellent humorous column to be much more liberal and much more enlightened than *The News-Letter*. The Belfast reviewer had said : " There is a new consideration which Mr. Churchill has advanced, and advanced with un-equalled knowledge. It is that but for Ulster at one time he was forced to consider the possibility of using force against Eire. . . ."

Now the whole business of Mr. Churchill's speech and Mr. de Valera's answer, and even of Captain Denis Ireland's fine *Open Letter to Mr. Churchill* published in the Belfast *Irish News*, now needs no comment. Acute observers were led to think that Mr. Churchill was feeling about nationalist Ireland much as a man would feel about the door that has bumped his face in the dark. Acting under this impression the publishers of this book forwarded to the *Irish Times* an advertisement that was rejected because it contained the sentence : *A book that would soften any bitterness Mr. Churchill may have in his heart for the Irish race.*

* "When he shall take who has the power,
And he shall keep who can."

A matter of this kind is obviously not the strict concern of the person who wrote the book but it is worth recording in relation to the remarkable review of the book that later appeared in the columns of that paper. A letter of protest from the publishers said : " We did not ask you to accept responsibility for the advertisement. We merely asked you to publish it as an advertisement in the same way as you publish the advertisements of other firms advertising their products and do not necessarily accept responsibility for the statements they make."

But when a reviewer writes down : " Other students of the phenomenon may take the view that ' partition ' had its origins a long, long time before 1912." I know enough about reviewing to form one of three possible conclusions : (i) the reviewer has not read the book ; (ii) he is not really capable of reading anything so as to understand it ; (iii) he doesn't give twopence. " Mr. Kiely," he says, " writes entirely from a Roman Catholic and Nationalist point of view." Did he not know that in a dozen different places I had said I was born and bred Roman Catholic and Nationalist, that I had practically prefaced the book by parading my possible prejudices in an effort to get them out of the way, to make the air clear and agreeable ?

" While much that he writes," says the *Irish Times*, " is bitter in itself and a lot of it would not be accepted as accurate by a Protestant Unionist, he is fairly successful in the avoidance of any personal bitterness." A gracious compliment, if one could only find out what it means, or whether it really means anything, or whether it merely happened that a reviewer who couldn't read clearly enough to understand couldn't write clearly enough to be understood.

Finally : " Every book and every speech about partition, unfortunately, tends to harden the will of the Protestants of Ulster against unity." And my only comment can be that that inanity is scandalously unfair to many Ulster Protestants who have more goodwill and intelligence than the reviewing anonymity gives them credit for.

It was for such people that this book was written, for Protestants and Catholics, for Englishmen and Irishmen and

Americans who are rationally capable of considering the bitterness of the mistakes of the past, of learning from those mistakes, of facing the future with hope and energy and infinite charity.

CHAPTER I

ACROSS THE STREET

"And he said to me: son of man lift up thy eyes towards the way of the north. And I lifted up my eyes towards the way of the north: and behold on the north side of the gate of the altar the idol of jealousy in the very entry."—*Prophecy of Ezechiel.*

(1)

On one side of the street were five houses of yellow mellowing brick, built on a terrace, named by the name of an Irish saint. On the other side of the street were five houses plastered with decorous sombre cement, named by the name of an English seaside resort. The people who lived on the terrace considered that the houses across the street were grey, fur-capped, Calvinistic houses. The people who lived in the grey houses looked up at the yellow terrace and wondered what devilishness or devaleraishness was being plotted there.

Apart from that little nervous suspicion on one side and that good-humoured repugnance on the other the people were good neighbours. Flying paving-stones, evictions, shootings, the burning of houses, drumming processions that swelled and burst in rioting, were all sixty miles away in Belfast. Once or twice in the year the echo of the drums was taken up again in the streets of the town: on the twelfth day of July, on the night when, with torchlight, tar barrel and squib, the effigy of Colonel Lundy was burned, and the siege of Derry was remembered and the gallant wee ship that broke the boom.

All very naïve and very harmless. But do you see the problem? When the banners flapped on the twelfth day of the yellow month, when the fantastic effigy of Lundy was burned on a loop of waste ground with the river around it,

9

sons and their fathers came gallantly out of the grey houses
to march, magnificent in sashes, behind the rattling drums.
Up on the terrace the people were conscious of disunion, of
something wider than the width of the street that separated
them from their neighbours. Nothing so serious as the flying
pavers, the shipyard workers armed with iron bars and bolts,
the guns, the evictions. Those things were only for genuine
die-in-the-ditch Orangemen who lacked some vague, delicate
decency that the men from the grey houses possessed. They
might be Protestants, they might be Unionists, they might
be as orange as the orange-lily ; but they were civilised.
When not actually marching in procession they were
neighbourly, reliable people, one or two generations removed
from the land that Presbyterian ancestors had held with some
little independence and power against landlordism. They could
talk quite naturally with the Catholics from the terrace about
the normal life of the little town. They could even joke
about politics. Belfast was sixty miles away in one direction.
The Border that divided the country was twenty miles away
in the other direction.

Still the division was there, the barrier, the disunion, as
if the material Border, cutting off six counties of Ireland
from the other twenty-six, had projected itself into the things
of the spirit. On the terrace they had one set of memories,
one set of hopes. In the grey houses they hoped for and
remembered quite different things. The greatness of the
division contrasted with the smallness of the town, with the
ordinary unambitious interests of the townspeople. The
contrast made obvious the foolishness of the division : such
a great gulf in one small town, such a long Border, with
Customs this way and Customs that way, in one small
country.

But this revealing of absurdity did not give to anybody
the sudden vision, the moral power to meet the neighbours
halfways across the street, to realise that the people on the
terrace and the people in the grey houses were citizens of the
same town, of the same country, of the same pathetically
small world. No bricks were thrown, no guns were fired
across the street. But some men put on their sashes and

went to walk in processions. Intellectually they were passive, accepting this leader and that speech, until one fiction added to another made them look up to the terrace and see there something like a dance of death, cavorting rebels flaunting flags of green, white and gold.

Actually the people on the terrace looked down on the sashes and banners, the bonfires and drums, with easy contempt. They too accepted the spiritual barrier, being possibly better informed as to its exact origin. But they saw no easy way of removing that barrier.

The division remained. That is the whole problem.

(2)

The country is an island. In a certain type of song its colour is vivid emerald. In a certain type of poem it is all brown bog and curlews and weeping rain. In novels like the novels of Thackeray, it has given birth to Captain Costigan and Barry Lyndon. In novels like the novels of Liam O'Flaherty, it has occasionally given birth to some troglodytes that the ordinary people of Ireland would cut dead if they met them in the street. It has produced missionaries, wandering scholars and wandering soldiers, a long legend of rebellion against domination from outside, the story of a monastic golden age, the story of years of persecution, years of black famine and bleeding-to-death by emigration. The earliest inhabitants of the island came from somewhere out of the sea-mist, left behind them a grotesque and fabulous reputation and a disputating ground for scholars. Rome came over the sea only when Rome was Christian, to build under the cross the new church, using as part of the building-material even the homely pagan legends of the people. Wave after wave of invasion rolled from the east over the island : the wandering, northern sea-robbers, the armoured, organised Normans, the Renaissance state with a new conception of man's duty to his temporal ruler, Puritanism with a new and distorted vision of Christ, new owners of the land with little or no conception of the responsibilities of high position. The people of the island, changing with the years, struggled to find remedies

for every successive evil, conscious all the time that their problems were complicated by the nearness of another island. In our own time there is a hope that the remedying of one more evil might bring to both islands a settled peace contrasting favourably with the chaos of centuries.

Any school geography gives the area of the smaller of these two islands as 32,000 square miles; so much emerald green and brown bog holding a total population of about four millions. The 32,000 square miles are divided into 32 divisions and six of these are boxed off in the North-Eastern corner of the island by a twenty-year-old line that in one place may run up the middle of a village street, cutting off the pub from the post-office, and in another place may cut comically between the oats in one field of a small farm and the turnips in another field. Three-fourths of the population of the thirty-two counties are in religion Catholics. The remaining fourth is made up of members of the various Protestant churches. This means, roughly, that in the twenty-six counties nineteen people out of every twenty are Catholics, and in the six counties one out of every three.

These are pathetically elementary statements about figures discoverable by any reader of the newspapers; but they have the merit, or demerit, of betraying the viewpoint of the person who goes to the physical trouble of writing them down. That viewpoint may be concisely stated by saying that to divide the small population of a small island by any rigid and unalterable barrier is quite as sensible as arranging a barbed-wire entanglement in the middle of the bathroom floor. Now there is a superstition that in writing on any controversial subject impartiality can be guaranteed, and the reader who is inclined to be suspicious soothed into gullibility, by a forewordish declaration detaching oneself from every imaginable form of definite opinion. It is more honest, possibly more effective, to clear the air by announcing prejudices, aversions, the ideals that should, in one individual opinion, be the goal of the united Irish nation.

For that barbed-wire entanglement is more than material for a comic opera, with the dining-room of a house under one legislation and the kitchen under another. It is more

than a background for complicated stories or comic cartoons about smuggling from a shop in one parish to a shop in the neighbouring parish. It brings us back to that allegory of the brick houses on the terrace and the grey houses on the street, of the neighbours uneasily conscious of endless misunderstanding. It is bound up with the flying paving-stones, shattered windows, looted shops, drumming exploding processions, with a dozen other unsavoury things that set house against house, reduce government to suspicious secret organization of one group against another. It is symbolic of the division that means mediocrity in social and municipal life, in politics, in economic and co-operative advancement, even in literature.

(3)

This book is an attempt to descend from the terrace, to cross the street, to be at home with the neighbours in the grey houses. It will have a multitude of faults, because the writer was born and bred very pugnaciously on one side of the street. But the making of the effort is everything, if the difficulty of the descent is fairly appreciated even by one man on the other side. Some such appreciation is very necessary ; for disagreement and division cannot be disposed of by what the diplomats call unilateral action.

In any one of those grey houses, in the narrow hallway or over the mantelpiece in the living-room, there might be the picture of a man with a hard, nervous face, Roman in outline, sombre and irritable but suggesting the possibility of a genuinely friendly smile. The picture might show him femininely slender in a tailed-coat of half-a-century ago ; or it might show the peculiar elation of his face when in 1911 he spoke to thousands of Orangemen, at Craigavon near Belfast, telling them of the "criminal folly" of Home Rule for a united island ; or it might be the picture of a prosecuting lawyer examining such a man as William O'Brien while very unsympathetic crowds gathered outside the courthouse, or in the depressing dusk of the Old Bailey breaking down the last epigrammatic defence of an unfortunate fellow-country-

man and poet. The man was loyally followed and loyally loved. He was also detested more than most Irishmen of the last century. For whatever his intentions may have been he became the great advocate and apostle of disunion. His name was Edward Carson.

PARADE TO CRAIGAVON

" Here was a man, till that day not one of themselves, who yet could realise that to the men of Ulster the Legislative Union between Great Britain and Ireland was infinitely more than a political question ; that it was a thing to be spoken of in the workshop and in the home ; a thing to be taught to their children as a religion is taught ; something personal and sacred."—*James Craig writing, in* 1921, *of Carson.*

(1)

By noon the crowds of people had crushed into Donegall Square, around the building, the great City Hall, that is the centre of Belfast. The sky was grey over the city, huddled gloomily between the straight wall of Cave Hill and the wide waters of Belfast Lough. Specially-appointed marshals wearing badges of red, white and blue kept the crowds in order, manœuvred them into the places they would hold in the procession, kept them waiting in docile patience while a passing cloud emptied itself over the streets. It was harvest rain. The day was the twenty-third of September, 1911. When the march began, up the three miles of streets to the sloping fields south of the lough, the rain had ceased and the sky was clearing. In the head of the procession went the visiting County Grand Orange Lodges led by the men from Larne and Antrim and Ballymena ; a journalist described them as an " army of determined and earnest loyalists marching four deep and preserving splendid formation."

On the heels of the sashed men from the visiting Lodges went the Unionist Clubs ; then the Orangemen of Belfast, who had politely taken the lowest place, walked in the rear. They crossed Queen's Bridge, over the muddy Lagan, went by way of the Newtownards Road and the Hollywood Road

to Craigavon. The brethren of the Portadown district arrived late, lost their place in the line of visiting Grand Lodges, followed the polite Belfastmen over Queen's Bridge, through streets with crowded, waving windows. Some sense of the special dignity of the occasion dispensed with the genuine giant Orange drums ; they drank in the elation and rhythm of marching from shrill fifes, kettledrums, bagpipes. They filled the sloping fields around Craigavon. Below them was the lough, the city, the factories, the skeleton steel arms over shipyards and dockyards ; and across the water, Cave Hill and the Antrim shore. Over the house at Craigavon flapped the flag that had been used at the Ulster Unionist Convention in 1892. For the men there it was a link with the almost legendary visit of Randolph Churchill, with a sentence written somewhere that Ulster would fight and Ulster would be right. For men who had seen through Randolph Churchill that flag might have recalled the greatest English statesman of the nineteenth century and his heroic, vain efforts to uproot *the Upas tree*. But the vast majority of the men at that meeting revered the memory of Randolph Churchill. Every step they took on that parade to Craigavon was hammered out to the jingle of Randolph Churchill's rhyming sentence : Ulster would fight and Ulster would be right. Neither they nor the visitor from the English Conservative Party bothered defining what they meant by Ulster. That neglect of the Aristotelian business of definition still causes confusion.

Definition or no definition it was an important march and an important meeting. What was said there was to affect powerfully the course of English history and Irish history and the awkward business of the relations between two neighbouring countries. According to some opinions it was to influence the leader of a great continental military power in a decision made three years later.

The old flag flapped over the house at Craigavon, the home of a certain Captain James Craig, a big name in Belfast industry. The captain had fought against the Boers in a war to establish and solidify Empire. He was to figure prominently in another struggle carried on professedly for the same

purpose. He had brought those sashed soldiers to the fields around his home to meet the leader chosen for them by bigger men than themselves.

(2)

The first speaker was the Earl of Erne. Then the Right Honourable Thomas Andrews thanked the chosen leader for his long and devoted service to the Unionist cause and welcomed him to Ulster to marshal the forces of Ulster against Home Rule. In addition to the already-mentioned debatable term *Ulster*, that sentence of welcome contained another undefined and debatable term : *Unionist*. As Thomas Andrews understood it, it meant that he, and the meeting, and that newly chosen leader who was Sir Edward Carson, were " Unionists " : that is, they stood for the union of Ireland and England under one crown, one legislature, one administration. That union had been effected about a century previously. Its genius had been Castlereagh ; his methods had become stock examples of wholesale corruption and bribery. The *Union* had never really been notable for uniting the two countries. The strongest argument ever put forward in its favour was based on the few material reforms effected in the closing years of the nineteenth and the opening years of the twentieth century. But men like Thomas Andrews never submitted the Union to historical or economic or cultural analysis. That whole great meeting was blinded by the radiance of red and white and blue ; excited by symbols : an ancient flag, a Dutch king on a white charger, a drum, an array of coloured sashes. That red, white and blue radiance shone obliquely on the great Gladstone, showed him up as no " Unionist," as a separatist, as something very like a rebel against the institutions that he revered.

The meeting proceeded. A resolution was passed sending a message by the Right Honourable Charles Scott Dickson, M.P., " to all loyalists across the channel asking them to aid Ulster in its determination to remain as at present under the Imperial Parliament, an integral part of the great British Empire." A series of addresses of welcome to Carson was

read; significantly, one of them was signed by about one thousand important manufacturers and merchants. The significance of those signatures would have different meanings for the enemies and friends of what came later to be known as Carsonism. The enemies would say : This is not a popular movement ; it has the allegiance of no section of the ordinary unpropertied people. A modern Irish writer has said that the whole secret behind that meeting and behind the subsequent agitation can be found in the Peerage or the Directory of Directors. The friends of Carsonism would say : The propertied and moneyed men of North-Eastern Ulster show by their support of Edward Carson that they understand that Home Rule, or Ireland governed from Dublin by a body of men democratically elected by the majority of the people of Ireland, would be against the best interests of those men of property and money. Both arguments are wrong in so far as they over-simplify a problem that John Redmond said did not exist until it broke his own heart and put the last nail in the coffin of a great English political party. Thirty years ago Irish Republicans thought it could be solved by a route-march. To-day most rational Irishmen know the twisted and intricate complexities of the business, the need for goodwill and infinite patience.

At Craigavon, and indeed all over Ireland, in the year 1911 the tendency was towards simplification. The Second Home Rule Bill had in 1893 provoked a free-fight on the august floor of the House of Commons ; and there is nothing so simple and so futile as punching the neighbour's nose and tearing the shirt off his back. That fight was only an outward sign of the prevalent mood in Anglo-Irish politics. Shibboleths and vague rosy hopes were put forward as practical policy. Sieyés could have said epigrammatic things about Redmondite " sunburstry." That was a manifestation of the mind of Ireland in a weakened state : the round-tower, the harp, the wolfhound, the rising sun. It was flamboyant, and its symbols even if they had once possessed a second-rate poetic quality had been cheapened by association. But it was at least positive ; and some of the things that came from Carsonite platforms were the last thing in negation. For

instance : when Carson was asked by one of the men who
more or less represented his followers at the Convention
held in Trinity College, Dublin, under the beneficent patronage
of David Lloyd George, what positive programme he stood
for, Carson is reported to have mentioned The Union of
Castlereagh. Inane simplification could go no further, for
if that futile Convention had any purpose in meeting and
talking, it was to find some remedy for the evils done by
The Union of Castlereagh.

That was characteristic of Carson. As a cross-examiner
and generally as a lawyer his notable ability was in grasping
the one significant central thing in a complicated case, in
finding the one weak spot in an opponent, either criminal
or witness, and striking again and again until all resistance
had collapsed. That was a great power. But there is a difference
between one man in the dock or in the witness-box and a
whole nation of men who are neither criminals nor sworn
witnesses but merely people with a different point of view.
By that simplification and concentration you can corner a
witness or convict a criminal or conduct a successful agitation.
You cannot make a few million men realise that their interests
are joined together and united. You cannot build a nation.

(3)

Somewhere between five and six o'clock in the evening
of that autumn day he stood up and " delivered what may
be truthfully described as a fighting speech." The journalist
who described the business in a special pamphlet published
afterwards in Belfast had the mental equipment of any comic
maker of *cliché* in a novel by C. E. Montague. The crowd
sang : *For he's a jolly good fellow*. That jolly good fellowishness
was part of the natural equipment of Edward Carson. It
provoked from an Ulster Protestant like Mr. St. John Ervine
the bitter names of the last of the stage Irishmen, Broth of a
Boy, the greatest of the Bedadderers and Bejabberers. At
any rate the crowd at Craigavon thought he was a jolly good
fellow. When they had ceased singing he was up and off
into his speech :

" We fought this battle twice in a straightforward fight.
We are going to fight it again and we áre going to win."

Every word in that speech is of considerable importance.
It was rhetoric and it was put forward for mass-consumption
but it was one of the first notable public statements of the
case against Home Rule made by the new leader of those
men resident in Ireland who were opposed to Home Rule.
That speech was one of the very important things in the
career of the man who made it. He always said that he
entered and remained in politics only to maintain that amazing
sundering and disuniting thing : The Union. Less favourable
critics of Carson than Carson himself suggested other motives
but, in the absence of any real convincing proof, there is
no reason for disputing his own statements. He naturally
opposed himself to the remains of the Party that had once
been strong under the leadership of Parnell ; and at the
Craigavon meeting he could congratulate himself on having
discovered the one weak spot in the argument put forward
by that party. Randolph Churchill had already discovered
it and used his discovery cleverly. Carson began his attack
in that speech. The big men who had brought him there
had found for their own case the best possible advocate.
They could listen with satisfaction. The thousands of ordinary
small men were getting the medicine that custom had taught
them to like. The man who gave it to them was a jolly good
fellow.

He told them that the Third Home Rule Bill was " the
most nefarious conspiracy that had ever been hatched against
a free people." He believed that there never had been a
moment at which men were more resolved than at that time
to maintain the British connection and their rights as citizens
of the United Kingdom. Ireland was advancing in prosperity ;
yet the Liberal government had decided to plunge Ireland
once more " into desperate political chaos, once more to
distract men's minds from the common measures which they
might take together for the benefit of the country, once more
to bring about that hatred of class against class and religion
against religion which every one of us would like to see
abolished in the interest of our common land."

It is interesting to see in the newspaper reports of the speech that the crowd, whose sons now form the stolid support of the Stormont government, cheered that very noble sentiment.

To Carson, the Asquith government was using Home Rule as a purely political vote-catching business, a gamble with civil and religious liberty. The primary task for the men at that meeting was to maintain the Union and oppose Home Rule. They fought with men who were prepared to destroy their own Constitution so that they could pass Home Rule, who had withdrawn the decision from the electorate, who were manipulating facts and figures to give their own conception of the financial implications of the Union and were manufacturing paper safeguards for the protection of minorities.

The arguments he put forward in that fashion were not new, not original, but they had then and they have even now a considerable persuasive force. For Carson the word " electorate " meant the united voters of England, Ireland, Scotland and Wales, joined in one kingdom under one crown. For the majority of Irishmen, especially in the resurgent years that lay ahead, it meant only the people of Ireland possessed of the power to decide their own national destiny, ready to live amicably with England only when that power was recognised. Between those two interpretations lay the great gulf across which all attempts at conciliation and agreement wandered as futile whispers or noisy clattering echoes. Carson himself was not above manipulating facts and figures so as to give his own conception of the financial implications of the Union. And, when, more than a decade later, after years of bloodshed and pogrom and frenzy a settlement that settled nothing was arrived at, it left a minority without the semblance of safeguard, paper or otherwise. It was not, as the whole world knows, a Carsonite or " Unionist " minority.

Carson on the public platform had that sort of heavy good-fellowy wit that tickles the palate of the naïve, and it is commonplace that an audience of our ordinary people in the north-eastern corner of Ireland has *naïveté* as its pre-

dominant characteristic. He joked heavily about the Eighty
Club, a Liberal institution that had sent a deputation of
members peregrinating Ireland, gathering information,
forming opinions. He joked heavily about Radical and Liberal
politicians running around asking people what was Home
Rule and where was Ireland. He joked heavily about John
Redmond and his followers who would, in the hypothetical
independent future, try to teach all Irishmen, Orangemen
included, the Gaelic tongue that they themselves couldn't
speak. The crowd laughed. But the real humour at that
meeting was unconscious. When Carson rhetorically asked
the crowd what should be done when the new Parliament
would be set up at Dublin with the Irish nationalists in
command a voice said : " We will not have John Redmond
as king." When he inquired who would appoint the new
administrators a voice said : " The Bishop of Rome." Now
to the detached and considering mind those remarks of the
anonymous voice are funny ; they are also a little bit pathetic.
The fear of John Redmond, of all men in Ireland that might
call themselves Nationalists, the fear of the Pope, have been
misshapen, distorted shadows in the minds of the Protestants
of north-eastern Ireland for many long years. Those fears
have combined a dozen crooked views of Irish history, a
dozen sinewy atavistic things burrowing backwards to John
Knox and the man who made a cheerful face a misdemeanour
in the Geneva of the sixteenth century. Combine these with
that previously mentioned business of the Peerage and the
Directory of Directors, with that very fundamental dis-
agreement about the meaning of the word " electorate,"
with the dread that men of capital and property always have
of radical changes of governmental method, and you will
have an approximate idea of the complexity of the whole
problem.

<div align="center">(4)</div>

There were a dozen or more hobgoblins that the Unionist
minority in Ireland always associated with the idea of an
independent Nationalist government. Carson's speech set
them actively dancing into the minds of his audience : the

old civil service would disappear ; the protective police would be taken away ; religious education would be in the hands of the Nationalist Party and that meant compulsory Papistry and compulsory Gaelic ; there could be no appeal except to a Parliament in College Green. Then the Unionist minority would gain nothing by Home Rule. " Do you gain financial advantage by dissolving partnership with the Exchequer of the richest country in the world ? Do you gain greater civil freedom in abandoning a Government which has been an example of liberty to every foreign nation ? Do you gain greater religious freedom ? "

It is interesting to look back through the thirty-odd-years at the excited dance of those hobgoblins ; to contrast the fearful forebodings of the horrors that would follow Home Rule with the conditions now prevailing in the two fragments of a broken country. The hobgoblins still dance, or at least they totter wearily through the incoherent pages of a pamphlet written by a Trinity College professor who is firmly convinced that the Protestant minority under the Dublin government endures some vague form of religious persecution. But in the six counties that surround Belfast the dance is as strong and frenzied as ever ; and we are confronted with the spectacle of men denying to their neighbours the rights that they claim the neighbours would, if they could, deny to them. In a military campaign attack is supposed to be the best method of defence. Applied to politics it may for a period establish security in dominance, but it is not statesmanship, and it is not justice.

Carson ended with that rhetorical appeal to which Irishmen of any political creed are never unresponsive. Belfast and something that he misnamed " Protestant Ulster " were, he said, the keys to the situation, as Derry and Enniskillen had been in 1688 and 1689. " Under no circumstances will we accept Home Rule, or acknowledge any executive government which is not responsible to the Imperial Parliament." Asquith had refused to allow them to put their case before the English electorate. He had driven them to rely upon their own strength, to organise at home, in England, in Scotland ; and in the event of a Home Rule Bill passing through

the English Parliament they must be prepared to adopt such measures as would carry on the government of the districts they controlled. The Ulster Unionist Council would discuss the methods to be adopted. They had been threatened with Mr. Redmond's strong arm, with military force; but force had never yet been used to drive loyal and contented citizens " from a community to which by birth they belong." When British soldiers attempted to do so, that day would end the British Empire. " We are out once more upon a great campaign against betrayal—a betrayal of the foulest and most humiliating character. Let every man take that betrayal to his own heart. Talk of it in your offices to one another, talk of it in your workshops to one another, talk of it at your firesides, and teach your children of it so that it may sink deep into your hearts as to what it is proposed to do."

(5)

There were other speeches at that meeting. There were other meetings, at Balmoral, at Blenheim, with F. E. Smith galloping to a peerage and the diffident Bonar Law talking red rebellion. But that speech made by Carson at Craigavon was notable for several reasons, not least for the inclusion of that fine passage last-quoted. It was good public speaking. It impressed Captain James Craig. It impressed the other big men on the platform. It impressed the audience with the jolly good-fellowy eloquence of this new leader who up to that day had been known to them only by the echoes of his legal reputation, and by the fact that in the House of Commons he represented Trinity College. For his origins were in Dublin, his background was law in Dublin and law in London. The distance from Trinity College, Dublin, to Craigavon in County Down is not very great; but Edward Carson had not made a direct journey. How he found himself on that platform and what he achieved from it, the forces that supported him and the forces that opposed him, make up almost the complete story of the origins of division in a small island. At Craigavon he did not plead the cause of

actual material division. But he over-emphasised the differences of opinion that, helped by the very unexpected events of the next decade, were to draw a strange line between six counties and twenty-six counties in the same country. We have just heard him state his case.

CHAPTER III

KING CARSON

"Sir Edward is the embodiment of Unionist Ulster; he is Ulster. In nothing, perhaps, is the absolute truth of that assertion more apparent than in the self-restraint of the people of the Imperial Province, through long months of anxiety and strain."—*James Craig in* 1921.

"Sir Edward Carson is a stage Irishman . . . the last of the Broths of a Boy. He has a touch of Samuel Lover's 'Handy Andy' in him. He is the most notable of the small band of Bedadderers and Bejabberers left in the world; the final Comic Irishman."—*Mr. St. John Ervine in* 1915.

(1)

His origins were in Dublin, in Harcourt Street on the south side of the Liffey, roughly within the area of wide Georgian squares and tall Georgian houses in which the vanishing Ascendancy died with dignity. The fighting of the revolution that was the tragedy and triumph of the new Ireland was, years afterwards, to cut its marks across those streets. When Carson was born in 1854 the railings in Stephen's Green enclosed private gardens. Outside those railings, outside Trinity College, outside the Georgian squares, the Georgian houses, the great mansions with their walled gardens here and there through the country, there was every evidence that the Irish people was dying a very miserable death. Less than ten years previously William Carleton, a genuine man of Ulster with one foot in the traditional Gaelic past, had written *The Black Prophet*, a mediocre story with a setting in horror and famine that gives it a unique value. O'Connell was gone. The great voice was silent; the great meetings scattered for ever; the people who had worshipped him, rotten in famine-graves, or sailing westwards to die miserably

26

or to gather up again the poor pitiful fragments of broken lives. The romantic and utterly futile revolution of William Smith O'Brien, the splendid, slightly Carlylean voice of John Mitchel who also came from Ulster, the ideas of Davis and Lalor, the poetry of Mangan, the oratory of Meagher, had apparently been swamped in the black devastating tide. Nothing could stand against the Great Starvation, except the privileged owners whose exactions had to a large extent made it possible. Dublin was making for itself a slum-problem that was to grow steadily worse until the new flats and garden-suburbs built under a native government showed the way to clearance and recovery. Across the street from Trinity College, where Carson was a student, was the dark, squat building that had heard the echoes of Grattan's voice pleading vainly the great cause of honour and public spirit. That was all gone. The Parliament that listened to Grattan was only a memory : volunteers in uniform, a small minority of honest men, a shameful end in bribery and corruption. The Ireland into which Carson was born prospered under the Union. The beneficent spirit of Castlereagh blessed the blighted potato-fields, the famine graves, the growing slums, the coffin-ships. And Edward Carson growing up into manhood was content with the Union.

His father was an architect, descended from a Carsoni who had come to Dublin from Scotland. That Carsoni had been one of those Italian architects who worked on the mansions of England and Scotland and Ireland during the eighteenth century. Somehow or other the final vowel was dropped, Carsoni became Carson ; and the official biographer in a very naïve sentence says that Edward Carson's father " despite his Italian blood lived and died a devout Presby-terian." On his mother's side the name was Lambert, the blood was Cromwellian, so that Carson was at least on the fringe of the very remarkable class of people that produced Swift, Wellington, Yeats, Shaw, Gregory. Tim Healy once said that Carson although always a Unionist was never un-Irish. An Ulster Protestant like Mr. St. John Ervine could interpret that in the sense of stage-Irish. Certainly it could never mean that Carson was Irish as Yeats or Synge or Patrick

Pearse were Irish. But then we must allow for many different types of Irishmen, reserving a special limited veneration for the stage-Irishman who, as every patron of Hollywood knows, is at least a very amiable and very able propagandist.

His father wanted his son to be a barrister, more or less against the son's will, and to that end he gave him the routine education designed by some Unionist Providence for young men of his class and creed. Lacking Oxford or Cambridge the course of that education led inevitably through Trinity College, where he had a not very distinguished scholastic career. The official biographer, with all the stuffed-owl quality that is characteristic of official biographers, records that Carson's poor health cut him off from athletics, but that he rowed now and again " and also played a game called ' hurley ' which was the precursor of modern hockey." The Gaelic Athletic Association might have a powerful instrument of propaganda in a coloured poster depicting Carson the Hurler disporting himself inside the railings of Trinity College ; but the followers of Michael Cusack—who is supposed to appear under another name in James Joyce's *Portrait of The Artist as a Young Man*—would be rather staggered by the suggestion that the highly-skilled game of hurling was merely a precursor of something so tame as hockey.

Trinity College has always been regarded with a certain amount of justice as the hothouse in Ireland of the tradition of the Protestant Ascendancy. A violent Nationalist once referred to it as Queen Elizabeth's Cesspool ; a rather uncomplimentary interpretation of the history of its foundation. It was associated with some of the noblest names of the strange class that lived between two nations, the Anglo-Irish Protestant Ascendancy in Ireland : with Burke, Goldsmith, Swift. Emmet, who died on the scaffold a little bit up the street, had been a student there ; and Tom Moore, the poet, who had been the friend of Emmet. The college had blotted from its records the name of the rebel John Mitchel. These names could have meant little to Carson. There is a report that at times he preached in the streets in the effort to evangelise the heathen papistry of Dublin. If he sang there, his songs

were not the songs of Tom Moore, much less the great songs
and poems of Mangan, who also had associations with Trinity.
For through the smooth romanticism of Moore and the rough
romanticism of Mangan, or even from the stories of Carleton
who knew the people of Ulster as no other novelist ever
knew them, he might have learned to look beyond the railings
of Trinity and the Georgian squares to see the suffering
in the souls of the people. The sight of that suffering had
sent Emmet to the scaffold and Mitchel to the hulks. When
Carson was still a rising lawyer, it was to make such a woman
as Maud Gonne break with all the traditions of her class,
to send her to help the starving and suffering people in Mayo
and the Rosses of Donegal. Those poor people saw her
almost as the reincarnation of some beauty of Gaelic legend.
To Edward Carson the legends were barbaric piffle; Emmet,
Mitchel, Maud Gonne were traitors and criminals. Maud
Gonne led by a generous, impulsive heart became a legend
to the grateful poor, and drew his greatest poems from the
greatest poet of his time. Edward Carson used his head,
became a successful lawyer, a successful politician, stood
solid for money and property against the claims of the poor
people of a decaying countryside. If they protested against
that poverty they were criminals and their leaders were
criminals. A real patriot does not begin life thinking that
way. It was a poor training for a king.

(2)

He became a lawyer, not immediately a famous lawyer;
his talents were not quick. Contemporaries in college were
to give more rapid beginnings to their careers but were to
drop behind him in the end. One contemporary was a brilliant
youth called Oscar Wilde who was to meet Carson again
at an English law-court. In politics the young student was
a Radical, which meant that he wanted to see capital punish-
ment abolished, the Church of Ireland disestablished, that
he approved of giving votes to women, that for some reason
or other he approved of the French revolution. That could
only have meant that he had not the least idea as to what

had happened in France during the Revolution, or that he
approved of the Revolution as interpreted by Thomas Carlyle
who saw the upheaval in France as a sort of supplement to
the religious revolution in sixteenth-century Germany. For
if the wars of the French Revolution had ever really reached
the fields of Ireland they would quite possibly have prevented
Castlereagh's Union and upset the appalling system of land-
tenure. These two not-revolutionary things were, as far as
we can gather, the only social and political ideas that the
mind of Edward Carson ever grasped. He was to occupy
very high positions in the councils of the British Empire,
to lend the support of his name and his ability to several
good and honourable causes. Despite cart-loads of adverse
criticism, both of his abilities, his deeds, the motives behind
those deeds, there is no very good reason for supposing
that he was anything other than a very able and very well-
intentioned man, that he did mean to advance the glory of
the British Empire, that he did mean to advance the welfare
of his own country, Ireland, which he considered part of
that Empire.

His most hostile critic was the Ulster Protestant, Mr. St.
John Ervine, who pointed out quite sensibly that Carson's
name could not be associated with any measure for the
amelioration of Irish or British life. " One cannot say of
him as one can say of Mr. Joseph Chamberlain, that he has
done things which compel the respect of his most bitter
opponent. He has never attempted, probably never even
thought of improvements for Dublin or Belfast such as Mr.
Chamberlain achieved for Birmingham. His name is not
linked with any statute of well-being as Mr. Chamberlain's
name is linked with the Workmen's Compensation Act."

That was very nearly true and it was part of the tragedy
of Carson. He did think of improvements for Dublin and
Belfast, for all Ireland. He was anxious that every advance
and improvement and beneficial innovation in the English
public-services should be extended to Ireland. He supported
the demand for a Catholic university in Dublin, although
the opinion of the Unionist minority in Ireland, clinging
frantically to the shreds of a lost, tattered dominance, opposed

that demand. He supported the work of Sir Horace Plunkett and of agricultural co-operation against the attacks of the Parliamentary Party. But all improvements must take place within the limits set by Castlereagh. Sir Horace Plunkett, A.E., the poet, Father Tom Finlay, might do what they liked to restore the country, to preserve the rural life that was dying in emigration and the drift to the towns ; but the landlords must remain. He could not see that the Union did not unite, that the system on which the landlords in Ireland held their land had been universally denounced by all honest men. That form of denseness, of inability to consider the viewpoint of the majority of the Irish people was a heritage that pressed heavily on the Protestant minority in Ireland. Their ancestors had been the garrison, the colony. They could never realise that the day of the garrison was done with, that the mentality that went with it should be discarded. It was not discarded. It remained as a specially strong atmosphere in the rooms of the college that educated Edward Carson.

When Trinity College projected him into the Irish legal world it started him in the one profession in which educated Irishmen holding extremely opposed political views could meet and mingle. On the Leinster Circuit he came first into contact with John Redmond and admired him for the loyalty with which Redmond, the young politician, had stood by Parnell, the fallen Chief. Irish law, too, made for Carson his genuine friendship with Tim Healy, whose tongue had at one time or another scarified everybody it commented on but failed to prevent its owner from maintaining connections with men of every imaginable alliance. Whether that was or was not an advantage depends exactly on what one thinks of Tim Healy and the politics of Tim Healy. At any rate neither Redmond nor Healy monopolised much of the friendship of Carson. As he made his way upwards on the Leinster Circuit he made his own personal friends, who found him generous and loyal, but who, with one exception, are not of any notable importance in the story of this book. When he was 32 years of age and of considerable standing in his profession he was introduced to the new Chief Secretary for Ireland under the Salisbury government

that had recommended for Ireland " twenty years of resolute
government," after the defeat of Gladstone's First Home
Rule Bill. The Secretary was Arthur Balfour, known as
Tiger Lily for one reason and as Bloody Balfour for another
reason. That meeting and the ensuing friendship were to
be of considerable value to Carson. What he said himself
was: " I was only a provincial lawyer, and, till I saw Arthur
Balfour, I had never guessed that such an animal could
exist."

<div align="center">(3)</div>

Arthur Balfour was supposed to dislike lawyers, but
he liked Carson the man, he was keenly interested in Carson
the lawyer. Gladstone's first great effort to make peace for
ever between the two islands had failed. The men who had
defeated him now controlled the government of Ireland and
their idea of how that governing should be done was summed
up in that phrase about resolute government : which meant
the suppression of agitation, the jailing of agitators. Agitation
and coercion and what we inexactly call agrarian-disorder
are so common through several centuries of Irish history
that any explanation seems unnecessary. When Tiger Lily
became Bloody Balfour and set out to jail agitators it meant
that the armed forces at his disposal were ranged in defence
of landed property against the poor people of the country.
The claims of the owners of property were placed anywhere
over centuries of conquest and spoliation ; their exactions
equalled anything the Turk or the Galician landlord or
feudalism in decay had to show. Back under the Melbourne
administration that had kept the peace for a while with
Daniel O'Connell, a young Scotsman called Thomas Drum-
mond had horrified the magistrates of County Tipperary by
telling them that property had duties as well as rights. Since
the death of Drummond there had been the appalling
Starvation, made possible principally by the existence of those
landed proprietors. In 1881 when Carson was finding his
feet in law the whole landed system was shaken by Gladstone's
Irish Land Bill, a milch-cow to all industrious lawyers. It
brought a good deal of work to Carson ; a good deal of reputa-

tion for his ability in defending the rights of tenants. There
is a story that that reputation once brought to him a deputation
of Nationalists asking him to stand as Nationalist member
of Parliament for Waterford. He said he was a Unionist,
that he had his living to make, that he had no interest in politics.

For about five years the accidents of his profession made
him the able defender of poor men. In 1886, under the same
Conservative wind that later wafted the Tiger Lily to the
Irish shore, John Gibson, who was Irish Attorney-General,
nominated Carson his Crown Counsel. The appointment
meant that henceforward he would prosecute criminals in
the august name of the Queen of England, and included
in the class described as criminal were the poor, exasperated
people who resented unfair rents and eviction, the men who
were banding those people into a nationwide organisation
to gain possession of the land they tilled. Behind and above
secret societies and separatists, the remnants of the abortive
Fenian rising of 1867, the land agitators and agrarian outrages,
was the Parliamentary Party under the leadership of Charles
Stewart Parnell. That was how Carson would have viewed
it. The attempts to connect Parnell with any sort of outrage
or revolution or physical force ended in dismal failure but
as far as Unionist opinion was concerned all men who were
not Unionist were lumped into one grand category, and the
operative adjective was " criminal." Now Carson was an
intelligent man who knew that, whatever else John Redmond
and Tim Healy were, they were not criminals. He might
not have been so certain about William O'Brien who had gone
so far in anti-Unionist wickedness as to advise poor, evicted,
ill-treated men to stop paying rent. But when at a later date
he found himself on political platforms he could speak only
of Home Rule as a nefarious criminal conspiracy to subject
a people (he meant the Protestant dominant minority in
Ireland) to the rule of men who were professedly disloyal
and who had risen to power by land-leaguing, and houghing
cattle. He meant every man who did not think, as he thought,
that the Union really did unite Ireland and England. Taken
all together those men comprised the vast majority of the
Irish people, an intelligent minority of the English people,

a great many members of the English Liberal Party. Burke, who had also been to Trinity, appeared to think that there was no way of indicting a nation. Carson knew better. Whether he believed it or not he shouted " criminal " ; and he included under the title many men who obviously only differed from him in point of view. And as far as the real outrages were concerned Carson with his paid prosecutor's complex readily lost sight of the appalling system that had provoked agitation and outrage : the endless, nagging exaction ; the crow-bar tumbling the walls and tearing down the thatch ; the families evicted, young and old, the sick man on his deathbed left without shelter from the rain, the pregnant woman in pain in the wintry ditch, the hoary old scoundrel of a landlord exercising *droit de seigneur* over his tenants' womenfolk. The system allowed those things ; and in 1886 Edward Carson became the paid defender of the system. Once again, it was a damnable training for a king.

(4)

He was a good lawyer. He had courage. He did his job well. The man who had faced Tim Healy and William O'Brien was well tested ; and when Balfour, the Tiger Lily, commenced the administrative labours that were to gain for him that other uncomplimentary title, he needed the help of such a man. Carson gave his help with an energy and ability that sent him soaring in the legal world, that sent him also into the political world. Balfour, at a later date, even offered him the position of Chief Secretary, a position that, for several reasons, he held only for one day. In the General Elections of 1892 he came to the House of Commons as member for Trinity College, came also to the commencement of a very distinguished legal career in London. The whole thing was quite normal, almost humdrum. The life of a great lawyer makes usually interesting reading only for students of law. The one incident in the career of Edward Carson that makes all this detail and comment excusable was certainly not in the orthodox tradition of Conservative politics, much less in keeping with the teachings of the law in which he was so well versed.

ULSTER : THE LAST DITCH

" Believe me, whatever way you settle the Irish question, there are only two ways to deal with Ulster. It is for statesmen to say which is the best and right one. She is not a part of the community which can be bought. She will not allow herself to be sold. You must, therefore, either coerce her if you go on, or you must in the long run, by showing that good government can come under the Home Rule Bill, try to win her over to the case of the rest of Ireland."—*Carson in the House of Commons in* 1914.

(1)

Now what and where exactly is Ulster ? The meaning of the name has a great deal to do with the complications of the controversy. In ancient Ireland there were five provinces : Ulster, Munster, Leinster, Connaught, and the province of Meath ruled by the high king. The provinces quarrelled with each other, and with the high king. But it would be a great mistake to imagine into that quarrelling a territorial exactness like that preserved in inter-provincial football matches. Every area that had within itself any political, social, geographical or economic tendency towards unity might quarrel with any other, more or less unified, area. To trace back the divisions of modern Ireland to that ancient intricacy would be little short of lunacy ; yet lovers of the logical and sensible thing have not been spared the spectacle of business-like Unionist politicians seeking historical validity for the Stormont government in ancient quarrels between Ulster and Leinster and the poor harassed High King at Tara. The very same men might be found referring to the Gaelic tongue as an uncouth tribal patois, which, to put it very mildly, does show a failure to realise what had and

had not real value and durability in the strange thing that was ancient Ireland.

Consider for instance a book like Mr. Hugh Shearman's *Not an Inch*. Mr. Shearman claims to have written a non-party work, and, indeed, a certain consciousness of what was required of highly-liberalised Episcopalianism prevents his displaying any noticeable sectarian bias, even allows him to admit familiarity with the more pro-revolutionary poems of William Butler Yeats. But if the retention of certain woolly ideas, accepted as part of the armoury of one party for sheer lack of anything better, is evidence of party feeling, then Mr. Shearman is as partisan as the old Orange flute. No amount of liberalising can keep him from automatically displaying those ideas, just as no amount of holy water could prevent the flute playing the familiar and beloved tunes.

Mr. Shearman does not, for instance, really believe that Cuchulainn "the great Ulster hero of mysterious divine origin . . . child of Lugh of the Long Arm" was really the forerunner of Captain James Craig "son of a distillery director." He would never maintain that the great duel at the ford between Ferdia and Cuchullain was the mythologic counterpart of the twentieth-century interview between Craig and De Valera, when the latter talked and the former smoked his pipe, yielded not one inch, and the ford was held. Mr. Shearman even goes so far as to grant that it "may be an absurdity" to claim anything of the sort. Yet he cheerfully carries on to maintain · that the barrier at present cutting Ireland in two has ancient foundations in geology and physical structure, "in human sentiment." He maintains that the Erne waterway was always part of the natural boundary cutting off Ulster from the rest of Ireland. Then he hurries on before he can ask himself why Donegal, the one county of historic Ulster most cut off by that barrier, is not included under the "Ulster" government that centres in Stormont. If this is done in good-faith then that good-faith has little penetration and no feeling for history. That is only a detail, but it is a perfect example of the sort of party misuse of history that Mr. Shearman should have outgrown. For there is no connection between those remote clan-wars and the modern

disputes and divisions. Saint Columban may have been the "blunt controversial opponent of Pope Gregory the Great" but he was as openly and unashamedly a Catholic as any man that ever lost his job or had his home looted in Belfast during an Orange pogrom. Hugh O'Neill, the greatest of Ulstermen, may have been reared a Protestant in the court of Gloriana but when he was broken in battle he was fighting against the English crown, against the whole extending power of the state that had grown up to fill the place of the medieval order. Irish Nationalists have frequently misread the portion of Irish history that precedes the Battle of the Boyne, imagining into it an idea of national unity that is the discovery of more modern times. But in their weakest moments they have never equalled that great leap backwards over thousands of years to give validity to a division that was unheard of and unthought of when Edward Carson spoke at Craigavon in 1911.

For we will never make any sense of the whole business unless we place ourselves in the opening years of this century, realising clearly that Ulster then meant, and had for many years meant, an area divided into nine counties, covering the complete northern portion of Ireland. A large Protestant and Presbyterian element in those nine counties centred mostly in the north-eastern corner of the country around the city of Belfast. That element originated in the early seventeenth century under King James the First of England. Hugh O'Neill's great battle against the new state had ended in defeat for O'Neill. To displace O'Neill's broken and disordered followers the divine right of King James introduced a number of immigrants or "planters," mostly men from Scotland who followed the new faith of Knox and Calvin. They were a colony and they preserved the colonial outlook. In the eighteenth century agrarian injustice drove many of the poorer of those planters into exile in the American colonies ; their names were heard of again in the armies of Washington.

But the colony remained and made for itself a democratic independent outlook that squared poorly with the memory of the wisest fool in Christendom. When French ideas were

in the air at least an active section of the colony went French
and for a brief period there was a hope that in the island of
Ireland there would be no more colonies, no more divisions,
but one united Irish people. The hope was in vain. Under
Castlereagh's Union the colony lived on, a minority preserving
a Liberal outlook in politics, until Gladstone's First Home
Rule Bill scared it into a sort of Ultra-Conservatism known
as Unionism.* To Randolph Churchill that Unionist colony
was a good stick with which to beat the Liberal Party.
Unionists were in a majority around Belfast, in a minority
in the nine counties of Ulster, in a smaller minority over
the whole island. But some name seemed necessary to describe
the intensification of Unionist feeling around Belfast, and
somebody called it " Ulster." The name stuck. Randolph
Churchill knew he was on a good thing and that the Ulster
card was the card to play. Two Home Rule Bills and a large
part of the life-work of the great Gladstone were in vain
because of that playing of the Ulster card. A Third Home
Rule Bill was born dead about the beginning of the first
European War. " It was a limping, pettifogging, gerry-
mandering, pocket-picking affair . . . it died on the first
day of the war."†

The debate on that Third Home Rule Bill involved the
making or the suggesting of several compromises. Four
counties of Ulster were to be excluded from the operation
of the Home Rule Bill. Then each county was to have the
option of including or excluding itself; there was to be

* This, it must be admitted, is a very questionable generalisation. What
Liberalism ever had existed in the politics of Ulster Presbyterians had practically
given up the ghost back about 1829 when the famous Dr. Henry Cooke said :
" Between the divided Churches (he meant only the Protestant churches)
I publish the banns of a sacred marriage of Christian forbearance, etc." What
he really meant was that Protestants of every variety should form a united
front against " papal aggression." In 1798 a majority of Ulster Presbyterians
appear to have condemned those who were among the rebels. All through
the Emancipation controversy only a lessening minority of Presbyterians
led by the Rev. Henry Montgomery were liberal enough to oppose the anti-
Catholicism of Cooke. By 1886 that minority must have been very small
indeed. The whole matter offers dangerous prospects of controversy ; more
profitably it offers opportunities for cool-headed investigators. Read, in
The Capuchin Annual, 1943, the excellent article " Ulster Presbyterianism and
Irish Politics, 1798—1829," by the Rev. Patrick Rogers, M.A., D.Lit., M.R.I.A.
† Jim Phelan in *Churchill Can Unite Ireland.*

exclusion with a time-limit, exclusion of the whole nine counties, exclusion of six counties, exclusion of some area to be defined by a commission. The name " Ulster " was applied to anything and everything. Carson for a while enclosed it in inverted commas. Politicians began to talk of " statutory " Ulster. It was as confused and difficult and utterly idiotic as all that. And contemporary with all this a revival of Irish national feeling went on, to burst in revolution under the cover of European war, to continue in a more practical and effective form when the war had ended. When the smoke had cleared away the Third Home Rule Bill was as dead as Julius Cæsar. The new settlement remembered that Bill only by preserving one of the suggested amendments or compromises : six counties boxed-off in their own little corner. Somebody, for no accurate reason, called the six of them : " Ulster."

(2)

Carson came to the House of Commons in time for the debate on the second Home Rule Bill, the debate that included the excellent, unparliamentary free-fight. A certain Joseph Chamberlain made a comparison between the obedience given by the Liberal Party to Gladstone and the obedience given by his sycophants to King Herod. T. P. O'Connor, keeping up the scriptural atmosphere, compared Joe Chamberlain to Judas. The first or one of the first intended blows in the battle was actually aimed at Carson. Very prominent and very effective in the fray was Colonel Saunderson, the model for all time for die-hard Unionism, and gallant unconvincible obtuseness. A Nationalist fellow-politician once suggested to him that he and his fellow-Unionists should throw in their lot with the Home Rule cause, that a Home Rule Parliament would give Colonel Saunderson the highest position in the land. The good colonel, with a sense of humour that took nothing from his native obtuseness and with no foreknowledge of the day to come when a pre-dominantly Catholic government in a predominantly Catholic portion of Ireland would give the highest position in the

state to a Protestant, wanted to know would the position offered him be at the end of a rope.

Colonel Saunderson was Unionist Member of Parliament for North Armagh.ʳ He sat with a group above the gangway. Marjoribanks, who wrote the first volume of the official life of Edward Carson, refers to the group as " a score or so of determined-looking men." They had no wit as Tim Healy had, but " they knew how to follow a lead, and how to greet their man with a chorus of steady cheers." American politics has invented virile, snappy names for that type of politician ; Marjoribanks describes them proudly as the men of Ulster, of the " other Ireland," but the reader knowing some of the wonderful things that could happen to that word " Ulster " will be wary of the description. The majority of the Unionist writers like to convey the impression that the rugged honesty of these men from the other Ireland, their doggedness, their absolute immovability, was all new to Edward Carson. That was not quite true. North Armagh is about two hours' journey from Dublin. There were Unionists in Dublin. There were Unionists in Cork. That rugged honesty and all those other exclusive other-Ireland qualities may have traced itself back to Scottish covenanting ancestry. It was much more likely the result of the fact that those rugged men represented majorities in their own localities.

Anyway Colonel Saunderson, apart altogether from fisticuffs, had something to say about the whole business of Home Rule. When he stood up to say it in the British House of Commons, according to Majoribanks, " the voice of the North rang out, harsh, clear, and unmistakable." Now Colonel Saunderson may have talked the English language with an inflection and intonation acquired while electioneering in Portadown, but he was not an Eskimo and what he actually said might have been said by any Unionist politician from any part of Ireland. It could not have been very new to Edward Carson. Colonel Saunderson held, in brief, that Parnell had been deserted and betrayed. That was no exclusively hyperborean thought ; in a few years most Nationalist Irishmen were to hold it ; Patrick Pearse found for Parnell a place just a little below Tone, Emmet, Mitchel,

Davis, his four evangelists of Irish freedom; James Joyce, who found for himself a very lonely, bitter freedom, was to write his most effective passages describing the shadow that the tragedy of Parnell had cast over Nationalist Ireland. But Colonel Saunderson's point was not so much sympathy for the lost leader, as superstitious dread of the clerical influence that Parnell's private life had forced into opposition. The Colonel was afraid that the next leader of the Irish Party would be the great Archbishop Walsh of Dublin. That dread and that form of superstition was one of the main characteristics of those strong, silent men from the far North ; they crystallised it in the catch-cry : *Home Rule is Rome Rule.* The other characteristic had its origin in the fact that the small corner of Ireland that had a Unionist majority was reasonably well industrialised, that the leaders of the majority were men of money, men with positions in industry, owners of land. Most Nationalist writers and some writers with Unionist backgrounds did actually maintain that the wealthy and established men represented the opinion of only a very small section of the Protestant minority in Ireland ; but it is very hard to get over the fact that the Protestant or Unionist* rank-and-file did follow their leaders. The reason was obvious. People can be convinced. The Protestant rank-and-file were told again and again that Home Rule was Rome Rule, that under a Dublin government there would be industrial collapse and unemployment, that the Pope would control their schools and teach their children the Maynooth Catechism. The force of that prejudice can be judged by the fact that in quite recent years it could, when carefully worked upon, produce weeks of dangerous and destructive fighting in the streets of Belfast ; that in the portion of Ireland now ruled from Dublin it can still produce in weak minds with little power to assess realities, what can, in all charity, only be described as persecution-mania.

Those characteristics of the Unionist group in Ulster had

* In Ireland the terms were unfortunately almost synonymous. There were exceptions : quite a few of the men who formulated the theory of modern Irish nationalism were Protestant or Presbyterian. But generally speaking a man was born Catholic and Nationalist, or Protestant and Unionist. To-day there are some hopeful signs of change.

D

appealed to Randolph Churchill. He was a Conservative politician and belonged, in so far as that label meant anything, to the group of English politicians who supported the Union and opposed all proposals of Home Rule for Ireland. In 1886 he wrote to Lord Justice FitzGibbon : " I decided some time ago that if the G.O.M. went for Home Rule, the Orange card would be the only one to play." He crossed to Belfast by way of Larne, coming, as Unionist publicists saw it, as a deliverer to those who lived under the shadow of Parnellism and crime, telling them the night was over, that the gallant descendants of those who held the walls of Derry against King James were now under the protection of English Conservatism. He said : " Now may be the time to show whether all those ceremonies and forms which are practised in Orange Lodges are really living symbols or only idle and meaningless ceremonies. The loyalists in Ulster should wait and watch, organise and prepare. Diligence and vigilance ought to be your watchword, so that the blow, if it does come, may not come upon you as a thief in the night. . . . I do not hesitate to tell you most truly that . . . there will not be wanting to you those of position and influence in England who would be willing to cast in their lot with you, and who, whatever the result, will share your fortunes and your fate."

Then, with execrable taste but with a passion for the rhetorical that has often distinguished his remarkable son, he quoted, with one adaptation, a verse from a poem that we have all, with reluctance, learned at school :

> " The combat deepens ; on, ye brave,
> Who rush to glory or the grave.
> Wave, Ulster—all thy banners wave,
> And charge with all thy chivalry."

That quotation trick was common to orators right up to our own mechanic self-conscious age. John Redmond once in the House of Commons did, with deliberate intent and with the appropriate gestures learned in his youth in the Clongowes Wood College dramatic society, quote a large section from

Macbeth. A modern Clongownian would, I fancy, with a certain sigh of gratitude thank God that we are not such men as our grandfathers. At any rate " Ulster " waved with all its chivalry ; and apparently the people in the Ulster Hall, Belfast, did not realise that the harder they waved the more power they wafted to Randolph Churchill and his friends. Their visitor may have rescued them from Captain Moonlight ; but they had rescued their visitor from certain definite political anxieties. He went back with a light heart and told his friends that Ulster would fight and Ulster would be right. He left behind him a legend, an apocalyptic expectation of a second advent ; for we must always remember that the Presbyterian minority in the North-East corner of Ireland had in it a strain of Covenanting ancestry. The Covenanters had been great men for simple symbolic visions.

In 1886 Carson was working at his law in Dublin. The chivalry invoked by Randolph Churchill helped to kill Gladstone's attempt to end an age-old dispute.; and incidentally the chivalry was not above throwing stones in the streets. Carson himself saw in 1892 the killing of the second attempt, with the knight-errants who had been elected to Parliament doing battle on the floor of the House of Commons. Parnell fell ; his party split up into bitterly opposed factions, then came together under a new leader. The Liberal-Conservative see-saw went up and went down until, after the General Elections of 1910, the Liberals under Asquith realised the desirability of the votes that John Redmond and his party could give them. In 1911, as we have seen, Carson came to Belfast to wear the armour worn so long ago by Randolph Churchill, to lead the chivalry to battle. It was the great day of the Second Advent.

(3)

Why exactly should it have been Carson ? Colonel Saunderson had died in 1906. He had never been the leader of a political party, for the stern men who sat above the gangway had never really constituted a party ; at the most he had been accepted as the central figure of that group of Irish Unionists

who represented constituencies in the province of Ulster. But the twice-repeated attempt to give Ireland the Home Rule that the majority of the Irish people wanted, had driven the Unionist minority into a closer party organisation. Unionist clubs in various places gave that extra-parliamentary support without which apparently no party is complete. The strongest organisation, the Ulster Unionist Council, centred in Belfast, traced its origin back to that epic visit of Randolph Churchill, worked through local Unionist clubs and had its connection with and its representations in the lodges of the Orange Order. When Colonel Saunderson was gathered to his fathers the Right Hon. Walter Long, member of Parliament for South Dublin, became leader of the Irish Unionists, until in the general election of 1910 Walter Long went back to parliament representing somewhere in London. The Irish Unionists were not exactly left leaderless. In the North where Unionism was strongest they had the Earl of Erne, the Duke of Abercorn, Captain James Craig, a superior form of Colonel Saunderson who had fought for Empire against the Boer farmers ; above all they had the notable Lord Londonderry, the personality of the movement, the patron of all other Unionists. In spite of this they asked Edward Carson to lead them in their opposition to the Third Home Rule Bill.

The reason was something like this : the demand for Home Rule was more insistent than on the two previous occasions, the advocates of Home Rule were in a stronger position than they had ever before occupied. For the Liberal Government had broken much of the power of the House of Lords by the Parliament Bill, and the House of Lords had been the outwork and first defence of the Union. James Craig would not have put it like that. He would have said that the cause of King and Empire was in deadly peril ; that the disloyal moonlighters, cattle-drivers and murderers of landlords, who lived in the South and bowed the knee only to John Redmond and the Pope, were thirsting for the blood of Ulster loyalists ; that Asquith and his followers were traitors who had not scrupled, by the Parliament Bill, to wreck the British Constitution in order to gain the votes of Redmond and Sexton

and the like. Under these circumstances the Unionists of
Ireland, notably of Ulster, wanted, they said, the leadership
of a man who could unite their own opposition to Home
Rule with the whole general sweep of Imperial policy. The
ideal man was Edward Carson. He was a lawyer of ability
and reputation, an excellent public speaker, and in politics
a convinced Unionist.

There were, of course, other ways of considering that
choice. A Nationalist writer said that Carson had not been
so much selected by as selected for the Ulster Unionist
Council ; that he was sent by Tory politicians to organise
the little colony of Unionists that clustered around Belfast.
An Ulster Protestant writer said that the wise business men
around Belfast had picked out Carson because he knew best
how far one could oppose the Government without getting
into trouble. Men who have been wise in business do not
want to end their days in gaol. The same writer suggested
that if the men who later patronised the Ulster Volunteer
Force had really wanted fighting they would have given the
leadership not to an elderly lawyer who talked about dying
in the last ditch until the young men and women in Ulster
made jokes about the last ditch, but to Captain Craig who
had seen some fighting, or to red-headed Fred Crawford
who was later to distinguish himself running guns, or even
to Sir Roger Casement who was to suffer execution for a very
different cause. Casement, who was really an Ulsterman, did
later say from the dock of the Old Bailey that he had taken
a path that he had known might lead to the scaffold, while
certain of his worldly-wise fellow-Ulstermen had taken the
path that led to the peerage and the war-cabinet.

It is now thirty years too late for anyone to find out whether
or not Edward Carson ever intended to lead the honest
Presbyterians of North-Eastern Ireland into bloody battle.
On the evidence it is not very probable. Neither Edward
Carson nor the men who backed him had much to gain from
the catastrophe of civil war, and Carson was out to win his
point, not to fall in glorious defeat on the barricades. The
guns and the marching, the signalling, the riding with dis-
patches may have been merely part of one glorious bluff.

We do know for certain that the bluff was almost success-
ful, that had the only opponents been Asquith and John
Redmond it would have been completely successful. And
whatever reason made the solid sensible business-men choose
Carson as leader, they could scarcely have made a better choice.

<center>(4)</center>

From 1911 onwards the legend of "Ulster" began to solidify
and to take a fixed, definite form. Edward Carson became
the leader of militant "Ulster," became in fact the typical
Ulsterman. Too much has, perhaps, been made of the fact
that he was born not in any of the nine counties of Ulster,
but in Dublin. Ulster is not in the Arctic Circle. He was an
Irish Unionist, and as such he had much more in common
with James Craig than with Patrick Pearse or Seán O'Casey.
He was one of the minority that had once been a minority
in ascendancy over all Ireland. The ascendancy had lost its
grip, dying in grey mansions or in mellow Georgian houses
in Dublin, strong and active only around industrial Belfast,
where it was in the majority. His leadership of that Unionist
concentration was the last great effort to preserve Protestant
ascendancy over the whole of Ireland, the last great effort
to keep the democratic majority subject to the will of a minority
that had never even been completely naturalised. He
achieved only a very little measure of success, so small that
it was little more than defeat ; but he divided Ireland to the
present day and by that division impeded her normal develop-
ment, postponed indefinitely the final making of friendship
between Ireland and Great Britain.

After the meeting at Craigavon, and partly as a result of
that meeting and of more private gatherings held about the
same time, two things began to happen : the big men in
Unionism in that part of Ireland talked of making their own
government for the areas they might manage to control if
the Home Rule Bill became law ; and the rank-and-file of
Unionism, encouraged and led by influential men in Britain
and Ireland, began to make what was to be known as the
Ulster Volunteer Force. A passage from the ablest apologist

of the movement will give a very good idea of the type of men who brought Carson to Belfast, who formed one of the strongest centres of resistance to Home Rule. It is an important passage.

" . . . the business community of Belfast did not consider its pocket more sacred than its principles . . . if there had been any doubt on that score in anyone's mind, it was set at rest by a memorable meeting for business men only held in Belfast on 3rd of November (1913). Between three and four thousand leaders of industry and commerce, the majority of whom had never hitherto taken any active share in political affairs, presided over by Mr. G. H. Ewart, President of the Belfast Chamber of Commerce, gave an enthusiastic reception to Carson, who told them that he had come more to consult them as to the commercial aspects of the great political controversy than to impress his own views on the gathering. It was said that the men in the hall represented a capital of not less than £45,000,000 sterling, and there can be no doubt that, even if that were an exaggerated estimate, they were not of a class to whom revolution, rebellion, or political upheaval could offer an attractive prospect. Nevertheless, the meeting passed with complete unanimity a resolution expressing confidence in Carson and approval of everything he had done, including the formation of the Ulster Volunteer Force, and declaring that they would refuse to pay ' all taxes which they could control ' to an Irish Parliament in Dublin. This meeting was very satisfactory, for it proved that the ' captains of industry ' were entirely in accord with the working classes, whose support of the movement had never been in doubt. It showed that Ulster was solid behind Carson ; and the unanimity was emphasised rather than disturbed by a little handful of cranks, calling themselves ' Protestant Home Rulers ' who met on the 24th of October at the village of Ballymoney ' to protest against the lawless policy of Carsonism.' The principal stickler for propriety of conduct in public life on this occasion was Sir Roger Casement."*

That was about two years after the meeting at Craigavon

* Ronald McNeill (Lord Cushendun) in *Ulster's Stand For Union.*

and many things had happened in those two years. There had, to begin with, been a considerable number of large public meetings that repeated and amplified what had already been said at Craigavon. Bonar Law, who had undertaken the leadership of the Unionist Party with much diffidence, did, in the course of those meetings, cast off his diffidence and vow that the Unionist Party would back Carson and Carson's promoters in whatever course they might choose to follow. A Covenant uniting Unionists in a sort of oath-bound brotherhood to resist Home Rule for Ireland was drawn up and signed widely among the minority in Ireland and their sympathisers in Great Britain. The Ulster Volunteer Force, beginning in a few accidental local organisations, was taken up and developed by the Unionist leaders, drilled and gradually equipped with arms. The son of Randolph Churchill visited Belfast to speak in favour of Home Rule and, in the fighting language so typical of Mr. Hugh Shearman, narrowly escaped having " his entrails kicked out on the stones of Royal Avenue." But more notable than any of these things, the suggestion of compromise had crept into the debate in the House of Commons.

The motives behind this organised resistance to the power of Parliament are, some of them, obvious and easy to understand, some of them twisted, complex, obscure. The big business-men did apparently think that a native government at Dublin would not be good for business. They argued, with little accuracy, that a Home Rule Parliament would tax the life out of industrial Ulster ; but the whole province of Ulster, with the exception of the corner around Belfast, was not any more industrialised than Leinster, Munster or Connaught. Nor was it any more prosperous. But they feared for their purses and they told their followers that Home Rule meant industrial slump ; that slump naturally meant unemployment. It was a good reason to give to the labourers of an industrial city, but by itself it would never have been effective. It had no influence on the Catholic labourers, tradesmen, factory workers, who knew that the men who prophesied slump and unemployment were the big men in a city notorious for the evil conditions under which ill-paid

workers existed. James Connolly and James Larkin found in Belfast in those same years any number of supporters among both Catholics and Protestants. To the Protestant proletariat, then, the big men (Mr. St. John Ervine called them the " old men ") gave another and more compelling reason. Home Rule meant the Pope, the scarlet woman, the Papishes riding in triumph, King William and the Boyne only memories, the drum silenced, the crown of England in the dust, the citadel betrayed as Lundy had tried to betray it.

These motives do not seem to have much in common, but in those uneasy years before the first European war they solidified in that part of Ireland the resistance to Home Rule. The moves of the period, the meetings, the incidents, the speeches, are very interesting ; but the detailed narration has been given a dozen times from every imaginable point of view. The easiest method of escape from protracted incoherency is to select for comment a few typical incidents that may serve to show why it was that John Redmond's Home Rule Agitation was virtually over and done with when a shot was fired in Sarajevo in the Summer of 1914.

(5)

The son of Randolph Churchill visited Belfast in the February of 1912. He was a young, enterprising politician as fond of the phrase as his father before him, but unlike his father he was a little Liberal and not a little Conservative. He came on the invitation of Lord Pirrie and the Ulster Liberal Association to speak in the Ulster Hall, from the same platform as John Redmond, and on behalf of Home Rule. Now the Ulster Hall had associations for the Unionist element in Belfast : Randolph Churchill had spoken there ; and the proposed visit of his son was to the Unionist mind a combination of filial impiety and base political perfidy. Winston Churchill more than any other of the English Liberal leaders was inclined to speak lightly of Carsonism, to regard it as wind and bluff. He was, in that, very close to John Redmond who knew that there was no such thing as the Ulster problem. Now that was in one way quite accurate, for the problem had been

miscalled the Ulster problem; but it was John Redmond's error to keep telling himself that because Edward Carson had given the thing a coat that did not belong to it, therefore the thing itself did not exist. It did exist. Winston Churchill found that out, found out also that phrases would not meet the needs of the situation and was, apparently, quite ready to use gun-boats. Asquith found it out. Lord Loreburn found it out; and they and the host of Liberal politicians began to hunt the compromise that would give peace in their time. John Redmond never found it out. He went on recruiting for the British army. That was his form of myopia. But at least he has for posterity this justification : that when Carson's army took unto itself the famous wooden guns even Patrick Pearse hailed it as a hopeful day for Ireland ; according to an idea that made guns, wooden or otherwise, good in themselves, and any defiance of British government a noble and laudable deed.

Winston Churchill, speaking in Dundee a little subsequent to the Craigavon meeting, mentioned " the squall which Sir Edward Carson was trying to raise in Ulster—or rather in that half of Ulster of which he has been elected Commander-in-Chief. . . . Are we never to be allowed to examine this great issue free from party rancour ? Sir Edward Carson says No ! . . . He will attempt to set up in Ulster a provisional— that is to say a rebel—Government in defiance of laws which will have received the assent of Parliament and of the Crown. . . . These are his threats. . . . We must not attach too much importance to these frothings of Sir Edward Carson. . . . I dare say that when the worst comes to the worst we shall find that civil war evaporates in uncivil words."

That was what he thought of Carson and the followers of Carson, that is, if a man ever does speak his mind from a political platform. In due time he also came to accept the inevitable and peace-making compromise, to pass from that to the suppression of rebels who were not followers of Carson. But at Dundee, and in the following year when he resolved to visit Belfast, he considered the whole business as froth and bubble. No threat of trouble in the form of street-rioting Orangemen deterred him. The Unionist leaders

in Belfast did manage to prevent the meeting being held in the Ulster Hall. The potential rioters were on the streets but no riot ever took place. Winston Churchill came and spoke his piece and departed. His phrase about examining the great issue apart from all party rancour went vain and empty on the wind ; the work of his father had entangled the problem hopelessly in the peculiar party system of English politics, had prevented men from approaching that problem as one that concerned the good of Ireland and the Irish people, that had in it the making or marring of good relations between England and Ireland.

The Carsonites held that the visit of Churchill had improved their position by making even hostile critics of their attitude realise that when they talked of resisting a Home Rule Bill they were not just releasing carbonic acid gas, by showing the small Ulster Unionists that their leaders could do something more than make speeches. They had practically chased the British Home Secretary out of Belfast ; and were inordinately proud of the feat. But a little more than thirty years later Winston Churchill was to mention in the House of Commons the names of John Redmond and his gallant brother who died at Messines. He mentioned their names with feeling and regret. He suggested that perhaps the leaders of Britain had made a great mistake in the years that preceded the first calamity of our century. Those years were filled with mistakes. Perhaps the Ulster Unionist Council made another mistake when it filled the streets of Belfast with potential rioters and closed the doors of the Ulster Hall on so arrant an Irish rebel as Mr. Winston Churchill.

(6)

As a background to the visit of Mr. Churchill the Ulster Volunteer Force drilled, marched, rode with dispatches, procured arms in various ways and discarded the wooden guns. In practice it was a sectarian organisation just as the forces of Special Police formed in and around the nineteen-twenties and the Home Guard recruited in the six North-Eastern counties during the second world war were sectarian

forces. A really wise statesman would be very careful about arming one religious denomination and leaving another unarmed in districts where politico-religious feeling was inclined to nervous, pugnacious outbreaks. But then it was always doubtful whether or not Carson the advocate knew much about wise statesmanship. His record in that matter of sectarianism was quite good, much better than that of the men who were to succeed him. As a general rule he did not utter sectarian incitements from the public platform merely because he thought his audience would like such pronounce-ments. Tim Healy complimented him on the way in which he kept his followers in order, but Tim Healy's observations while often acute, invariably witty and sometimes scandalous, were frequently devoid of any solid foundation in fact. There were various opinions on the order preserved in the ranks of Carson's army. General Macready could possibly be accepted as an impartial witness, more reliable and well-informed on matters military than the facetious Mr. Healy. Macready wrote that in those years : " the troops looked on with amused indifference at the warlike preparations of the Ulstermen, and I had no more fear that the soldiers would be the aggressors in any conflict than that they would fail to carry out their duty if called upon. It was otherwise with the combustible elements of which the U.V.F. were composed, many of whom were drawn from the rowdy classes of Belfast, and who, though under excellent control, might not be able to resist a favourable opportunity of proving their powers. It was a dangerous game which their leaders were playing, and one which the merest accident might have turned into a bloody tragedy. This was my one anxiety during the time I spent in the north of Ireland, lest the blood of the soldiers for whom I was responsible should be spilt in a useless encounter with fanatical enthusiasts."*

The bloody tragedy was to come and, although the first shot was not fired in the North of Ireland, there can be little doubt that the example of what Jim Larkin called Carsonian expedients had a lot to do with the pulling of the trigger.

* *The Life of John Redmond* : Denis Gwynn, p. 344.

Incidentally, it is interesting to remember that when Larkin threatened the adoption of those expedients, on behalf of exploited workers, he was very promptly put in gaol. The Ulstermen, as they called themselves, had their guns shipped into Larne and motored them through the country with considerable facility and no interference from the police. The Irish Volunteers had their guns shipped into Howth, encountered a road-block of troops on the way back to Dublin, successfully evaded it. The troops later in the day shot two or three civilians on the quays of Dublin. The tragedy was very near then, for Ireland, for all Europe. Edward Carson was not by any means responsible for the ideals that sent Pearse, Clarke, Plunkett, MacDonagh to quicklime graves ; but all the drilling, volunteering and gun-running of his followers made it easier for Nationalist Ireland to think that its problems could be solved only with the gun. The misuse of words still makes it possible for some weak minds to think that *Sinn Fein* meant physical force. It meant national liberty, cultural and economic and social independence, the right of every nation to make its own mistakes ; but it was Edward Carson and not Arthur Griffith who talked about dying in the last ditch, who incited armed men, who signed his name to the Ulster Covenant, who was in with the politicians and the officers who decided at the Curragh mutiny that if the Government asked them to coerce " Ulster " they would disobey the Government. That was a new military ethic.

The clouds gathered over Europe. The debate dragged on in the British Parliament. The speeches became more fiery ; the meetings more enthusiastic. James Craig thought a Covenant would be a good idea and was delighted to discover that a Craig had signed a Scottish Covenant against papistry, episcopacy, the Stuarts, and the naughty lady of Babylon. Accordingly a Covenant there was, with Edward Carson signing it, first before all others, on a table covered with a Union Jack in the Belfast City Hall. Colonel Wallace, Grand Master of the Belfast Orangemen, presented Carson with a yellow silk banner carried before King William III at the battle of the Boyne. Somebody else presented him with a

silver key that symbolised " Ulster, the key of the situation."
Captain James Craig presented him with a silver pen with
which to sign the Covenant. The Covenant said : " Being
convinced in our consciences that Home Rule would be
disastrous to the material well-being of Ulster as well as the
whole of Ireland, subversive of our civil and religious freedom,
destructive of our citizenship, and perilous to the unity of
the Empire, all, whose names are underwritten, men of Ulster,
loyal subjects of His Gracious Majesty King George V,
humbly relying on the God whom our fathers in days of
stress and trial confidently trusted, do hereby pledge our-
selves in solemn covenant throughout this our time of
threatened calamity to stand by one another in defending for
ourselves and our children our cherished position of equal
citizenship in the United Kingdom, and in using all means
which may be found necessary to defeat the present conspiracy
to set up a Home Rule Parliament in Ireland. And in the event
of such a parliament being forced upon us we further solemnly
and mutually pledge ourselves to refuse to recognise its
authority. In sure confidence that God will defend the right
we hereto subscribe our names. And further, we individually
declare that we have not already signed this Covenant. God
Save the King."

<center>(7)</center>

Armour of Ballymoney was a Presbyterian clergyman who
did not think that Home Rule threatened anything or that
a legitimate constitutional movement was a conspiracy to be
resisted by force of arms. He called the day of the Covenant,
Protestant Fools' Day. The Carsonites called it *Ulster Day*.
The foolery was to have fatal consequences ; even though
that strange incongruity in symbols, that mixing of covenanting
and yellow banners, significant keys and silver pens, might
seem to justify Armour's sarcasm. The great effort of
Gladstone that had left behind it a political tradition, the
weary honourable years that John Redmond had given to
debating and negotiating, were vain because of that foolery
and volunteering. The Home Rule Bill became law, died

and was dishonourably interred shortly afterwards. Ulster, somebody said, was the rock on which the vessel of Home Rule foundered. Ulster was the key to the situation. Ulster was something that would not allow herself to be sold. Ulster was nine counties. Ulster was six counties. Ulster was four counties. Ulster was something statutory, an undefined area. Ulster was any damned thing that a Carsonite politician or some semi-illiterate London journalist wanted to make it. Ulster was the last ditch ; and squelching in the weeds and muddied water the Protestant Ascendancy struggled desperately to maintain its dominance.

Ulster (that is, the degraded, corrupt, applied-to-anything term) was really the ignominious compromise of politicians who wanted peace. It did not bring them peace. It brought the war that people can make when united, even if almost unarmed, and no equal in physical power for the enemy. The compromise remains to-day, still failing to give peace in perfect unity to Ireland, still failing to blot out for ever the centuries of discord that have been between two islands. It was defeat for Edward Carson just as it was defeat and heart-break for John Redmond. They both wanted complete union but one thought union a form, the other thought it a feeling. While the compromise remains they cannot be, in spite of Mr. St. John Ervine, forgotten politicians.

CHAPTER V

THE LOYAL MEN

" Happily, we live in better days, days when all sections of Irish Protestantism are drawing more and more closely together in pursuit of one object, the welfare of their common country, and if they fail the cause will lie entirely outside themselves ; it will be the work of foes in the guise of friends. This new spirit is largely owing to the leavening work of Orange principles, which guarantee toleration to the adherents of every Church and party. As long, then, as Orange lodges exist, liberty of conscience will never be a lost article of Christianity."—*Orangeism in England and Throughout the Empire*, p. 194, Vol. 1.

" The modern history of Ireland would be almost a blank page without the villainies of Orange persecution, the complicity of Government in those villainies, and their consequences upon the general well-being of the island . . . however well inclined to forget those horrors, we have not been permitted to do so for a moment down to the present day."—*John Mitchel in his " History of Ireland."*

(1)

THE support of Belfast business interests, the political power of the English Conservative Party, helped each other to steady the platform upon which Edward Carson stood when he spoke at Craigavon. These two powers had an ally, by no means so easy to define or describe. You may call it the Orange Order, or the Orange mind formed by the influence of that order, or, if you do not feel very charitably disposed towards it, you can class it as blunt, ignorant bigotry. Yet it would be very unfair to allow uncharity to carry one on to sweeping condemnations of the large number of inoffensive citizens who batter drums and carry banners, very puritanically unfair to condemn drums and banners as, in themselves, evil. Any attempt to estimate the force and influence of that Orange

thing is hindered by three initial difficulties : (i) the definite contrast between Orangeism before Carson, i.e. in the nineteenth century, and Orangeism after Carson, i.e. of the present day : (ii) the definite contrast between the harmlessness of the pageantry in itself and the evils that have frequently had their origin in Orange pageants : (iii) the definite contrast between the men who have used Orangeism for political purposes, and the ordinary Orangemen who, left alone, would live peaceably with their neighbours.

To understand the story of any institution, or of a nation or of a man, you must get behind and beyond the plain catalogue of incident to the mind that considers and the spirit that inspires. So much is commonplace. The dates and details tell us very little about Napoleon, Froissart, Chaucer, Savonarola, about any of the men who have puzzled other men. To appreciate the people of France you need some savour of the French spirit. Hilaire Belloc suggests that one of the ways of approaching that spirit is by careful study of some work that has reflected the soul of France, say, a play by Racine. You can learn a lot about the Jesuits merely by reading the terse text of the Spiritual Exercises of Saint Ignatius. By way of contrast there is the Orange Order. Now it is not easy to get at the Orange mind through the study of a work of any representative value for the simple reason that no such work exists. Orangeism has no classic. There is the official two-volume history,* more than one thousand closely-printed pages of historical error, wild statements and positively picaresque anecdote given without proof or without authority, and of rabid anti-Catholicism. But no one will ever convince me that those amazing volumes really represent the minds of the men of my acquaintance who wear sashes and follow the drum. The book is a product of the new Orangeism ; Orangeism as Carson left it, as it became especially when it had a statelet to control and a parliament to dominate ; Orangeism, the official thing, the step up to office, the instrument of coercion and bigotry. All that is a million miles of the spirit away from the drums and sashes

* See list of Authorities.

E

of pageants and processions that could provide one colourful aspect of life in a united Ireland ; yet there is some connection between the political power and the harmless pageant. Again it is not easy to understand, not easy to analyse ; but it is safe to guess that the intrusion of political things has made many a pageant end with broken heads, even with broken homes and dead men.

If you are living in any of the six North-Eastern counties of Ireland, if your religion is Catholicism, if your politics are Nationalist, then the outward display of Orangeism makes a certain impression on your mind. The opening years of the second European war did temporarily disperse the sashed processions and silence the drums ;* but six or seven years ago the Orangemen marched and fluted and piped and battered to the complete content of their simple souls. As the Nationalists or the Catholics regarded them, those processions were as regular as the sequence of seasons, and, outside Belfast, were, in themselves, quite harmless. They flaunted the banner with Dutch William on his white horse fording the River Boyne, they recalled the walls of Derry and the battle of Aughrim, the scuffle at the Diamond, the affair of Dolly's Brae. The pipes piped and the flutes fluted tunes that associated the whole proceedings with these same events, implied that King William was responsible for the whole business and that the details were possibly to be found in the chapters of Revelations. The marching men had a very sociable day, marched to some big field and listened to speeches abusing the Church of Rome, consumed quite an amount of spirituous liquor, went home infused with enough loyalty to last them round the twelve months of the year. That was the twelfth day of July and that was the Orange mind as it chose to reveal itself to the neighbours and to the world. Quite harmless or almost harmless except in Belfast where the marching men did not always display a notable inclination to go home quietly, where what began as a procession could end in appalling civil disorder.

* The Ban on Party Processions was lifted in 1943 ; but the continuance of emergency conditions has prevented the Orangemen, for various reasons, from demonstrating on the traditional scale.

Behind this musical and symbolical manifestation the outsider saw or felt Orangeism at work in another way : associating itself with and inspiring politicians who proclaimed that *they* were Orangemen, that the North-Eastern piece of Ireland had become a Protestant state for Protestant people, that no loyal man should give employment to Catholics who were ninety-nine per cent. disloyal. It inspired the little local jealousies, the refusals of employment and the tenancies of houses, the little organised gerrymanders of rural and urban administrations, the giving of regional scholarships to Catholic children only if they attended Protestant schools ; later, when war broke out, the care taken to ensure that the Home Defence Forces should be almost exclusively Protestant. Somewhere, hidden from the light, an organised body of men arranged those exclusions, negations and prohibitions ; and that body was the local branch of the Orange Order.

That is Orangeism, exactly as it appears in six counties of Ireland to the person who does not belong, who has never entered the charmed circle. If the description would appear to the initiate as a libel and yet another Romish attack on honest and God-fearing men then Orangeism has only itself to blame. For, in spite of the laudable civil and religious aims proclaimed at regular intervals by the Orange Order, the circle *is* a charmed circle, a secret circle ; and every secret organisation runs the risk of misrepresentation and misunderstanding. A Catholic in a town in north-east Ulster knows that the affairs of the locality, the jobs, the houses, the scholarships, have been talked about inside that circle. He may be personally acquainted with every one of the men who make up the circle, finding them on the whole good neighbours. But he will not find it easy to understand or even to approach sympathetically the collective mind that asserts itself when those men get together in the local Orange Hall. His only knowledge of it is in that outward manifestation of processions and pogroms, petty discrimination, political gerrymander.

(2)

The Orangeman of the present day sees the processions, the banners, the sashes in orange, purple and black, as part of an historic sequence* of demonstrations beginning in the eighteenth century when the Orangemen of the city of Dublin began to walk in circles around a statue of King William they had built in College Green. To be exact, they were not Orangemen at all, for the circular walking predated the Battle of the Diamond and the consequent foundation of the Orange Order. They would have called themselves *loyalists*, by which they actually meant that they represented the section of the people living in Ireland who had given their support to William of Orange, and to the men who had introduced him to the throne of England. They were exclusively Protestant. Gaelic Ireland had been broken finally at Aughrim and the walls of Limerick, allying itself, in one of those ironies that give bitter humour to the story of man, with the English monarchy that it had fought against at Kinsale. A Catholic Irishman was something to which English law did not even grant existence, for the name of James Stuart had been associated with Catholicism; and the Protestant majority in England with the Protestant minority in Ireland had resolved to protect itself by any and every means from any resurgence of Catholicism. The Protestant popular imagination aided by the suggestions of interested leaders had gone to work on the battles of 1641 and 1690, had painted them with crimson and lurid flame, the white of naked swords, the red blood of butchered Protestants. Somewhere in those unfortunate times an idea was born, to grow and develop into a mania, the worst form of mania, that imagines persecution, lives in fear of some possible or probable slaughter. To prevent that imagined catastrophe, men afflicted with the mania will persecute their neighbours just as they fear the neighbour will, if he ever has the power, persecute them. Modern

* To avoid misunderstanding, it might be well to mention again that Orangeism to-day with its hold in high places is a different dish, in some ways, from the original Orangeism, from nineteenth century Orangeism. For one thing, it is a deal more respectable. As regards the earlier Orangeism even its connection with a member of the English Royal family only managed to make its reputation worse than it had been, for it was accused of definite political and treasonable ambitions.

psychology could find a name for that mental state. It is
evident in the official literature of the Orange Order, in the
continued delirium that for more than two centuries has stood
on guard against murdering rebels and designing priests. It
supplied part of the material that built the wall around six
counties as a protection against rebels and priests. When the
wall was built, it began to make life unpleasant for the large
number of priests and alleged rebels still left within the wall,
for the simple reason that they and their fathers and grand-
fathers really belonged there. Again, it is not easy for the
Irish Nationalist to appreciate the point of view that considers
gerrymander, discriminations, even pogroms, all part of that
historic defensive action against potential persecutors : the
rebels, the Pope, and, strangely enough, a great gallery of
English statesmen and officials, including, notably, Gladstone,
the whole Melbourne administration that allied with
O'Connell, possibly Mr. Winston Churchill who spoke in
1912 in favour of Home Rule, who visited the Pope in the
Vatican in 1944.

They walked in circles around the statue of King William
in College Green, presuming that the spirit of that man from
the Low Countries was with them, that his eyes approved
their circumambulations. It was the eighteenth century and
they were the precursors of modern Orangeism. Outside
Ireland there was an Old Revolution Club and a Britannic
Society. Inside Ireland there was a Boyne Society ; and the
River Boyne was to become the Ganges of Orangeism. There
were the Aldermen of Skinner's Row, the Enniskillen Men,
and loyal organisations isolated in Kerry and Mayo. The
men of Bandon in County Cork thought that sham commemo-
rative battles would be a good idea. Associations were formed
against the awful possibility that somebody or other would
bring in a Pretender. The Apprentice Boys of Derry, whose
predecessors had slammed the gates of the city against the
armies of James, formed their first commemorative club in
1714. A century later another club of Apprentice Boys was
founded in Dublin, and a certain Lieutenant-Colonel Blacker
wrote a song in honour of the men who had held and defended
Derry :

" And Derry's sons alike defy
 Pope, traitor, or pretender,
And peal to heaven their 'prentice cry,
 Their patriot, ' No Surrender.' "

The Pope was over the sea in Rome and during that eighteenth
century the ministers of a faith, that remembered Rome
because Peter the Apostle had died there, lived in misery,
sometimes hunted for their lives, sometimes enjoying an
uneasy and illegal tolerance. The traitors were the great
mass of the Irish people, Catholic in religion, and on that
account considered dangerous by a Protestant minority that
the accidents of conquest had placed in a position of economic
and political dominance. That position became known as
the Protestant Ascendancy, and when the Orange Order
came into the world its speakers said again and again that it
came to defend the English throne, the principles of the
Reformation, and the Protestant Ascendancy.

The word *defend* is important. Very little understanding
of the ways in which men govern and react to government
will be needed to show how the political thing, with its
economic and social background, in eighteenth-century
Ireland could not produce universal content among the
people. The majority of the people had no political rights,
no political existence ; the system of land tenure was irrespon-
sible and inefficient, founded on conquest. Disorder was
inevitable, sporadic disorder, unintelligent, not very well
organised. It was inevitable also that the illtreated majority
should look with little favour on the land-owning minority
and the governmental system on which it depended. Into
all this disorder the Orange mind read a unity and a definite,
continuous aim : to overthrow British rule in Ireland, to
massacre the Protestant minority. The official Orange
propaganda links up the agrarian crime of two centuries, the
Whiteboys, Defenders and Ribbonmen, with every movement
for the establishment of political independence, manufacturing
some sort of fantastic connection between Captain Rock and
Eamon de Valera. Against this long-continued conspiracy the
Orange propaganda pictures the Orangemen standing on a

perpetual and loyal defensive. The idea is not history. It
could not stand against a serious, scientific scrutiny. But it
is accepted as gospel by the men who meet in Orange Lodges
and march in processions ; it is powerful enough to keep
those men in this twentieth century on a wary and suspicious
defensive against their fellow Irishmen. They see the Battle
of the Diamond that happened in County Armagh in 1795
as an important pitched battle waged successfully by loyal
Protestants against the aggressions of rebellion and papistry.
The victory had its blessed result when some of the victors
organised at Loughgall the first Orange Lodge. Actually the
battle was a depraved and undignified scuffle that did credit
to no man and reflected disgrace on the age in which such
brawls could take place, on the governmental methods that
made them inevitable. The Orangemen organised, as they
said, to defend themselves, to uphold civil and religious
liberty ; and if defensive measures necessitated an effort to
clear every Catholic out of the County Armagh that was only
in keeping with openly-expressed Orange policy. Catholics
were idolatrous and had no savour of true religion ; Catholics
were rebellious and knew nothing of loyalty. Catholics did
not enjoy nor did they deserve to enjoy civil and religious
liberty. Looking backwards Orangeism saw that a momentary
weakness for Catholic emancipation had forced Grattan's
Volunteers into a degeneracy that ended in the United Irish-
men. That again was not history ; but along with the
tragedy of 1798 it went to build the walls that were shutting
off Orangeism from any real contact with fact. The Orange-
men claimed and still claim that they saved Ireland in that
year from a papal aggression that had in some amazing way
allied itself with the revolutionary ideas that came from
France. They saved Ireland also from certain unfaithful
Protestants affected by democratic French principles. The
man who does not know the power of myth, the creative force
of legend, will be puzzled by that alleged alliance between
Carnot and Condorcet and the Pope ; he will be puzzled also
by the important position and influence that the Orangemen
assign to themselves in the battles of the tragic rebellion that

ended the Irish eighteenth century and with it the independent
Irish parliament.

Edward Carson who supported the proposal for establishing
in Ireland a Catholic university should have had little sympathy
with the mentality that objected to the Act of Union because
that Act was bound up with some obscure, half-hearted
promises about the possibility of Catholic emancipation. But
the century that was to see his birth saw also the hardening
and shaping of that mentality ; saw the accumulation of
memories twisted and distorted out of all relation to the actual
fact of the incidents remembered. When the Orangemen of
North-East Ulster gave their support to Edward Carson they
were still remembering the walls of Derry, the waters of the
Boyne, the " defensive " things done in Armagh in the
eighteenth century, the fight at the Diamond, the Lodge at
Loughgall, the burning barn at Scullabogue.* The tragedies
of a misrepresented and misunderstood past had none of the
sanative power that somebody claimed as an attribute of past
sorrows. But sorrow begat sorrow and misunderstanding
was the cause of additional misunderstanding, twisting the
commencement of the twentieth century as it had twisted the
commencement of the nineteenth century, filling the future
with gloom and apprehensive guessing.

(3)

The Orangemen like the grand old duke kept marching
up and marching down, fighting sham commemorative
battles, fighting other battles that were not shams. As they
saw it, their processions were always orderly, decent, civil,
quiet, well-behaved, displaying ill-will to no man, parading
only their own loyalty to the Crown of England, their devotion

* Here it may be wise to point out that the strength or weakness of Orangeism
depends to a certain extent upon the economic environment. A friend in Belfast
points out that when times are bad the Orange boss there is powerful, when times
are good the humbler members may stop paying their subscriptions. They
feel that they do not need the assistance of the Lodge to hand them an economic
priority over the heads of their Catholic neighbours. Correlate this fact with
the economic background to pogrom. But on the other hand an explanation
must still be offered for the existence of the mass-feeling that glosses over
the injustice of victimising the Catholic neighbour.

to the principles of the Reformation. Their peaceful proces-
sions moved with difficulty in a land that was stiff with those
children of the diagon's teeth, Moonlighters and Ribbonmen,
Land Leaguers, fanatical Papists, plotting priests, rebellious
dynamiters. Collisions were inevitable. Orangemen were
forced to defend their right to march, to drum, to celebrate,
to commemorate, against wanton and uncalled-for aggression,
against even the unjust condemnation of government officials,
against the tyranny of Acts of Parliament that occasionally
banned party symbols and party processions and had the
audacious wickedness to class Orange loyalists among the
disturbers of the peace. A member of the English Royal
family acted as Grand-Master and provoked a considerable
number of people to say that he was aiming at the Crown for
his own benefit and the benefit of the society to which he
belonged. The loyal men did not enjoy the popularity which
they considered their patient and proved loyalty deserved.
Against their wishes political freedom was given to the
Catholic majority of the people of Ireland and, as the Orange-
men saw it, loyalty and true religion were gravely imperilled.
From the Orange Corporation in Dublin a certain Mr. Giffard
painted the horrible implications of this extension of civil
and religious liberty : " I wish the Roman Catholics every
enjoyment under, and consistent with, our happy Constitution.
I would not defraud the Jew of his synagogue, the Moham-
medan of his mosque ; much less would I wish to injure
the Roman Catholic, a fellow-Christian, who acknowledges
the same Redeemer. But I would not put a sword into the
hand of a madman, as much in mercy to him as to myself."
The sword, apparently, was intended to symbolise the civil
and religious liberty that Catholics could enjoy under the
constitution without destroying the constitution. Mr. Giffard,
although his little speech was moderate in comparison with
other Orange declamations, had not realised that a nation
is free, only when no one class or creed in that nation has
ceased grinding the life out of the other classes or creeds.
The Orange mind never did realise that truth, even to-day
when it expresses itself through a government controlling
a miniature, artificially-established state it sees liberty as

something that stands only on a foundation of oppression. That may merely be an application of the old defensive action against imagined dangers, but it is the essence of negation, it has never at any time inspired constructive action, it has made the whole history of Orangeism a desolatingly dull collection of trivialities. Chesterton maintained that the history of cows in twelve volumes would not make interesting reading ; and, with all due respect to the many excellent men who have beaten drums and worn sashes and with all reverence for the excellent principles voiced at moments when they were not scarifying the Pope, the history of Orangeism in two volumes is depressing, desperately depressing. The Orange nineteenth-century is a dreary waste of processions followed by riots, and the Orangemen blamed the Catholics for the riots, and intelligent men of high principle, such as Thomas Drummond who was Under Secretary for Ireland under the Melbourne government, were not by any means disposed to swallow the stories told by the loyal men. John Mitchel and most other nationalist writers suggested that the British government maintained Orangeism as a convenient means of keeping a grip on the people of Ireland, while the Orangemen maintained that they were persecuted, neglected, overridden, treated ungratefully by disloyal Britishers who had found their way to office, supposedly, by means of Vatican intrigue. That certainly was the last subtle refinement of persecution-mania.

Internally they had their own quarrels, squabbles about ritual, about whether or not there should be sashes of any colours other than the original orange and purple. The outsider finds it very difficult to be interested, except the outsider is interested in ritual for the sake of ritual : from the chaste forms and noble phrases that symbolise and describe sacrifice, down to the lowest forms of ritual, the mere business of dressing-up or the noisy business of beating drums. The garments, symbols, signs, passwords of Orangeism will interest the man who studies the connection of Orangeism with Freemasonry and the implications of that connection. But those things are in themselves only effective or harmful when joined to the spiritual thing, the defensive attitude

that issues in offensiveness, the goblin fears that have gathered strength from three centuries of history distorted into malignant legend. They stood on the defensive in the name of civil and religious liberty, against the enslaving tendencies of the Church of Rome about which their speakers and writers were grossly ignorant, and for some reason or other they arrayed themselves always against every movement that made for human liberty, for the welfare of the poor. The official history of the Order is inordinately proud of the little weight that a few zealous Orangemen, by their activities during Luddite riots, managed to add to the crushing burden of the English wage-workers in the years that followed Waterloo. O'Connell who taught democratic methods to half Europe was to the Orange mind the greatest of the goblins. They opposed the giving of political power to Catholics because the Catholics might be able to put more force behind their unwillingness to pay tithes to the ministers of a church to which they did not belong. They accused the Catholic clergy of rapacity but saw nothing in any way peculiar in clergymen of the Church of Ireland seeking military aid to seize, in lieu of tithes, the property of poverty-stricken Catholics. If there was chaos and disorder in Ireland they did not blame the iniquitous system of land-tenure that kept the majority of the population in a state of helotage. They were not able to appreciate the amount of disorder that was the result of unsuccessful conquest, of proud memories of something that had been, of uneasy reachings towards something that was vaguely and by instinct desirable. They blamed Rome : " the imp that spoiled all the good traits in both sections of the population, the imp that attended every council where plans were discussed for the proper welding of the nation, the imp that drove men, who should have been friends, to acts of madness and butchery, was the imp of exclusive salvation, born and bred in Rome, the profligate Church, the Mother of Harlots, whose religion is the paganism of the Cæsars, dressed in the cerements of the Man of Calvary."*

* *Orangeism in Ireland and Through the Empire*, Vol. 1, p. 634.

That weird rigmarole was not written in Geneva in the sixteenth century but in Belfast in the twentieth century. It explains many things : why the men of an organisation whose history is a series of riots can still believe why they and they only stood for peace and brotherhood and loyalty ; why that organisation, in spite of its professions, was classed by responsible statesmen among the forces of disorder and disquiet. The men of the twentieth century have found so many things to fight about, so little ground for common agreement, that it seems a pity to hear in one of the few countries that escaped the great calamity the blast of bigotry that once set Europe fighting for a hundred years.

(4)

Somewhere in the writings of Shan Bullock, whose novels and stories reflect perfectly the peaceable, passive, admirable aspects of Ulster Protestantism, there is an old man broken in health and broken in mind, bending over a fire and holding his memories of ancient fanaticisms and ancient fervours, muttering again and again to himself : " It's shivery cowld the day. Tell me, did-did—was it true that they disestablished the Church, Gladstone ?—Ach, no !—ach, a bad man ! " That was how they saw Gladstone. That is how they still see him when they look back on those same fervours and fanaticisms : a bad man, wicked because he wanted to deprive the Protestant Church in Ireland of certain established revenues, traitorous because he wanted to destroy the British Constitution and dismember the British Empire by giving his support to Home Rule for Ireland. In comparison with that amazing distortion of historical fact, with that libel on the character of a very noble and very devout man, no Irish nationalist has any reason to complain when his Orange fellow-countryman accuses him of murderous and treasonable intentions. But it is very wearying to realise that that mentality still exists, as solidly fortified against any contact with fact as it was sixty years ago. Gladstone did disestablish the Protestant Church in Ireland for very good, defensible, obvious reasons. Orangeism said he was next-door to

heathenry. He attacked the system of land-tenure and Orangeism said that he was a vile revolutionary upsetting the idea of caste and economic privilege upon which the Protestant Ascendancy had been founded. He introduced the Home Rule Bill and Orangemen rushed together to defend themselves against the unkindest cut of all. They said that nationalist Ireland urged on by the papacy and ably assisted by William Ewart Gladstone was renewing again the traditional attempt to get control of Protestant destinies, to tyrannise over Protestants ; and no argument could penetrate to the Orange mind to prove that what Protestant Ascendancy really meant was not self-defence but tyranny.

The Orange Order gave what support it could to landlords whose tenants were fighting for just rents, for an economic status that would make life tolerable ; and in all the chaos of that time Orangeism could see nothing but murder and outrage, plotted possibly in the Vatican, drawing authority from the writings of Saint Alphonsus Liguori. The adventures of Bradlaugh in the House of Commons and the attempt to resume diplomatic relations between Westminster and the Vatican were viewed in the same yellow light as attacks on loyalty and pure religion. Orangeism came to a new strength in the resistance to the First Home Rule Bill but Orangeism, naturally, had nothing to do with the riots that in 1886 followed the defeat of Gladstone's motion ! Behind the proposed Home Rule Bill the loyal men saw the spectre of an increased grant to Maynooth College, and state salaries being doled liberally to the Catholic clergy. The police who suppressed the pogroms were, also naturally, rabid papists who battered and assaulted inoffensive Protestants ! The men of the lodges, who were all loyal and peaceable, spent their spare time in drilling and learning the use of arms so that they could resist the decrees of Her Majesty's government. The Pope objected to the Plan of Campaign not out of any good will to Britain, not out of any wish to maintain order, but merely because he saw that Ireland was drifting to " Nihilism " ; and " Nihilism," whatever it was, would naturally be rough on the papal revenues. The lodges

opposed ritualism in the English church and carried their
own private ritualism into the innermost recesses of the
symbolic, and to the drumming boundaries of the barbaric.
An Ulster Convention stated its objections to Home Rule ;
and Gladstone was referred to as the "arch-separatist."

All that whirling, delirious fantasy would have been
excellent fun if it had been intended as either fantasy or
fun ; but it was seriously meant to preserve and sum-up
the experiences of the past, to shape and guide a positive
policy for the future. It did not end in 1886 or 1892 ; it did
not die with Gladstone. It remained to steady the platform
upon which Carson stood when he spoke to the thousands
at Craigavon. It remained to inspire a new parliament behind
a new wall, to shape again the policy of ascendancy, to claim
that one piece of Ireland was forever the preserve of
Protestantism and that any man who disagreed with those
words was an interloper, a rebel or a papist.

But it would be the last thing in inexactitude to identify
the myopia and manias of Orangeism with Ulster
Protestantism, to identify Orange self-defence with many
quite sensible objections to the policy of nationalist Irishmen,
even to identify all the men who attend lodge-meetings
with the extreme, fantastic views on Irish nationalism and
on the Catholic Church. In 1893 the Orange Order went
out of its way to declare that although it participated in the
general Unionist resistance to Home Rule it did so as a
separate organisation, emphasizing and keeping prominently
before the public "the necessity of resisting all attempts
to re-impose a Vatican policy on this Kingdom."* As a
separate organisation, with considerable representation on
the Irish Unionist Alliance, it helped to stiffen the resistance
to Home Rule in those years preceding the first European
war. It spoke loyally and loudly against the villainies of the
Boers, coming down in the customary fashion on the side
of the big battalions, although the economic upheavals of
that time have left on record one exceptional thing that has
in it the makings of real hope, that throws light on the

* *Op. cit.* Vol. 2, p. 598.

character of the Orangeman when detached from his official
organisation. W. P. Ryan in his book *The Irish Labour
Movement* writes that during the 1913 struggle in Dublin :
" the most faithful subscribers from the ranks of Irish toil
were Orangemen."

No man familiar with the character of the ordinary Ulster
Protestant, either inside or outside the Orange organisation,
will be surprised by that record of something charitably
and generously given. For contrary to the superstition there
is little dourness, little niggardliness, much generosity in
that character ; nothing at all that should reasonably make
it different to the character of any other Irishman, Catholic
or Nationalist. But what can normal, natural generosity
avail against the amazing thing that official Orangeism sees
when it looks back to the Battle of the Diamond, back to
the coming of William, back to the Confederation of Kilkenny ?
The Irish Nationalist is popularly supposed to be a person
who walks with his eyes on the ground, his mind acid with
meditating on the persecutions and injustices of the past.
There is something of that in the character of a very small
minority of Nationalist Irishmen, but they have never imagined
persecution where it did not exist, nor do they read behind
quite accidental and harmless actions in the present a whole
policy of malevolence and aggression. The official Orange
historian says, for example, that the Pope was responsible
for the first European war by his efforts " to force the Romish
religion upon a small Balkan State by the sword of Austria."[1]
The Vatican was, according to that historian, in active
sympathy with the aggressions of the Kaiser. The Pope
positively blessed the arms of the men who fought in the
Easter Rising in Dublin ; and the suppression of this truth
in the contemporary British press was due to " the extent
to which Romanism had become entrenched in British
newspaperdom and the Imperial services."[2] From Fleet
Street, that same writer, bringing his work up-to-date,
pursues the Pope across the Irish Sea to Dublin where he
finds that : " the driving force behind Mr. de Valera and his

[1] *Op. cit.*, Vol. 2, p. 637. [2] *Op. cit.*, Vol. 2, p. 635.

party all along has been unblushing and vengeful popery. This can be very easily discerned in the importance attached to the Church of Rome in the new Constitution."[1]

Shades of Titus Oates, Popish plotters, Bloody Mary, Maria Monk, and the glare of the fires of Smithfield, the inquisitorial rack of Torquemada! What can one do with the man who writes down sentences like that? There is no use, absolutely and utterly no use in asking him to read that same Constitution, to discover why and for what reason and under what circumstances a certain position was stated in that document as already belonging to the Catholic Church. All argument is useless; and against a mind like that even the gods are dumb.

But the mind of every Orangeman is not built like the mind of the man who wrote officially the story of the Order. Every Catholic in the Six Counties knows the innumerable things he has in common with his Protestant, even with his Orange neighbours. Those six counties are now the preserve of Orangeism. The Order has come into its kingdom. But the kingdom is not a very stable or a very satisfactory kingdom, since its present policy entails the perpetual coercion of a very large minority of the inhabitants. Some day every Irishman may see that coercion and consequent bitterness do not really produce true liberty, and all the miseries of the past will be seen in a new light and from a new angle, and the real barrier, which is a thing of the spirit, will go down like matchwood before the advance of a new and united people.

[1] *Op. cit.*, Vol. 2, p. 675.

Chapter VI

THE WESTMINSTER PHASE

" I mean by Home Rule the restoration to Ireland of representative government . . . government in accordance with the constitutionally expressed will of a majority of the people, and carried out by a Ministry constitutionally responsible to those whom they govern. In other words, I mean that the internal affairs of Ireland shall be regulated by an Irish Parliament—that all Imperial affairs, and all that relates to the Colonies, foreign states, and common interests of the Empire, shall continue to be regulated by the Imperial Parliament as at present constituted. The idea at the bottom of this proposal is the desirability of finding some middle course between separation on the one hand and over-centralization of government on the other."—*John Redmond speaking in Melbourne in July,* 1883.

" Ireland is turning her face once more to the old path . . . the new generation is reaffirming the Fenian faith, the faith of Emmet. It is because we know that this is so that we can suffer in patience the things that are said and done in the name of Irish Nationality by some of our leaders. What one may call the Westminster phase is passing : the National movement is swinging back again into its proper channel." —*Political Writings and Speeches of P. H. Pearse,* p. 72.

(1)

WHEN Carson and his men : the big business men of Belfast city ; the clubs here and there throughout the country that had dedicated themselves to the cause of The Union ; the plain men who marched hammering drums or carrying wooden rifles ; the plain but more powerful men who encouraged them to keep hammering ; entrenched themselves in the last ditch, the enemy whose advances they feared was known as the Parliamentary Party, the Irish Party, or the Nationalist Party. That Party has, when one excepts a few universally-acknowledged-to-be-noble periods in its

F

career, been the object of a fairly general and not very just
derision. Somebody has said that its history is a consoling
and comic demonstration of the ways of God to man. Its
main object in existing was to withdraw from the Parliament
in which it formed a party. Daniel O'Connell agitated for
that withdrawal and called it : Repeal of the Union.

After O'Connell there is a great darkness and a great
silence. In the awful shadow of starvation and mass-emigration
even the most zealous scientific historian would have difficulty
interesting himself or anybody else in what the Irish members
of the British House of Commons did between the passing
of O'Connell and the gentlemanly entrance of Isaac Butt.
Butt, too, is partially forgotten because of that very gentle-
manliness, because of his disposition to reason things out
with men who were too ignorant or too well-fed or too
contemptuous, intolerant or uninterested to pay any attention
to what he was saying. Whether they heard him or not he
also wanted Repeal. A pork-buyer from Belfast and a young
arrogant landlord from Wicklow were more successful.
They spoke to an audience who did not want to hear them,
who had not the least intention of heeding them ; and they
decided that the members of that audience would have very
little opportunity of discussing freely their own business,
certainly very little opportunity of talking any topic to the
completely satisfactory conclusion.

The principle of the business was as simple as a child's
game, a naughty child's game. The actual practice called
for ability, quickness in the mind and the tongue, no shame,
no self-consciousness, infinite patience, complete knowledge
of the ground over which the game was played. Charles
Stewart Parnell and J. G. Biggar had most of the required
qualities and their obvious success at playing the ungentle-
manly game of parliamentary obstruction made the audience
eventually sit up and listen, broke the gentlemanly heart
of Isaac Butt and ended his political career, drew eventually
around that queerly-assorted pair every Irish Parliamentarian
that stood for Repeal of the Union. Even the person who
has read nothing but printed titles in the cinema knows
some fragment of the story of Charles Stewart Parnell : his

tragedy; the split between his followers that came because
of that tragedy; his lonely death; the great funeral that cast
a shadow over the streets of Dublin, over every village
in Ireland; the legend that he had never died but that he
would return like a legendary hero, end the bitter war of
tongues between his scattered followers, lead Ireland to
victory. Victory meant giving every man his own land,
smashing the landlords and repealing the Union. Our
grandfathers were as simple, as sensible, as closely bound
to reality as all that.

When the war of tongues ended and the men who wanted
Repeal united, their leader was not Parnell arisen from the
grave or recalled from exile, but a man called John Redmond.
He was as gentlemanly as poor Butt, in the end he was even
more conciliatory; and he lived, breathed and had his being
in the atmosphere of the British Parliament. He admired,
even reverenced, parliamentary methods but he was able
to use them to gain a position as powerful as that held by
Parnell. He was honest and generous and the soul of honour.
Even his political opponents admired the loyalty with which
he had defended the fallen Parnell. His own fall should
have been honourable, without insult, without disgrace. Yet
not even Parnell suffered Redmond's fate, the symbolic
fate of men rejected by their people, stoned in the streets,
hissed at and mocked by the crowd. It is the misfortune of
such men as John Redmond to be trampled upon and left
behind by an eager, revolutionary generation; for they are
less decisive, less successful than the half-revolutionaries that
Carlyle called the *World's Girondins*. It was his singular
misfortune to be rejected for dallying with the prospect of
something not quite so bad as the eventual compromise
accepted by many of those eager revolutionaries.

To-day most men who talk politics from the Nationalist
point of view in Ireland think of John Redmond as an
ineffectual honest man, leader of a host of gombeen men
and country grocers, who was beguiled into acting as a
recruiting sergeant for the great armies of England, who
surrendered without a struggle almost everything that Irishmen
regard as essentials of national liberty. You can shape the

facts to look that way without a great deal of trouble ; but it would not be fair to John Redmond. It would not even be fair to, the gombeen men. After all, the stones and the hisses did, the common unpolitical people of Ireland said, break his heart. It is hardly possible to break the heart or the head of a man whose only good quality is ineffectual honesty.

(2)

That was John Redmond and the Party ; now what about The Union that they wanted to repeal. There were or are a dozen different ways of looking at it. The men in College Green in the beginning of the nineteenth century who had been persuaded that the Union was truly meet and just must have considered it a very good business-deal. It set quite a few of them up in life. In the opinion of all honest men they had sold their country ; but then the opinion of honest men never had much weight with dishonest men. Otherwise there would be much less difference between honesty and dishonesty. The good solid English Conservative thought that The Union preserved the solidity and integrity of the Empire and conferred on the Irishry the benefits of British legislation and administration. If the Irish preferred their benefits in another way then the Irish were damned rebels and needed coercion. The various types of Irish Unionists regarded The Union from angles that differed like the subtle adjustments of camera-angle in the making of a Hitchcock film. For some it propped-up and protected the landed system and the great houses ; for others it protected certain industries around Belfast from rapacious Southern plunderers ; for others it was the sole defence against the advances of the Pope of Rome. To the Irish moderate Repealer The Union meant that the men of Ireland were deprived of certain rights that were theirs as members of one nation ; the extent to which those rights should be modified to avoid conflict with the claims of Empire differed from man to man. To the majority of the proverbial plain people of Ireland, who were Repealers but were not essentially moderate, the

Union was an attempt by the British to take something that did not belong to them, to stay somewhere they had no right to be. Pearse who came at the end of what he stigmatised as *the Westminster phase* considered that the abolition of the thing miscalled Union justified fighting and the shedding of blood. All down to his time, running as a fierce undercurrent to parliamentary agitation, was the idea that the existence of The Union justified anything, right up to blowing the British House of Parliament as high as dynamite could blow it.

There were, then, differences of opinion about The Union, about many of the things that were fruits of The Union or of previous wars of conquest. What it meant, apart from all question of point-of-view, was that laws for Ireland were manufactured in London ; and, since it is the experience of men that powerful nations do not legislate with any notable insight or distinction for neighbouring, less-powerful nations, the laws were mostly coercive laws. If we consider carefully the opinions of two Irish Protestants on The Union we may learn almost everything about it. The first is the opinion of Edward Carson ; the second of Captain Denis Ireland, an Ulster Protestant.

At a meeting of the Ulster Unionist Council in 1920 Carson said : " Every injustice and every harm . . . committed on Ireland . . . were inflicted before the Union and not since the Union, and none of them would be possible with the present representation of Ireland in the Imperial Parliament." Ian Colvin suggests that Carson considered that the agitation for Home Rule hazarded the benefits enjoyed by the Irish people in this " prosperous partnership." The Union had given to Ireland local self-government ; £150,000 a year in relief of taxation ; a system of education such as Carson wished England had, in which every child was trained in the religion of its parents and the cost discharged out of Imperial taxation. The Union had given Ireland University education and land purchase. Speaking in 1910 at Macclesfield he put forward a series of rhetorical questions intended eventually for the ears of Asquith, leader of the Liberal government. What, under Home Rule, would be the fiscal relations of Ireland and England ? As Carson understood or interpreted

the figures, Ireland was, under the Union, a debtor to the Imperial Parliament ; but then the adaptability of figures is as remarkable as the quotability of the Bible. " Was England to go on paying two-and-a-half millions to Ireland without having any voice in the expenditure of that sum ? Were Irish members to continue to sit in the House of Commons ? Was England to continue to advance money to Ireland for the purchase of land by the tenants ? " Over and above these purely material considerations Carson thought that : " Mr. Asquith was playing with fire if he thought he was going to trifle with the loyal minority, who were as keen for King and Constitution as any Englishman."

Spiritual and material, that was the substance of his argument for the maintenance of the Union. It was not a particularly strong argument. For instance : that system of education that trained every child in the religion of its parents was a very idyllic picture of the National Schools, and rather neglected to allow for all the amazing forms of proselytism that had been tolerated and even subsidised under the Union. More obviously idyllic was the picture of Ireland, the petted child, drawing liberally on the bank-account of the beneficent parent at Westminster. A Royal Commission had been set up in 1894 under the Chairmanship of the Right Honourable Hugh C. E. Childers, an ex-Chancellor of the Exchequer. A passage in the joint report presented by the members of the Commission stated : " That the Act of Union imposed upon Ireland a burden which as events showed she was unable to bear ; that whilst the actual tax revenue of Ireland is about one-eleventh of that of Great Britain the relative taxable capacity of Ireland is very much smaller, and is not estimated by any of us as exceeding one-twentieth." Other members of the Commission in minority reports were not even so moderate in the statistical estimate of the injury done to Ireland under the Union by that over-taxation ; it was calculated as highly as £3,500,000 for every year since the passing of the Act. On that Commission Thomas Sexton, M.P., was the Nationalist representative ; and subsequent to the publication of its findings a movement began with the professed object of righting the wrongs in that legacy left

by Castlereagh. It had a very brief life; but it was at least notable in having among its supporters the Rev. R. R. Kane who was Grand Master of the Belfast Orangemen.

The argument against the Union went beyond the balance-sheet, to those things that give grace to life and help a people to find its soul. It is put quite convincingly by Captain Denis Ireland in a pamphlet* written a few years ago: " All that Unionism could ever accomplish in Ireland, while remaining true to its creed, was to hold back the moral and intellectual development of the Irish nation; and this pious duty it so effectually performed that the gifted and sympathetic observer, Louis Paul-Dubois, could diagnose the disease from which Ireland was suffering on her emergence from the nineteenth century only as a case of ' arrested development.' For a century and a quarter Irish Unionism had acted simply as a brake on Irish Nationalism, and the moment it ceased to do so it blew the Unionist position sky-high. . . . Unionism could never in any conceivable circumstances have become an Irish policy at all; it was simply a *nothing*, a void in Irish history, an interval between one historical explosion and the next. Apart altogether from the moral and philosophical factors involved in the situation, the diametrically opposed economic conditions of over-industrialised England and over-agriculturalised Ireland had rendered the attempt to govern Ireland from Westminster absurd *ab initio*. . . . Unionism failed because it was merely an ideal—an ideal unsupported by, and unconnected with, the *facts* of the Irish situation; and Nationalism triumphed because it was in itself an inherent fact of the Irish situation, because in Mr. Shaw's illuminating phrase in the preface to *John Bull's Other Island* it was merely ' the agonising symptom of a suppressed natural function.' "

The writer of that penetrating passage is an Ulster Protestant, from the portion of Ulster that was ringed-off for a separate government when Unionism, bogged in the last ditch, made a pitiful compromise. There are other Ulster Protestants conscious of the fact that the old brake, now in a very worn-out condition, still holds back the development of the country.

* *Eamon de Valera Doesn't See It Through*, by Denis Ireland (The Forum Press, Cork, 1941).

(3)

The Westminster phase had its most representative figure in John Redmond. Parnell despised the English Parliament with an intensity that has only been equalled by a very small number of English ultra-Radicals. John Redmond venerated the English Parliament; he and his whole family moved against the background of the House of Commons. A modern Irish socialist writer has maintained that James Craig and John Redmond had more in common than they ever found out : they were wealthy men of wealthy families, with interests in industry and interests in land, with the great common interest of seeing that the moneyless, propertyless, landless workers, whether orange or green, remained with little money, no property and no land. There is a little, a very little substance in the theory. The actual facts are that Craig was Protestant and Unionist, Redmond Catholic and Nationalist in a country where political and religious division were marked for the most part by the same line. There is another great difference. Redmond would have been incapable of the organised contempt for parliamentary method that characterised the course of the Carsonite agitation. That was perhaps the secret of his pitiful failure.

The Redmond family had " for centuries played a leading part in the life of his native county, Wexford." They were of that class of people whose money and influence can set things moving in the locality in which they live : introducing material improvements that benefit the lesser people of the place, adding in that way to their own influence and their own money. The connection with the House of Commons went back to early Victorian days, to a grand-uncle of John Redmond ; and John Redmond's father had, with Isaac Butt, been one of the founders of the Home Rule movement. Had Ireland been a normal country enjoying its normal rights it might, possibly, always have chosen its leaders from families like the Redmond family. But the real leaders of the Irish people, the men who found their place in songs and ballads, were not men of property and money ; later when John Redmond's political career was coming to an end.

a crowd of young men who had inherited that tradition of romantic, revolutionary leadership put a sudden and violent finish to the Westminster phase. Redmond's education was not designed to make a revolutionary : Clongowes Wood College, Trinity College—which he left to go to help his father in London. Then in 1880 when Parnell and J. G. Biggar were beginning to displace the gentlemanly Isaac Butt the young Redmond got an official job in the Vote Office. Later on he was elected as one of the parliamentary representatives for County Wexford, the youngest member of the new Nationalist Party under the leadership of Parnell. He figured in the Parliamentary war waged around the two Gladstonian attempts to solve the Irish problem by giving Ireland a certain limited measure of self-government ; and in the debate that took place in 1886 he described the position of Ulster in a way that was prophetic then and has a great deal of validity to-day.

He said : " Ulster, they say, is a Protestant and anti-Nationalist province, and could not be put under the domination of a Nationalist Parliament in Dublin. But let me ask is Ulster either Protestant or anti-Nationalist ? First, is Ulster Protestant ? Last year a return was issued by Parliament giving the religious denominations of the population of Ulster. From that it appeared that 48 per cent. of the whole population was Catholic, and the remaining 52 per cent. was made up of all other creeds. Leaving Belfast out, the Catholics were to-day 55 per cent. of the whole population.

" Is Ulster anti-National ? The answer is supplied by the returns at the last elections. Out of nine counties of Ulster only one—namely, Antrim—went solidly against Home Rule. Four entire counties—Donegal, Fermanagh, Cavan, and Monaghan—went solid for Home Rule. The remaining four counties—namely, Derry, Tyrone, Armagh, and Down—were so divided that the net result was to give the Nationalists a clear majority of the Ulster seats, while West Belfast and Derry were only lost by thirty-seven and twenty-seven votes. In the face of these facts it is the utmost folly to speak of Ulster as anti-National.

" I deeply regret having to speak of Protestants and

Catholics in connection with this matter at all. Ours is not a sectarian but a national movement. If Home Rule were granted the Protestant minority would have equal rights and liberties with their Catholic fellow country-men. Protestants led the national movements of Ireland for generations."

Lengthy quotation is a tedious business but, for several reasons, that quotation should be given in full. It is an excellent statement of the position before the Parnéllite agitation for a native government and the Radical reform of the system of land-tenure had given organisation and a new spirit to what was left of the Irish people by famine-fever and emigration ; before the possibility of repeal of the Union by an English Liberal Government taught the Conservative Party the resistance value of the politico-sectarian element concentrated around Belfast. After half-a-century, and in spite of the artificial conditions imposed for pure political expediency, the attitude of the nine counties of Ulster towards the authority of a Dublin government has not materially altered. Yet those artificial conditions were imposed against the clear will of the majority of the Irish people, against the will of the majority of the people of Ulster. That makes the quotation from Redmond's speech doubly interesting. He knew the facts. He knew that if the theory that is popularly supposed to stand at the back of democratic government were really applied, the Home Rule Bill would and should be law. What he did not know was the force a wealthy well-organised minority in Ireland, with the assistance of powerful political influence in England, could use to wreck the whole attempt to make a lasting peace between the two countries. If he did know that, then he kept his eyes closed, told himself the force did not exist, that because the figures showed that Ulster was not totally Protestant and certainly not anti-Nationalist then there was no Ulster problem. The fate of the first two Home Rule Bills, the antics of Randolph Churchill should have taught him better. Yet he went on trusting in the promises of British politicians who found the whole damned thing so awkward that they had to lie liberally to both sides. He even trusted the British people

who were, obviously and without any fault of their own, completely ignorant as to what it was all about ; except, possibly, that a number of people in Ireland, mostly dynamiters and cattle-drivers, considered themselves too good to belong to the British Empire. He trusted in the real union that would come between all Irishmen fighting side-by-side in the trenches in the first great catastrophe of our century. He pinned his final hope on an all-Ireland Convention talking the time away in a hall in Trinity College ; a hall notable for imperfect acoustics. Then his heart broke and he died.

But all that was many years ahead. In 1886 he was a young man telling the British House of Commons that Ulster—it then meant only a province of nine counties, a part of one country—was not a genuine obstacle to the passing of a Home Rule Bill. The Home Rule Bill did not pass. Gladstone went to his grave frustrated by the shadow of Castlereagh. Parnell fell ; and Redmond, who had been his faithful follower, stayed faithful to the memory of his fallen chief. It is his great merit in the eyes of his countrymen that when the men who had followed Parnell united again he was selected to lead them. He led them through the years when Home Rule was a neglected and forbidden topic in the House of Commons because no English party needed the votes of Irish members. He was their leader when the elections of 1910 returned the Liberal Party with an insecure majority that made them see the value of the Irish votes. Winston Churchill in that speech at Dundee in 1911, in which he advised his audience not to take Edward Carson too seriously, said also that in the next parliamentary session the government would introduce a Home Rule Bill. They would, he said, press it forward with all their strength.

(4)

John Redmond had his chance and he did and said everything that he, John Redmond, could do and say to make use of that chance. Two things, apparently, he could not do. He could not estimate the driving force of the organised and well-supported minority that had begun to call itself

" Ulster " ; nor could he play their game of extra-parliamentary
threat. The Volunteer idea was always repugnant to him.
He loathed the Ulster Volunteers and the threat of anti-
constitutional disorder that they symbolised. Only experience
made him realise how far that threat could be pushed, without
real danger, by the skilful management of Carson. In 1886
he could only have classed as a nightmare the idea that an
English political party, with all its opportunities for con-
stitutional action, could stoop to intervene between army
officers and their duty. When he did realise what was
happening he could state his mind clearly enough. In a cable
to Irish supporters in Australia he said what he thought
about the remarkable business known as the Curragh Mutiny.
" The Ulster Orange Plot is now completely revealed. Carson
and his army have not, and never had, the slightest intention
of fighting as a fighting force. Against the regular troops
they could not hold out a week. The plan was to put up the
appearance of a fight, and then, by Society influences, to
seduce the Army officers and thus defeat the will of the
people."

The man who recognised the thing when it was done
was not asleep, not blind ; but success was with the man
who did it. The initiative was with Edward Carson ; with
Major Crawford who would have preferred rather than
submit to Home Rule " to change his allegiance right over
to the Emperor of Germany or anyone else who had got
a proper and stable government," with Sir Henry Wilson, the
commander of the Ulster Volunteers, who supported the
business at the Curragh from an advantageous position in
the British War Office, who demanded belligerent rights
for Carson's army, referred always to the Irish Volunteers
as " murderers," helped to wreck Redmond's recruiting
campaign by insisting upon conscription for Ireland. Redmond
stood fast by the more conventional Westminster methods.

When the Irish Volunteer force came into existence he was
alarmed and displeased, not only because there was a suspicion
that the frankly revolutionary Republican Brotherhood had
a hand in the business, but because the whole idea of an
extra-parliamentary force was alien to the mind shaped in

the Vote Office. His efforts to gain control of the Volunteers were inspired by the desire to keep them from doing anything, from drilling and marching, from obtaining arms, and, in the North, from counter-demonstrating against Carson's army. A new Ireland was growing up around him and he was hardly aware of its existence, except to record his displeasure, in a letter to Douglas Hyde, at being hissed at by some young and not over-parliamentary members of the Gaelic League. Right to the end he regarded the men who were making that new Ireland as an unimportant, eccentric, tattered, illiterate minority. In the House of Commons in September, 1914, he spoke of: " A little group of men who never belonged to the National Constitutional Party, who were circulating anti-recruiting handbills and were publishing little wretched rags once a week or once a month." The battle in 1913 between the workers of Dublin and their employers appeared to Redmond as : " The Larkin incident." That contempt or that ignorance was his second great disability. He did not understand the change that was happening to the majority of the Irish people that he was nominally supposed to lead. For purely oratorical purposes he had pandered, now and again, to their sentiment, and had, possibly, been quite affected by the consideration that he inherited something from the men who had died for Irish freedom. But somewhere beneath the consciousness of the men who walked to his meetings those rhetorical figures had a sort of suspended life, waiting for the word, the deed, the sacrifice, the inspiration. All that came one Easter Monday morning from the circulators of handbills and the publishers of wretched little rags.

In spite of it all he put the Home Rule Bill on the Statute Book. He understood perfectly neither the majority of the Irish people that he led nor the minority that opposed him ; but he did understand the British Parliament and he knew his own ability and the favourable position that his party occupied. Inside Westminster he won his battle. The cartoonists of the time delighted in producing grotesque drawings intended to represent the tyranny of John Redmond over the House of Commons, particularly over Asquith, the

Liberal Prime Minister. A favourite cartoon depicted him as *The Dollar Princess*, nurse to a juvenile Asquith who sat in a tiny cart, driving the two tiny horses of Labour and Liberal policy. It was not as bad as that; but he had power and he knew how to use it. Against the whole array of Unionism in Westminster he—in the appalling metaphor of the time—steered the vessel of Home Rule safely into port. He set himself against the suggested amendment that was to change what was called the Ulster problem into what we now know as the Partition problem; for he sensed in that compromise the threat of endless and inevitable dissension. He said that the democracy of Great Britain had now decided to trust the Irish to govern themselves; and the men of the handbills noted down the phrase to be used in evidence against him. At Clongowes Wood College, where he had been educated, he spoke at a centenary gathering. Much of what he said is worth remembering: his advice to the youth who were to grow up in the Ireland of civil and religious freedom that Home Rule would make for them, " at no far-distant date "; his review of the century of gradual escape from persecution that had coincided with the history of Clongowes. He was at that moment at the height of his power: the man who had made Home Rule a near and tangible thing.

And all the time he was beaten: beaten in that extra-parliamentary place where he disdained to fight; by Carson at Craigavon; by Bonar Law at Balmoral; by Craig and the Covenant; by Crawford and the guns that came so easily into the lovely town of Larne; by Sir Henry Wilson conniving at mutiny. It is just possible that had the Home Rule Bill passed into law without any spancelling amendment those men would have flattened the whole thing after the next change of government. That is one of the subjunctives that scientific historians can exercise with when they slip out of the strait-waistcoat of fact. The facts of that time are the shot in Sarajevo that set men moving like terrible tides over the fields of Europe; the action that John Redmond took when Great Britain went to war. The handbill-men said he had become recruiting-sergeant for the armies of the

British Empire ; and the dozen different forces that had been making the new Ireland came together to sweep John Redmond and the Party out of existence, to hold Carson down to that amending compromise that was defeat for a man who considered the Union of Castlereagh a constructive policy.

(5)

Redmond saw the war as an opportunity. Like most people then, and apparently like most people at the beginning of every war, he thought it would all be over in twelve months. During those twelve months the people of Ireland were, by their diligence in fighting the war, to place the British people permanently in their debt ; to squash forever the legend that the Irish were hostile to the cause of King and Empire ; to show that England's difficulty was Ireland's opportunity to help England. He was firmly convinced of the justice of the Allied cause. Fighting together in the trenches, Irishmen from Cork and Belfast, Connemara and Rathmines, Catholic or Protestant, Nationalist or Unionist or Republican, would realise that they were men of one country and one allegiance. In twelve months the Kaiser would be beaten, possibly hanged ; the world would be safe for parliamentary democracy ; the Home Rule Bill would be law and nobody would want a partitioning amendment. The idea was good. It remained just an idea because the British War Office did not co-operate ; because the Conservative mind distrusted a united Ireland, even if Ireland united to help the Empire ; because, in spite of the hand that Carson offered in public, neither he nor the men that followed him genuinely meant to join forces with Redmond, much less with the younger men who were soon to displace Redmond. It remained an idea because those young men, with a certain amount of justification, distrusted the War Office, the Conservative mind, the hand of Edward Carson ; because they had come to regard John Redmond as either a windbag or a rogue ; because, although some of them were prepared to accept Home Rule as a step on the way to something better, there were others who regarded it as a colossal fake.

They considered, too, that England's war was England's business, and they did not share Redmond's conviction that the war was one of those universal defences of justice that appeal to all brave and honourable men. They may or may not have been right. The number of them prepared to advance those ideas against the thrones of the Parliamentary Party was small, a minority in the country. But their ideas had appeal, and they had enough sincerity to propagate those ideas by dying for them. In their name and in the name of the whole Irish people John Redmond stood up in the House of Commons and offered the strength of Ireland to help England in her hour of need.

Sir Edward Grey had just said that the one bright spot in the shadow that was falling over the world was the changed feeling in Ireland. The phrase inspired Redmond. Not so long ago it was recalled by Winston Churchill who thinks it possible that English statesmanship may have missed something when it refused to take John Redmond at his word.

"I say to the Government," said Redmond, "that they may to-morrow withdraw every one of their troops from Ireland. I say that the coast of Ireland will be defended from foreign invasion by her armed sons, and for this purpose armed Nationalist Catholics in the South will be only too glad to join arms with the armed Protestant Ulstermen in the North . . . if it is allowed to us, in comradeship with our brethren in the North, we will ourselves defend the coasts of our country."

Some of the apologists for the attitude of the brethren of the North point out that Redmond mentioned only home-defence, not the sending forth of an Irish Expeditionary Force ; a dangerous boomerang argument that uncharitably passes over the fact that neither Redmond nor anybody else knew that the war would necessitate, for the first time in history, the mass-conscription of English man-power. When he did realise that, he did everything he could do to send Irishmen to France, fighting together as Irishmen under their own insignia in the cause of universal liberty. Almost every concession to Irish sentiment that he pleaded for as a

help to his recruiting campaign was denied or given grudg-
ingly by the mentality that kept demanding conscription
for Ireland, although even John Redmond knew that con-
scription was the fastest way to revolution. Lord Kitchener
and Edward Carson were of genuine assistance to the young
men with the handbills ; and all over the country the ordinary
people began to come alive to those handbills, to the violent
little newspapers ; began to think that John Redmond had
been too soft altogether, marching men off to war and never
a blessed question about how long the Home Rule Bill was
going to dangle in the air, beautiful and. useless.

Edward Carson had got the special insignia for his soldiers
with no trouble at all. They had been the Ulster Volunteers.
They marched off to the front as the Ulster Division, distin-
guished themselves, fought side-by-side with men from Cork
and men from Dublin and learned, some of them, that Ireland
was a small island inhabited by people who differed little
from parish to parish, had nowhere horns or cloven hooves,
did not burn people at the stake for being Protestant boys.
But even in the tumult of Flanders it could not have been easy
to forget Carson's parting message ; it compares interestingly
with Redmond's speech :

" To The Members
of the
Ulster Volunteer Force

" I greatly appreciate the action of our Volunteers in rallying
so enthusiastically to my call for defenders of the Empire.
To those who have not already responded to that call and
are eligible and can go, I say, ' Quit yourselves like men,
and comply with your country's demand.'

" Enlist at once for the Ulster Division in Lord Kitchener's
Army for the period of the War.

" You were formed to defend our citizenship in the
United Kingdom and the Empire, and so preserve our civil
and religious liberty. Now the United Kingdom and the
Empire are threatened we must fight with our fellow-Britishers
until victory is assured.

" To those loyalists who are not eligible or cannot go

G

I appeal that they shall fill up the vacancies in the U.V.F.
ranks caused by those going to the Front, so that we may main-
tain in fullest efficiency the Ulster Volunteer Force to protect
your homes and hearths. That is a duty we owe to the
Volunteers who go abroad to fight the country's battles.
Let every Loyalist be faithful to the trust, and by each one
doing his duty our country will be saved and our own interests
preserved."

The last four words are significant. There was no mention
of co-operation within the country to guard the coasts, or of
union on battlefields beyond the sea. That conception was
something that Castlereagh had not left behind him and
Edward Carson was not able to find it by himself. In a later
declaration he made his meaning very clear.

" I tell you this : that the Home Rule Bill, now an Act
of Parliament, is to my mind, as far as you are concerned,
nothing but a scrap of paper. When the war is over and we
have beaten the Germans, as we are going to do, I tell you
what we will do ; we will call our provisional Government
together, and we will repeal the Home Rule Bill, as far as
it concerns us, in ten minutes. We are never going to allow
Home Rule in Ulster, and I tell you why : All our Volunteers
are going to kick out anybody who tries to put it into force
in Ulster."

In the teeth of all that, Redmond stood by his unconditional
promise until John Dillon and other Irish members began to
wonder at the depth of his unwisdom. An official return
supplied to Redmond in January, 1917, showed that of the
Irishmen then wearing British uniform 94,000 were Catholics
and 64,000 Protestants. Large numbers of that section of the
Nationalist Volunteer Force that had remained under
Redmond's control went to fight. Ledwidge, the poet, went
and died. Tom Kettle went and left behind him a political
testament in which there was much wisdom and much
bitterness : " Had I lived, I had meant to call my next book
on the relations of Ireland and England, *The Two Fools: A Trag-
edy of Errors.* . . . I have mixed much with Englishmen and with
Protestant Ulstermen, and I know that there is no real or
abiding reason for the gulfs . . . that now dismember the

natural alliance of both of them with us Irish Nationalists. . . .
In the name . . . of the blood given in the last two years,
I ask for Colonial Home Rule for Ireland—a thing essential
in itself, and essential as a prologue to the reconstruction of
the Empire. Ulster will agree. And I ask for the immediate
withdrawal of martial law in Ireland, and an amnesty for all
Sinn Fein prisoners. If this war has taught us anything, it
is that great things can be done only in a great way."

Redmond's younger brother spoke his last appeal to the
House of Commons and went out to die fighting in the
attack on the Messines Ridge. Those were the last gallant
gestures of the Westminster phase, and no subsequent talk
of a movement for gombeen men and no conviction of the
wrongness of their policy, can take anything away from the
genuine nobility of those men. The Party had once represented
the wishes and hopes of the Irish people, but the people had
outlived the Party. That was made evident when, at a by-
election in North Roscommon, the Redmondite candidate
was badly beaten by a certain Count Plunkett, whose son
had been one of those men that Redmond would have classed
among the insignificant circulators of handbills. Actually the
son was a poet of considerable genius, and, like his father,
a man of culture. Count Plunkett had been Director of the
National Museum in Dublin, had been dismissed from his
post because his son had been executed in the Spring of 1916
as one of the seven leaders of the Rising that was to inspire
and to shape the new Ireland.

(6)

John Redmond was fond of Shakespeare ; at least he
quoted in the House of Commons a passage from *Macbeth*.
In the last act of his own life there is a mingling of tragedy
and comedy worthy at least of such plays as *Measure for
Measure* or *All's Well that Ends Well*. The circumstances were
roughly as follows :

England, in the managing of the war, felt the need of
American assistance. Now in America the Irish-American
vote was of importance, and to capture American sympathy

it was necessary to give the impression that England, the
champion of small nations, was making a genuine effort to
solve the Irish problem that had been serious enough to
cause a week of bloodshed in the streets of Dublin. Lloyd
George thought of an idea that would soften American
prejudice without making any notable change in the actual
situation. He arranged for the summoning of an Irish Con-
vention, to represent all parties and all interests, to discuss
Irish difficulties and to find a Constitution that would be
acceptable to all Irishmen. Like so many other expedients
suggested at that time it was a good idea. Redmond accepted
it eagerly and did everything in his power to make it end in
achievement and success. The men with the handbills who
had formed a new party with the title *Sinn Féin* refused to
attend. After some discussion the Unionists of North-East
Ulster decided to attend. They asked Carson for a positive
policy and he suggested the inevitable Union of Castlereagh ;
and one can only hope that he saw the humour of the sugges-
tion. The Convention met in Trinity College, Dublin, under
the presidency of Sir Horace Plunkett ; and talked and talked
in a room where imperfect acoustics must have added consider-
ably to the grim fun of the whole affair. Lloyd George was
quite content that the Convention should never get beyond
the talking stage ; F. E. Smith even went so far as to suggest
that he hired the members of the Convention to keep talking
at the rate of a guinea a day. There was much talk about the
fiscal provisions of the Home Rule Bill, about whether or not
Ireland should or should not enjoy fiscal autonomy. J. M.
Robertson had in 1912 thought fiscal autonomy impossible
because it implied separation. The Convention split on that
rock, split into a dozen different fragments ; and John
Redmond came out from the atmosphere of awry discussion
into a city where new forces were at work. Somebody in
the street fired stones at him, and he knew it was the end.

Years before when he had stood by the falling Parnell he
had said : " I believe that your overthrow will be an instance
of ingratitude such as has been shown by no other country
in the world, and such as will stamp the Irish people' as
unworthy of those rights for which you and all of us have

been working." At least he could console himself with the reflection that he had failed as Parnell had failed. It was not ingratitude that crushed him and made room for new men and new ideas. The people had changed and he had helped to change them; to a certain extent they never had been as he had imagined them to be. Yet it would be ingratitude and folly to forget one thing that John Redmond knew very well: that the amending compromise tacked on to his Home Rule Bill had in it the making of as many evils as the Union manufactured by Castlereagh. He had gone as far as conciliation could go to avoid that compromise: offering friendship to those stubborn and suspicious men in the North-East corner, offering the manhood of Ireland to the armies of the British Empire, sacrificing his own career, his political position, the party that he led, to the dream of an Ireland united and at peace. He died in sorrow; foreseeing perhaps the sorrow and agony that was to come upon his country in years of flame and terror, ending at last in the making of the compromise that he had done so much to avoid.

CHAPTER VII

THE NOBLE HOUSE

" The proffered pap of discussion (i.e., The Trinity College Convention)
failed to lure the howling carnivore—Sinn Fein, which still prowled
unappeased outside the railings of Trinity College, whilst those within
talked on and on, and lost themselves in interminable argument, during
which some, exhausted and despairing, passed into another world."
—*Jean V. Bates in " Sir Edward Carson, Ulster Leader."*

" O wise men, riddle me this : what if the dream come true ?
What if the dream come true ? and if millions unborn shall dwell
In the house that I shaped in my heart, the noble house of my thought."
—*P. H. Pearse in " The Fool."*

(1)

WINSTON CHURCHILL who was poorly received in Belfast in
1912 and Patrick Pearse who was shot in Dublin in 1916
would have disagreed about a good number of things. One
of the points of disagreement would have been the importance
and significance of Belfast's lack of hospitality for Winston
Churchill ; and, in the light of all the things that happened
between 1912 and 1922, only a very fervent Irish patriot
would maintain that Pearse would have been right and
Churchill wrong. When the English Liberal Party and the
Irish Parliamentary Party were professing themselves greatly
amused by the spectacle of Orangemen and wooden guns,
Pearse and the young men whose opinions he moulded were
not amused. They took Carson's army seriously ; but their
reason for taking it seriously was the wrong reason. They
admired it because it was a sign that the brethren in the North,
who were after all the descendants of gallant Presbyterian
rebels, were displaying some of the fire that had made their
fathers noble, were asserting their right to self-determination,

were defying a British Government. Pearse, who had no prevision of the Stormont that was to come, even went so far as to claim that Carson's provisional government would make a better job of managing Ireland than His Majesty's Imperial Government. Winston Churchill was better able to calculate the exact weight of Northern Iron that came out of the coffers of the Conservative Party.

So, while the Parliamentary Party laughed at Carson, Pearse laughed at the Parliamentary Party, numbering them among the many incongruous things that would provide good material for the more fantastic side of the genius of John Millington Synge. He made a list of the incongruities that disgusted or ought to disgust: a millionaire promoting universal peace; an employer accepting the aid of foreign bayonets to lock-out his workmen, then accusing the workmen of lack of all nationality because they accepted foreign alms for their starving wives and children; a public body in an enslaved country passing a resolution congratulating a fellow-citizen upon selling himself at a good price to the enemies of that country. These were not intended as abstract philosophical examples; and at the end of the list he placed the Irish Nationalist, unable to use a gun, yet sneering at the drillings and rifle-practices of Orangemen.

Now Pearse writing his praise of the gun was part of the new Ireland to which Edward Carson, emphatically, did not belong. The new Ireland was not necessarily a political thing. It comprehended the revival of rural life on the land that had only recently come into the possession of the people; connected with that revival went such names as those of Sir Horace Plunkett, George Russell, Father Tom Finlay. It comprehended the Gaelic League and Doctor Douglas Hyde, all the scholars and men of letters who were discovering and revealing the cultural content of the Gaelic language, all the young men and women who were learning to speak that language because it was a national badge and possession. With that pride in a language that had survived the nineteenth century only in certain remote parts of the country went a quickened interest in national dances, in the picturesque costume that was popularly supposed to have been the

fashion in ancient Ireland, in Irish music, in the ancient game of hurling, in the more recently-manufactured game of Gaelic football. The new Ireland had room for athletes and for intellectuals. In the city of Dublin it gave birth to a new nationally-minded literary theatre in which the main figures were descendants of Protestant landed people ; and around that theatre a very notable literary movement began to form. In the city of Dublin, too, it organised working men against the exploitation of employers who were largely supporters of the Parliamentary Party because the Parliamentary Party seemed to be the safest horse to put your money on. That new Ireland included the Irish Volunteers who had come into existence partially as a protest against the existence of the Ulster Volunteers, partially under the guidance of a force that went much deeper than the rhetoric of John Redmond. Pearse, who praised the gun, had his connections with that force : the Irish Republican Brotherhood. (Lord Cushendun with the contempt for accuracy that frequently characterises the Ulster Unionist publicist states that the Brotherhood was responsible for the Phoenix Park murders.)

But Pearse was a great deal more than the mere eulogist of the gun. He was a schoolmaster with original and valuable ideas on the education of youth. He was a scholar, a poet of considerable merit, a playwright, a lucid and vital thinker. He is not, perhaps, the most perfect representative of the new Ireland, for his ideas went upwards to a white-hot mysticism that was not for every man. But for various reasons he stands in the centre of and dominates the thing that we speak of as resurgent Ireland ; and any consideration of his ideals entails some sort of examination of everything from co-operative creameries to labour-movements and plays in verse. That resurgent Ireland was to take up the battle where John Redmond had failed. It included a score of different impulses, ideas, movements, organisations. One thing it did not and could not include : Edward Carson and the Union of Castlereagh. He had no share in any one of those constructive or cultural activities that were moulding and shaping the Irish people. He only suggested the use of the gun, organised his little army against the constitutionalism

of Asquith and Redmond, and then discovered that, with Redmond in the dust, the Irish people had taken to heart his lessons in defiance. But for that he might have preserved the Union intact, and might never have known the compromise, that he had almost forced on Redmond, come back on his followers as the only alternative to an Irish Republic.

(2)

Pearse said : Ireland Gaelic and Ireland free ; and gave a maxim to the majority of Irishmen as Randolph Churchill had given a maxim to the minority in the North-East. Maxims can clarify and be helpful. They can also bind and be dangerous. That maxim given by Pearse was a helpful source of inspiration and courage at least to an intelligent minority of nationalist Irishmen during the very difficult years that were to follow the killing of Pearse. But if it inspired in one part of Ireland it must have added to the superstitious terror in another part. What the average Orangeman understood or misunderstood by a "free" Ireland not even the average Orangeman would be capable of defining clearly ; certainly it had something to do with the triumph of rebels and the establishment and enforcement of papistry. James Craig once said, not without some unconscious humour : " If any person can be found in Ulster to lead the people into a Free State it will not be me ; " from which an outsider, ignorant of the incongruities of modern Ireland, might conclude that James Craig was one of those peculiar individuals who did not consider freedom desirable. But there was never any doubt as to the attitude of the Unionist section of Ulster towards the Gaelic vision that was a genuine and valuable inspiration to some of their fellow-countrymen. Edward Carson could be jocose about the attempts that a hypothetical Nationalist Parliament might make to compel Unionists to speak a language of which they, the Nationalists, knew nothing. James Craig, who was much more ignorant than Carson, considered Gaelic an archaic tribal tongue, by which he meant that it was savage and uncouth like something out of the jungle, not simple and noble like the language of Homer. Even today the prospect of Gaelic taught compulsorily to children at school, made

the essential requisite for jobs in the Civil Service, is one of the goblin visions terrifying the average Protestant in the Six Counties ; and the policy of the *Fianna Fáil* government quite obviously gives horns and a tail to the cavorting goblin. If every other obstacle to the welding of a united Ireland were removed the linguistic problem would possibly solve itself. Still there was and there is nothing in that vision of Ireland Gaelic, to terrify any man of any colour ; the sceptic, and every Irish household has at least one, would tell the Orangeman not to worry about something that was never going to happen.

The Gaelic vision was a great part of Patrick Pearse, and Pearse had a great part in the making of modern Ireland. He had not, by any means, a monopoly of that vision, but he is a very typical and notable specimen of the type of man who shared it. It was a vision of heroic things, a poetic vision ; and no man who venerates the men who held Derry against the armies of James Stuart could quarrel with the heroic thing, even if poetic visions are not too common among Belfast business-men. Pearse wanted to bring back to Ireland : " that Heroic Age which reserved its highest honour for the hero who had the most childlike heart, for the king who had the largest pity, and for the poet who visioned the truest image of beauty."

That, at any rate, was one of his ideals, and he set about implementing it by editing a bilingual paper, by founding and conducting a school, by leading a revolution. You may think, if you are a Belfast Unionist, that the ideal is as daft as anything that Dublin ever produced. You may have the horrors at any one of the three methods adopted. But any man can see for himself that that ideal is in a different and much more intellectual atmosphere than Edward Carson's devotion to the shade of bribery-and-corruption Castlereagh, than his speeches to the Ulster Volunteers. The poems of Yeats could come out of the same atmosphere as that ideal, but Randolph Churchill was content with an appalling quotation from " Hohenlinden " and John Redmond stopped at a schoolroom-acquired passage from the Swan of Avon. The difference in atmosphere may explain why only very

recently has there been a cultural awakening in the city of
Belfast. It makes the ideals of Pearse worth some considera-
tion, so that one can understand more clearly how they
impinged on the last stages of the Liberal attempt to solve
the Irish problem ; how they, too, failed and ended in the
compromise of misunderstanding, how they might possibly
help towards furnishing a solution for the problem of our
time.

Speaking once off the same platform as Joe Devlin, Pearse
said the young Ireland he spoke for would accept Home Rule
as the first step on the road to complete National independence.
Unionist speakers would have classed that speech as portion
of the evidence that, running under Redmondite Consti-
tutionalism, was a hot turbulent current of Separatism. They
would have been, so far, quite correct ; but the subsequent
assumption that the idea of an independent Irish nation
implied perpetual hostility to Britain was something that
neither Pearse, Clarke nor Connolly would have maintained
for five minutes. That idea did imply certain things : a political
and economic independence that would give the people of
Ireland the foundation on which to build an individual
nationality, distinct in culture, possibly distinct even in lan-
guage, from that of England. It did not admit the possibility
of the compromise suggested to amend Redmond's Home
Rule and to partition Ireland. To Pearse Ireland was, in
Keating's phrase, a little world in herself : " *domhan beag innti
féin* " ; and, into a unity so well-defined as that phrase
suggested, no thought of partition or of the legend of two
hostile nations should intrude. Between the visionary and
extremist ideas of Pearse and the moderate separatism of
Arthur Griffith there was a difference in degree ; but the more
moderate man believed also in that little world in herself, in
independence, in self-reliance. The name that he gave to that
idea was loosely applied to every aspect of the national
resurgence until even the young lads in the flying-columns
were known as " Sinn Feiners." The idea went through the
country like a flame ; even to-day the majority of younger
Irishmen, struggling painfully to a realisation of their own
claim to national integrity, find it hard to appreciate the

enthusiasm that made their fathers send representatives, not to London with John Redmond, but to Dublin to meet with other Irishmen to discuss the affairs of Ireland. That was the end of Redmond and the Party. It was the end, too, of the Parliament of Southern Ireland that later in 1921 met for one farcical meeting in Dublin. Four Unionist members attended ; and the Parliament then dissolved into air, dispersed by the will of people who wanted their own institutions. For the will of the people really was behind that vision of Ireland as a little world in herself. Against that background the minority who came to the Parliament of Southern Ireland, and that other minority who listened to King George open the Parliament of Northern Ireland, did not shine with any noticeable splendour. They had, as far as we know, no vision ; except a nostalgia for a dead day when a minority who lived in great houses ringed by tall walls dominated over the people of the country, or a nightmarish vision of a scarlet woman or hordes of murdering rebels. For some of them there might also have been the pleasing vision of packed purses and jingling pockets. For some the illogical idea of an empire made stronger by perpetuating the running sore known as the Irish problem.

Pearse taught his school, made his speeches, wrote his poems and plays and pamphlets. His school was a model of what his ideal Ireland should be : conscious of the rich past of poet and saint, legend and gospel, disciplined bardic verse, hero tales ; active and manly and clean in the present ; filled with hopes and plans for the future. Some Ulstermen, one of them a Protestant, helped him to bear the financial burden of an enterprise that opposed itself to the accepted systems much as his vision for Ireland opposed itself to the fashionable ideas of international political theorists. Three of his most valued teaching-colleagues were Ulstermen. Some of his most promising pupils came from Ulster. " Ulster," he wrote, " is supposed to be the ' dour ' province ; but my experience of Ulster boys and Ulster men is that they have more of the Celtic gaiety than the boys and men of any other part of Ireland, and also that their gaiety is more joyous and less mocking than the gaiety of the South. I speak of Celtic

Ulster—Donegal and the non-planted parts of the other counties."

He traced the origins of the idea of Separatism back to the twelfth century. He found it in the eighteenth century in Berkeley, Swift and Burke ; in the sixteenth century in the wars of Hugh O'Neill against Elizabeth. He found it, under the shadow of the French Revolution, in the writings of Theobald Wolfe Tone who had come very near to solving the Ulster problem almost a century before the visit of Randolph Churchill to Belfast. In Tone he found the idea of political unity : the Irish nation is one ; it has a right to freedom ; freedom denotes Separation and Sovereignty ; national freedom rests upon and guarantees personal freedom ; the object of freedom is the pursuit of the happiness of the nation and of the individuals who compose the nation ; and so on. In Davis he found the spiritual unity that was needed to give life to the French ideas of Tone. Davis " recognised that the thing which makes Ireland one is her history, that all her men and women are the heirs of a common past, a past full of spiritual, emotional and intellectual experiences, which knits them together indissolubly." Then in James Fintan Lalor,· whose ideas are at the beginning of the war that the people of Ireland were to fight for the undisturbed possession of the fields they tilled, he found the idea of The Sovereign People who owned the land not because of legislation made in London but because of " God's grant to Adam and his poor children for ever." " Let no man," Pearse wrote, " be mistaken as to who will be lord in Ireland when Ireland is free. The people will be lord and master."

That teaching was not designed exactly to set at ease the minds of Edward Carson and his followers. Pearse may have allowed his ideals to carry him miles above the streets and fields and factories, above the awful Dublin slums that—in spite of Mr. Beverley Baxter—were the most notable social legacy that the great Saxon builders of the city left to be handled by a native government. Mr. Séan O Faolain thinks, or thought, that Pearse was too busy writing about the poor old woman who symbolised Ireland to bother about the poor old women of those slums. The argument is unfair to Pearse,

and passes very lightly over some of the most notable passages
in his writing. Even from his study he saw that famine and
evictions meant that his people, the poor people, had known
agony. Edward Carson from the lawcourt or the Unionist
platform saw a few landlords killed by people that he called
rebels and murderers ; and as the defender of the system of
land-tenure he did not recognise any grant made to Adam
and his poor people. That was the real gulf between Pearse
and Carson. It will be bridged when the people, the whole
people of Ireland, know in one dazzling inspiration that when
God put men together on one island he meant them to work
together for the common benefit.

On one point Pearse and Carson were in agreement. Carson
said that if the Unionists of Ulster did not get what they
wanted peaceably they would take to the gun. Pearse approved
of that attitude. He wrote : " The Orangeman is ridiculous
in so far as he believes incredible things ; he is estimable in
so far as he is willing and able to fight in defence of what
he believes. It is foolish of an Orangeman to believe that his
personal liberty is threatened by Home Rule ; but, granting
that he believes that, it is not only in the highest degree
common sense but it is his clear duty to arm in defence of
his threatened liberty. Personally, I think the Orangeman
with a rifle a much less ridiculous figure than the Nationalist
without a rifle ; and the Orangeman who can fire a gun will
certainly count for more in the end than the Nationalist who
can do nothing cleverer than make a pun." Carson may
or may not have meant to fight. Certainly when
Pearse made the same claim for the majority of the Irish
people as Carson had made for the Orange minority, Carson
professed himself horrified at the traitorous attempt to attack
the Empire in the rear and at a very critical moment. For
Pearse and Casement were prepared genuinely to take to the
gun or to end up on the gallows. Pearse could not depend,
like Redmond, on the Liberal Party, nor, like Carson, on the
Conservative Party. He depended only on the Irish people
who had consistently over a long period of years wanted the
same thing. The people were not all armed, only a minority
were prepared to look revolution in the face. But that young

schoolmaster and the men who, with him, signed in 1916 the declaration of the Irish Republic knew that the first shot fired and the first man killed would give life to a desire that found very little satisfaction in parliamentary debates. And in spite of the thousand cynical and bitter things that were said then and since, those men were right.

(3)

The great mistake that Englishmen and Orangemen, and even nationally-minded Irishmen who did not approve of armed rebellion, have always made, was in supposing that armed rebellion was the essence of the whole business. According to that theory the 1916 Rising and the years of guerilla fighting that followed were wrapped up in the same parcel as the Phoenix Park murders or the vindictive assassinations of landlords—some of whom richly deserved assassination—that punctuated the latter half of the nineteenth century. A section of Unionist opinion in Belfast thought that an organised pogrom, involving sectarian-inspired raids on Catholic homes and the murder of women and children, was a poetic reprisal for a guerilla war that, if it included attacks from behind hedges, at least made certain that those attacks were on armed men. The man—whether from Belfast or Cork or Chelsea—who is capable of examining evidence and discounting atrocity-stories, such as the imaginings of Lord Alfred Douglas or some of the details recorded naively (we hope) in Colvin's volumes on Carson, will recognise that the *Sinn Féin* movement had no notable resemblance to the knifework of the Invincibles or the stone-throwing of Belfast rioters. Pearse talked of blood and a nation redeemed through the sacrifice of its sons. The talk was in the tradition of Tone and Emmet and John Mitchel, so much in the tradition of Irish Nationalism that even John Redmond had now and again to throw a bouquet to the memory of Tone. But what Pearse wanted was a free Ireland, shaping its own life through its own institutions, and if he had thought that Ireland could have become free in peaceable fashion he would not have preached the necessity of fighting. He wanted also a Gaelic

Ireland ; but many who venerate his memory still regard that as a counsel of perfection, to be treated with the friendly neglect reserved for counsels of perfection.

Anyway he was only one man in a varied and complicated movement that included poets and barmen, shop-keepers, labourers and labour-leaders, university professors, farmers, doctors, lawyers, young girls, housewifes, noble ladies, priests ; the whole Irish people except the Unionist minority, marching together to obtain by new methods an independence that went infinitely beyond Home Rule. If they had completely succeeded there would be no problem to-day.

The movement went under the name of *Sinn Féin*, but it went beyond and included many more things than Arthur Griffith had planned. Griffith's talented moderate mind had seen something almost ideal in the eighteenth-century institution inaccurately referred to as Grattan's Parliament ; but most young Irishmen of his time remembered that it was to rid Ireland of Grattan's Parliament that Wolfe Tone had plotted the bringing in of the French. Like most moderate men who associate with men who are more extreme Arthur Griffith was to experience the ironic contradiction of his position, when, at a table in Downing Street, he was offered more than he had ever desired only to realise that the offer mocked the aspirations of the men he represented. But he was always extremist enough to disapprove of John Redmond and Edward Carson in the British House of Commons pulling (as somebody said) at the coat-tails of the British Prime Minister to decide the fate of Ireland. He wrote of the " useless, degrading and demoralising policy " of the Parliamentarians ; and recommended as a remedy that the men elected for Irish constituencies in the British parliament should stay in Dublin and, literally, mind their own business. They did, after the general election of 1918 ; and this amazing application of the widely-publicised principle of self-determination, combined with the insult to the dignity of Westminster, produced the inevitable coercion, the raids and arrests, that, in their turn, produced armed resistance. No people in the whole history of the world stated more clearly its claim to nationhood and its deep desire to be left alone than the Irish people did when

men from every province came to Dublin for the first meeting of *Dáil Eireann*. But the traditional wooden-headed policy of imperialisers did not allow the magnanimous gesture that would have for ever solved the Irish problem. That policy demanded arrests and was amazed when men began to resist arrest. The dark spirit that comes to life now and again in the streets of Belfast demanded such reprisals as the murder of the MacMahon family, to protect the civil and religious liberty, won at the walls of Derry, from the Pope and the monster known as *Sinn Féin*. The man who gave the movement that name was by no means a monster. In a nation that has produced many good journalists he was the supreme journalist. He was friendly and witty and wrote brilliant parodies. He was also a notable political thinker ; and, when the person interested in political thought, or in thought of any type, turns from the platform at Craigavon to the poor house in a poor street where Arthur Griffith lived a life of remarkable self-sacrifice, he is shaken by the sudden change from the worst poverty of all, which is poverty of ideas, to a solid and genuine intellectual richness. That applies to most of the men who figured prominently in the movement. You may detest the whole business ; but, at least, there was about it a certain atmosphere of thought. It did not mean venerating the political corruption that had taken place a hundred years previously. It did not involve viewing through a fog of historical error the fall of James Stuart. *Sinn Féin* still appeals to all democratically-minded men because it drew together men and women of most amazingly different types. It smashed barriers and abolished taboos. In one thing only it failed ; it could not convince the men with the sashes that they stood in no immediate danger from the Pope, nor could it convince the Protestant business-man in Belfast that a Dublin government meant anything but red ruin.

(4)

The new departure of Nationalist Ireland had then the merit of variety, in men and in methods. James Connolly and James Larkin had very little in common with Arthur Griffith.

H

They had organised and agitated in Belfast, threatening the hold of Orangeism on the Protestant working-class by the effort to unite workers of all denominations who shared the common quality of being sweated and exploited in a city that had a malodorous reputation for social injustice. Larkin had led the 1913 resistance to the attempt of the Dublin employers to starve the poor into submission ; and in that battle had found common ground with many political revolutionaries, among them two of the most remarkable women in the Europe of that time. Now the whole foundation of Griffith's ideas was solid against the internationalism that ran through the labour movement. He made his protest against the injustice and oppression of the employers but he would not associate himself or the idea for which he stood with Larkin's activities because Sinn Féin was a " national not a sectional movement." James Connolly was more realistic, judging every political theory by the practical test of the standard of welfare given to the people ruled by that theory, knowing that a national movement would in the end be judged by the lot of the poorest class in society. In the shadow of Fintan Lalor, Pearse and Connolly came together, died together ; and the struggle to give Ireland political freedom and a native culture became also a struggle to clean out the pestilential slums that the conquering race had willed to Dublin, to provide a decent life for the poor. All those things were naturally not accomplished by the Easter Rising and the War of Independence ; but the ideas were there to enlighten and inspire. Those men had thought seriously about the problems of existence. They had thought seriously enough to prevent their ever being confused with oath-bound murderers or with men, maddened by injustice, battering a landlord to death with the butts of their guns.

A dozen different influences and men with scores of vital and varying ideas came together in that way. Neither Sir Horace Plunkett nor Father Tom Finlay nor " Æ " were remarkable for their propensity to shoot with blunderbusses through the hedges. But they, and all the men who were interested in the co-operative development of rural Ireland, contributed very definitely to the making of the new Ireland

in the new century. Men who could run a successful creamery, who could organise the farmers of a district until they realised the value of union and co-operation, could not easily be convinced that they were unable to run their own country through their own institutions. And there was little reason for the stoutest Belfast Unionist to imagine that a co-operative creamery was the thin end of the wedge of rebellion or of Vatican influence. Father Finlay, once lecturing on behalf of the Agricultural Organisation Society, found himself speaking to an audience of Orange farmers. The Jesuit knew he was in rather unusual surroundings but he told his listeners that there was no need for any misunderstanding. They were there to discuss a practical issue and the shadow of an ancient fight between a Dutchman and a Scotsman had nothing to do with the case.

On some such basis of understanding on a practical issue the unity of Ireland may some day be solidly established. Father Finlay did not live to see the day, nor did John Redmond nor Arthur Griffith. The desire for independence that had been in Ireland through the centuries grew stronger with the addition of every new idea for political or social improvement. The parliamentary debate had dragged to a boring standstill, the voices of the debaters drowned by the thunder of world-war. An amending clause that implied some form of exemption for some part of the province of Ulster hung vaguely in the air when the whole appearance of the debate was changed by the Easter Rising and the subsequent executions, by the meeting of a native Irish parliament in open defiance of all Imperial law, by the sudden rise of a group of young men that included prominently Eamon de Valera and Michael Collins.

<center>(5)</center>

The poets joined to lament the young men who died for liberty in the Spring of 1916 and their lamentations emphasised very well another difference between the movement led by Carson and the movement that had apparently ended in the burning ruins of the streets of Dublin. This new resurgent

Ireland—" rebellious " or " murderous " are adjectives that can
be substituted for ' resurgent ' to suit any point-of-view—
carried along with it a notable literary activity. There
was the research into the past, the collection of precious
and beautiful Gaelic things, that we associate with the
name of Douglas Hyde. There was the Irish Literary
Theatre, and the names of Yeats, Gregory, Martyn,
Colum, Synge in the centre of an intellectual and
creative activity that would have been remarkable in a city
six times the size of Dublin. The main personages in that
movement were not notable for rabid revolutionary ten-
dencies ; but all their activity was building up the atmosphere
of an independent and integral Ireland, thinking her own
thoughts, making her own plays and stories and poems,
digging deep into that field of precious Gaelic memories and
traditions. The young Yeats, living among the London
intellectuals and writing for American papers that valuable
series of essays and reviews known as *Letters to the New
Island*, was stating, with a dogmatism that would be too severe
for modern Irish literary men, the necessity of nationality in
the making of a literature. Yeats was not a Catholic. He
was not even the son of an evicted peasant. He lived to write
lines that were as hard as steel but he had never knifed a
landlord, never blunderbussed a member of the Royal Irish
Constabulary ; nor did he desire to diminish the profits of
the iron-founders and others who had made Belfast a great
city . . . for men who were rich enough to build ships or own
iron-foundries. But he had the sensitive receptive mind of
a genius that the whole world of letters was to learn to
respect ; and he found the material in which that genius was
to work not in the memory of Castlereagh but among the
people of Ireland. Nationalist Ireland has accused him of
inconsistency, has reproached him with his origin among
hard-riding country-gentlemen ; but he was a poet, not a
politician ; he was sternly, even arrogantly consistent to the
ideal " fascination of what's beautiful "; and when he was
stirred to write that remarkable salutation to terrible beauty
he found that beauty, not in the speeches of Edward Carson,
but in the gallantry of the young men who defied a great

Empire, because they genuinely believed and were ready to die for those beliefs. To his mind they were part of the thing that he had admired in O'Leary, the Fenian; part of the romantic Ireland that the long " delirium of the brave," Lord Edward Fitzgerald, Tone, Emmet, had died to save. They stood for the peasantry, the hard-riding foxhunters, the monks at prayer, the laughing porter-drinkers, the lords and ladies that, through the centuries, had fought proudly and in vain. They were " the indomitable Irishry "; and no man who reads the splendid poem in which Yeats advised the poets of the future to learn their trade could ever doubt again for five minutes that Ireland is a nation. Before the force of those hard lines the theories about two nations—hard-headed Presbyterians in the North and irresponsible Papists in the South —collapse into dusty fatuity. The statement is as definite as the four shores of Ireland.

But a poet . . . a crazy poet who saw fairies in his room and signs in the stars ? The iron-founders and ship-builders had precious little use for poets. Rebels were rebels; and Yeats writing about terrible beauty, James Stephens entreating the Spring to grow green on the graves of the young and eager men who had died, Colum crying out that the spirits of men and women who had died in torture and famine would rise to meet the brave soul of Roger Casement; all this had no effect on Unionist Belfast. It was rant, damned rebellious rant; or it simply did not penetrate as far as the Ulster Hall, until perhaps a stray reference to it cropped up in recent years in a book written by Mr. Hugh Shearman. For the literature of the Irish intellectual renaissance was not distributed free of charge to enlighten the ranks of the Ulster Volunteers. They had Randolph Churchill quoting *Hohenlinden* : a good, respectable, conservative poem, available in all school-readers. They had Kipling writing a poem whose historical squint provoked " Æ," a real Ulsterman, to write in an open letter the best existing criticism of Kipling : " You had the ear of the world and you poisoned it with bigotry and prejudice. You had the power of song and you have always used it on behalf of the strong against the weak."

Kipling wrote :

> " The dark eleventh hour
> Draws on, and sees us sold
> To every evil Power
> We fought against of old.
> Rebellion, rapine, hate,
> Oppression, wrong and greed
> Are loosed to rule our fate,
> By England's act and deed."

All that, apparently, was meant to describe the Pope and poor John Redmond crouching, each in his cave, like Pope and Pagan in the nightmare of John Bunyan, Pilgrim ; and we are left to wonder at the ingenuousness of the minds that could have taken it seriously.

William Watson wrote something that was both a better poem and a closer approach to sanity. His thesis was that " Ulster " had done a whole lot for England and that His Majesty's government now, with the basest ingratitude, threatened " Ulster " with the punishment of being forced to participate in an Irish government. It was not very sound history but like the bulk of Watson's work it was good readable verse :

> " Jeered at her loyalty, trod on her pride,
> Spurned her, repulsed her,
> Great-hearted Ulster ;
> Flung her aside."

That was the extent of the literature provoked by the Ulster Unionist resistance to Home Rule, if one excepts some articles in English Conservative papers, the speeches of Edward Carson, the text of Craig's Covenant. To-day, young Belfast, Protestant and Catholic, has come alive to the barbarity of it all and there is a possibility that the lute may some day be louder than the drum. In a Dublin café a young Belfast poet, a Protestant, a student at Queen's University and Trinity College, once talked to me of the harm that division had done not so much to the amount and value of literature

produced as to the effort to create a liberal, sympathetic reception for literature.

(6)

Pearse and Griffith ; Larkin and Connolly ; Douglas Hyde and the Gaelic League ; Michael Cusack and the footballers and hurlers of the Gaelic Athletic Association that General Parsons needed so badly for the fields of Flanders ; Tom Clarke the Fenian, MacDonagh and Plunkett ; Father Finlay, " Æ," and the other Plunkett, neither a poet nor a rebel, but a man who believed in creameries ; Yeats the poet and his new theatre ; Maud Gonne and Constance Markievicz who had ridden to harriers ; Eamon de Valera who lectured on mathematics until he found himself commanding a tattered garrison in a battered flour-mill as a prelude to leading a people ; Michael Collins who might have died a civil-servant : all these men and ideas mingled together in the burning crucible of revolution. Barriers were broken : women of the Ascendancy became goddesses to the people of the slums ; university professors and coal-heavers fought together and went to gaol together ; the first movement of armed workers in the world to swear by the accepted international principles went to fight under James Connolly for the integrity of one small nation.

In the centre of all this, and representing, perhaps, more aspects of the movement than any other single man, was Pearse and his vision of the noble house where the poor that were hungry would be filled, where the hero would have honour if he had the heart of a child, and the king would have honour if he had pity for little men who were not kings, where the poet would have honour who had seen the truest image of beauty. Our Ireland is only a sardonic comment on that vision ; for when all other barriers fell, one barrier remained ; a contradiction of the spirit that made for itself, by accident and compromise, a material symbol. To-day it is the greatest obstacle to the building and shaping of the noble house.

THE BITTER STREETS

" ' I've never been in Belfast,' said Bernard, ' but from all I hear of them the people there must be a hard bigoted lot.'
" ' No,' said McCall. ' They're mad and ignorant on politics and religion, but otherwise they're just the same as the rest of the Irish— a decent, kind-hearted, hospitable people. Of course their politics are absurd. I had to leave Belfast on that account. I was never more than six months in a job before they found out I was a Nationalist and gave me the sack. And the whole thing's just sheer downright ignorance. In their schools they never learn a word about their own country. They know they're Irish and not English just as they know they're male and not female, or *vice-versa*, but it's a matter of no importance. The only history they learn is English history and they think King William founded the Orange Order.' "—*Eimar O'Duffy in " The Wasted Island."*

(1)

A WILLIAMITE officer by the name of Bonnivert came from London to Belfast in the year 1690 with the escort that protected the two hundred and fifty thousand pounds to go in pay to the Williamite army. He found Belfast a large and pretty town. " All along the road you see an arm of the sea on your left, and on the right great high rocky mountains whose tops are often hidden by the clouds, and at the bottom a very pleasant wood. . . . The town is a seaport, there is in it the King's Customhouse, and you see hard by it a very long stone bridge, which is not yet finished. The town is compassed round about it with hills. The people very civil, and there is also a great house belonging to my Lord Donegall, Ld. Chichester, with very fine gardens and groves of ash trees. The inhabitants speak very good English."

Modern Belfast has come into existence since Bonnivert made his journey. The nineteenth-century industrial expansion

tumbled together streets, factories, parallel rows of houses
for workers, cranes and gaunt gantries to make the " large
town " of the latter seventeenth-century much larger, but to
detract considerably from its prettiness. Nothing less like
Dublin could be imagined : you miss the Georgian squares,
the long wide streets where colours mellow and concentrate
in the sun, the air of something planned at ease by men who
had money and culture, when labour was dirt-cheap. The
two largest cities in Ireland display the mind of the English
in two different moods.

And the people of Belfast are as·civil, Orange or Green, as
they were in 1690. The legend of the dour covenanting
north-east of Ireland has remarkably little basis ; and if there
is evidence of ill-feeling, of organisation to protect oneself
against the neighbour by tyrannising over him, the explana-
tion must be looked for in events much nearer to the present-
day than the wars of William of Orange. It is not so easy to
explain many things about Belfast. It is not easy to understand
why a city, whose citizens are by nature civil, should have an
unquestionably evil reputation for incivility.

(2)

One of the works on the nineteenth-century that will some
day give great entertainment to earnest historians will be
discovering by documentary evidence why the. Protestants
of Ulster had, by the time of Gladstone's First Home Rule
Bill, abandoned altogether even any slight tendency to
Liberalism in politics.* The explanation is so much tangled
up with atmosphere, with certain atavistic terrors, that it is
almost impossible to put it down completely and coherently
on paper. Back in those dark midnight raidings and inglorious
brawls, in which the Orange Order had its eighteenth-century
origin, there was a notable flavour of purely sectarian bitter-
ness. That was much less remarkable then than now ; Europe
had for almost two centuries been rancid with the same black
bitterness, concentrated in Geneva, concentrated again in

* See Footnote to p. 38.

Scotland and exported from that country into the northern portion of Ireland. Certain economic reasons may have added to it there; for some Protestants, organised against the abuses of the eighteenth-century system of land-tenure, could proclaim with almost equal, venom against landlords and against papists. The Catholics who, under the system, were not even presumed to live, were often willing to pay higher rents to landlords than Presbyterians would pay, because a Catholic had much less chance of attaining anything even remotely resembling a fair-rent. Whatever the cause was, the bad feeling was there, exploding in undignified and dangerous brawls. John Mitchel, an Ulster Presbyterian, claimed in his History of Ireland that the " Orangemen " were always the aggressors. Then the French Revolution cracked most of the existing European systems from top to bottom and the alliance of the Presbyterian and Republican ideas led to something like a minor revolution in Belfast and the surrounding counties. It failed; and the reaction set in, not against the English power that had crushed the revolution but against the Catholic majority that had been very ready in a few places to take part in it. That was peculiar. One of the reasons was that the Wexford rebellion revived the ghost of the 1641 rebellion, always regarded by Irish Protestants as a sort of Irish Massacre of Saint Bartholomew. In reality it was nothing of the sort, but then reality has never had much to do with popular prejudices of that sort, not even with the popular prejudice about the Massacre of Saint Bartholomew. Including that detail there was, perhaps, the general realisation that if Ireland really did accept Republican ideas, and if the people of Ireland could successfully introduce Republican institutions, the position of a privileged minority would be gone for ever. That realisation was made all the more clear by the agitation for and the successful gaining of Catholic Emancipation. It does seem illogical that a minority that spoke so frequently of civil and religious liberty should consider itself in peril unless the majority in the same country enjoyed neither one nor the other; but that literally was the position. Today the same dread shapes the policy of the Stormont government towards the Catholic

minority under its control, towards the rest of Ireland. That fear was very powerful in strengthening the resistance of North-East Ulster to the establishment of one independent government for a united Ireland. A few Unionists may genuinely have considered that the maintenance of Castlereagh's Union was the best possible Irish policy for the British Empire. That was what they said. But the average Ulster Protestant was more moved by the idea that if the Irish people were allowed to rule Ireland in the way the majority of the Irish people wanted, then all the Protestants would promptly be murdered in their beds. Twenty years of native government in the greater part of the country has left the Protestants—with the exception of those who died from natural causes—hale and hearty and enjoying their night's sleep. A clause in the Constitution of that portion of the country specifically protects their rights. Dignitaries of the Protestant churches have testified to the consideration shown by the Dublin government for religious minorities ; just as a worldwide proclamation by Jews resident in that area defended the government against the charge of anti-Semitism. If we accept an unbalanced little booklet by a professor in Trinity College and an obscure and incoherent wail from some Orange Lodges in County Donegal—whose own organised existence testified to the falsity of their complaints— the majority has something to be proud of. It has advanced from degrading slavery to the position that rightfully belongs to it by democratic principles, and it has shared its new liberty with the minority.

But the fear remains in one small part of the country, in the six north-eastern counties, in the bitter streets of Belfast. Men have been murdered in bed there, and they have not been Unionists or Protestants. The dark spirit that went the roads of Armagh in the end of the eighteenth-century lives there ; and the amazing thing is that the men who hunt other men from the occupations on which their livelihood depends, who beat drums and burn houses and fling paving-stones, are the civilest people on the face of God's earth.

(3)

No man was more strongly influenced by the fear of the majority coming into its kingdom than the Presbyterian, Dr. Henry Cooke. More than any other individual he helped to build that notable nineteenth-century ultra-conservatism into the political life of Belfast ; persuading the Presbyterians, in the years following the passing of Catholic Emancipation, that for purposes of self-preservation they should join their cause to English Conservative politics. In the early years of the second half of that century Belfast began to make a name for itself. The reason behind the rioting was partly economic, partly politico-sectarian. Belfast, at no time, had a particularly good reputation as far as fair treatment of workers was concerned. A political organisation that had very little respect for the Pope would not be familiar with the social encyclicals that had come from the Chair of Peter at intervals during the last century. That same organisation had very little affection for Connolly and Larkin who, while not exactly briefed by the Pope, had tried to break down politico-sectarian barriers in a struggle for workers' rights. Now it was childishly easy to convince the Protestant working-class that the real cause of poverty, unemployment, slump, hard times, was the presence in Belfast of Catholic workers who were willing to take jobs. Right up to the present-day that motive had been operative ; it has, in fact, been emphasised, since the establishment of a special government for the North-East corner, by a theory put forward from public platforms by responsible men, that that corner is now the preserve of Protestantism. That may be good politics on the part of the Stormont government. It is not democracy. It is not even one of the many ways of keeping the peace.

When peace was re-established, and all the bricks were thrown, back in the July of 1857 the Lord Lieutenant of Ireland set up a Committee of Inquiry to find out what the rumpus had been about. The Report issued by that Committee said their investigations had shown that trouble in Belfast around the twelfth day of July was not exceptional. Outrages " arose with greater violence this year than in former years ;

and in this year more solemnly and with greater pomp than in former years the festival of July was celebrated. The celebration of that festival by the Orange Party in Belfast is plainly and unmistakably the originating cause of these riots. The Orange system seems to us now to have no other practical result than as a means of keeping up the Orange festivals and celebrating them, leading as they do to violence, outrages, religious animosities, hatred between classes, and too often bloodshed and loss of life."

Seven years later they were at it again. In Dublin, the grateful majority of the nation were building a monument to honour the name of O'Connell. In Belfast, Protestant workmen in the shipyards on Queen's Island hunted Catholic workmen from their employment. There was another Committee of Inquiry which discovered that the Belfast police, even if they had not actually taken the side of the attackers in the conflict, would have, at any rate, been utterly unable to restore peace. A new regulation stated that one of the two resident magistrates must be a Catholic ; and the Royal Irish Constabulary replaced the local police. But no regulation could give permanent peace to the streets of that town, which in 1872 saw the beginning of a pogrom that was rendered abortive by speedy and efficient action on the part of the law, and in 1886 saw the first of the three great disastrous disturbances.

(4)

Lord Randolph Churchill came in February of that year to give his blessing to the Unionists of Ulster and to enlist their aid for the Conservative Party, to quote *Hohenlinden* and to exhort the chivalry of Ulster to wave all its banners ; to write later that Ulster would fight and Ulster would be right. Ulster did fight, but there was nothing very chivalrous about the battles, nothing that any honest man of Ulster could look back to with the pride that men have in the great deeds of their ancestors.

The average Unionist account of the chivalric jousting in 1886 would possibly claim that the whole trouble began when

a Catholic workman in the course of an argument on religion
laid his spade across the head of a Protestant workman.
The controversial couple belonged to a gang of 180 navvies
engaged on excavation work at the Alexandra Dock, and a
Unionist writer like Colvin would lay emphasis on the fact
that most of the men in that gang were Catholics, that when
the injured theologian went for help to the Protestant riveters
of the Queen's Island Dockyard he was merely following
the natural course of action that a man would follow on
finding himself hopelessly outnumbered. But what happened
afterwards was too appalling, and similarly horrible things
have happened too often in Belfast, for anyone nowadays
to attribute much significance to those forgotten workmen
and their forgotten quarrel. It is undeniable, even proverbial,
that very unimportant incidents can have momentous after-
maths, yet, when a quarrel between two workmen can provoke
months of terror, it is obvious that the background for terror
had been already prepared by years of sullen bigotry, by
the sudden heat of organised agitation.

Some time ago a Belfast Protestant clergyman was main-
taining in a Dublin literary periodical the theory that pogroms
—he objected to the word—were always provoked by violent
Catholics who made ferocious attacks on harmless and orderly
processions. When Belfast went mad in 1886, after the defeat
of Gladstone's First Home Rule Bill, there were roughly
208,000 people in the city and 59,000 of these were Catholics,
which meant Nationalists. The Nationalist cause had just
been defeated, and defeated men do not make attacks when
they are in a hopeless minority.

On Friday, 4th June, 1886, the Islandmen invaded the
Alexandra Dock, took the Catholic workers by surprise
assault, bombarded them with iron nuts and rivets. The
Catholics fled; some of them leaped into the river Lagan
and attempted to escape by swimming, some of them put
out on a raft, others on pieces of floating wood. From
the shore the Islandmen continued the murderous bombard-
ment. One young Catholic navvy, a lad of seventeen named
Curran, was battered into the watery mud and drowned.
Almost ten thousand mourners marched behind his coffin

through the Catholic Falls Road district to Milltown cemetery and on the sloping ground that is now the site of Dunville Park the cortege was attacked, horse police rode in with long staves, foot police charged with batons, somebody used a gun as a sign that Belfast rioting was beginning to wake up to the possibilities of mechanised militarism as distinct from the hand-thrown missile.

These pages lack the space to follow the awful days in detail : how the incited mob besieged a police barracks on the Shankhill Road, how seven of the besiegers were shot dead, how down through the June, July and August of that year the disturbances continued, how the houses of Catholics were burned and looted. A special order from John Morley, then Chief Secretary, overruled the local authorities who had discouraged rather than supported the police ; and by mid-June there were 5,000 men in Belfast, police and soldiers, to keep the rioters quiet. That order from the chief secretary came in answer to a Catholic appeal for protection, and it is not customary for the aggressors in a riot to ask for more police to keep the rioters quiet. The general attitude of the local borough magistrates was that the police who patrolled the Protestant Shankhill area should be replaced by special constables, chosen locally ; and against this the Catholic population repeatedly protested to higher government authority. They did not trust special constables chosen locally ; and every withdrawal of police from the Shankhill area was a signal for a renewal of the appalling disturbances.

Afterwards, there was the usual Commission of Inquiry, monotonously investigating why the riots had happened, monotonously bringing to light the same causes : the incitement by Orange publicists and public-speakers, the deliberate whetting of anti-Catholic feeling, the rigid exclusion of Catholics from the public life of Belfast, the secret organisation uniting and inciting the Islandmen who acted as Protestant shock-troops in almost every disturbance ; the disturbing influence of the Orange Society. Not that the Catholics were completely blameless, but they certainly were not the aggressors and in life and property they suffered almost all

the losses. Their spokesman before the Commission said that they would come into conflict with authority only under exceptional circumstances and, even then, only the very rowdiest elements of the Catholic population would be, in any way, troublesome.

That was what the defeat of Gladstone's First Home Rule Bill and the visit of knight-errant Randolph Churchill meant to the people of Belfast; the chivalry from the shipyards went jousting with iron bars and paving stones. The causes were investigated and discovered and Belfast was quiet until the next time. The politicians who profited by the actions of the Islandmen and their Shankhill dupes had little intention of doing anything to remove those causes. Ulster's resistance to Home Rule, or at least the resistance of a section of Ulster, gave reason for denying to the Irish people what the majority of the Irish people obviously wanted. At the heart of that resistance was this onrush of plain, rough men made into fanatics by organised incitement, the hail of stones and lumps of iron, the looted houses, the burnings, the shootings, the lives lost; an organised gangsterdom that would have made Lepke, Diamond and Capone look like boys from preparatory-school. For when the Orange mobs moved, even Tim Healy, who was so fond of complimenting his opponents and insulting his friends, said that they moved at a signal. They moved like a black cavalcade through the story of Belfast, ending the nineteenth century of liberal principles and enlightenment by two serious disturbances in ten years: in 1893 when the Second Home Rule Bill was defeated; and again in 1898. A hundred years previously the great transcendent ideas of liberty and equality, that were actually somewhere in the confusion of the French Revolution, had burst into the bitter streets of Belfast. Presbyterian and Papist had died together for one ideal and with one simple vision of a free nation that could inspire its children to work together for the common good and in which the people would own, at least, the right to live like human beings.

(5)

Tim Healy complimented Carson on his ability in keeping
his followers under control, in providing for them a safety-
valve in the disciplined exercises of the Ulster Volunteer
Force. The safety-valve had not been fitted by the July of
1912, despite Carson's protest against " spasmodic and
sporadic rows which could lead to no result of any kind
except disaster to the various parties concerned," and down
along the Lagan where the ships were made the fun was on
again. Ian Colvin in his official biography of Carson is not
quite certain how it began, beyond a timid suggestion that
it was the result of incitement by Catholics, and he admits
that the only definite record tells how Catholic workmen
were assaulted, kicked, beaten, assailed by showers of the
iron missiles euphemistically called " Belfast confetti " or
" Queen's Island confetti." The ship-builders, Harland and
Wolff, closed their yards " in view of the brutal assaults
on individual workmen and the intimidation of others." In
the House of Commons Joe Devlin reminded Carson that,
if rather than submit to Home Rule he was prepared to break
the law, his place was in Belfast throwing rivets ; and Carson
told Joe Devlin that he was glad to find him at last on the
side of law and order after all the years he had spent en-
couraging boycotting and intimidation in other parts of
Ireland. For those disturbances Carson was prepared to
put certain reasons before the members of the House : the
policy of Home Rule had aroused feelings of deep passion,
had revived historic memories. Devlin could have given
more definite and tangible reasons for the boycotting and
intimidations that he was accused of favouring : the awful
conditions under which the people of Ireland had existed
on the land, the rack-renting, the evictions, the consequent
poverty and hardship. If the worst of those evils had been
remedied under the Union the credit was not due to the
Union but to the men who organised the people, who were
prepared to break laws and go to gaol because those laws
had not been made for the benefit of the people.

In the September of 1912 the really serious rioting of that
I

year began at a Celtic-Linfield match in Celtic Park, flared
up in a brief hectic battle and was eventually suppressed.
After that, we are told, the elevating influence of the Covenant
began to take effect, and the discipline of the Ulster Volunteer
force used up the energy of the rivet-slingers in marching,
drilling, and riding with dispatches. Some cynics were not
completely convinced by that discipline, among them, as we
have seen, the shrewd and experienced General Macready,
who was not a Sinn Feiner. The remarkable Mr. Bonar
Law was, in that same year of 1912, telling the world, at
Blenheim, that he could imagine no length of resistance to
which the Unionists of Ulster might go in which he and the
overwhelming majority of the English people would not
be ready to support them. Now how was a simple-minded
rivet-slinger to know that that offer of support did not extend
to the activities with which he brightened up his leisure
hours? Bonar Law may have been zealous in the support of
law and order but when he talked fire from the public platform
he could only expect to be taken at his word. That evident
connection between the wild words of leaders and the wild
deeds of very subordinate subordinates has always been a
feature of riots in Belfast. Carson, for instance, told his
supporters in Newry that the action he might be forced to
take in resisting Home Rule would be illegal. " Drilling is
illegal . . . the Volunteers are illegal and the Government
know they are illegal, and the Government dare not interfere
with them. . . . Don't be afraid of illegalities." That was
not the best possible foundation for discipline and order ;
and, according to a British Intelligence Officer,* that discipline
and order constituted an attempt to get control of the hooligan
classes. In Derry City, according to his account, all militant
Unionists, young and old, went carrying revolvers, and on
the twelfth of August a crowd of Orangemen went from
Belfast to Derry on a special train. On the way they cheerfully
fired off their revolvers at the passing countryside. In Derry
they created a riot.

All that offers a pleasant contrast with the behaviour of

* C. J. C. Street (" I.O. "), *The Administration of Ireland*, 1920.

John Redmond who, in a desperate anxiety to keep the peace, moved heaven and earth to prevent the Derry members of the Irish Volunteers, on another occasion, from marching in a quite inoffensive parade. The contrast provides, possibly, one of the reasons' why John Redmond was defeated.

(6)

Before the second great pogrom broke out John Redmond was dead and the whole of Ireland was up in armed revolution against British rule. The story of that revolution is not our immediate concern but it is well to remember some features that offer contrasts with what happened in Belfast between 1920 and 1922. The Irish revolution did not begin in an attack upon labourers in a shipyard but in an orderly meeting in a public building of the elected representatives of the people. The measures of physical force that were eventually resorted to were not a primary part of the revolution, were something that the Irish people would have been very glad to do without. The only party in the business that went into battle with the evident appreciation and relish of the Belfast rioters would have been the members of the force known as *Black-And-Tans ;* and the aforementioned biographer of Carson never even seems to have heard of them. The very fact of that revolution being in progress set Carson on the platform at Finaghy on the twelfth of July, 1920, to tell His Majesty's Government that if nothing was done to keep *Sinn Fein* out of Ulster, then Ulster would arm in her own defence ; and for two appalling years Carson's followers defended Belfast for law and order and good government. Two hundred Catholic men and women were killed in the course of that defence ; hundreds were injured, crippled, maimed ; about 30,000 people in Belfast were left homeless and destitute ; hundreds of houses were burnt ; shops were looted ; about 100 Protestants lost their lives. The fabled ravages of *Sinn Féin* could not even be associated with anything remotely resembling that enormity ; and in all Ireland outside Belfast it could only be hinted at by what happened in Cork City when the *Black-And-Tans* had an incendiary night-out.

In May, 1920, Dawson Bates had written a letter to Carson mentioning the threat implied by existing unrest in Belfast. As a protective measure against possible rioting, Bates proposed that the old Ulster Volunteer Force be restored with legally-approved power to use rifles ; and the ingenuousness of that proposal can only be appreciated by considering that the Catholics of Belfast had always suffered most in riots, that anti-Catholic feeling was inflamed by the guerilla warfare going on all over Ireland between Nationalist (mostly Catholic) Irishmen and the Crown forces, that the arming of a new Ulster Volunteer Force meant actually the arming of those Protestants who could be relied on as enemies of all nationalist ideas. The real meaning behind the proposal of Mr. Dawson Bates was that he, as well as Carson, was saying that the Orangemen of Ulster would do everything they could do to squash *Sinn Fein* in the territories under their control. The reasons given for the actual outbreak were the shootings of District-Inspector Swanzy in Lisburn and of Colonel Smythe in Cork ; and it is quite true that after the first, the mob burned the houses of Lisburn people who had patently nothing to do with the shooting but who happened to be Catholics ; and when Smythe was buried in Banbridge his funeral was the signal for concerted attacks on the houses of Catholics who were certainly not in Cork when Smythe was killed. In the shipyards and factories of Belfast men were driven from their jobs ; driven afterwards from their homes, forced to sign declarations stating that they had nothing to do with and no sympathy with the aims of *Sinn Fein*. Those shootings, burnings and banishments had commenced in Belfast and Derry a month before the shooting of Swanzy ; and there would be no possibility of convincing a sane and unprejudiced man that the ghastly pogrom was merely an outburst of loyal and violent zeal, enraged into action by the murder of two public servants. It was the customary reaction of Orangeism in Ulster to the expression of Irish nationalist feeling. All over Ireland Nationalism had been crushed underground, driven to depend on the gun, the flying column, on guerilla war ; but that war was made on men in arms. The Belfast reaction

against *Sinn Fein* was by no means so particular. It did not confine itself to taking reprisals on armed members of the Irish Republican Army. Catholics as such were the object of its activities even though they might belong to the British army ; for instance, it drove from his home in Belfast a man called Michael Cunningham who with his two sons had served in the European war, who had suffered from wounds and gas. They were Catholics, and that was the only distinguishing mark that the speakers from public platforms had taught the Belfast roughs to recognise. (Twenty-four years later the Orange spirit still had little consideration for the wounds of a war-hero : refusing to Gerald Cassidy, an ex-service man who had lost a leg in the North African campaign, a post for which he was the most suitable applicant. No particular penetration is needed to guess the man's religion.)

The proposal of Mr. Dawson Bates was taken up when Sir Henry Wilson commenced the organisation of a force of special police whose labours rather added-to than diminished the day-to-day list of atrocity. In the House of Commons Joe Devlin was driven to protest against their " barbarities." The Republican Army boycotted Belfast to the material detriment of the city's industrial and commercial life. James Craig and Michael Collins made an agreement that the pogrom and boycott should cease simultaneously. The boycott relaxed and the pogrom continued. In the August of 1920 only Protestants remained in the Belfast shipyards, five thousand Catholics had been driven out, the damage done to property in the city had been valued at half-a-million pounds. Hugh Martin, correspondent for the *Daily News*, said : " There can be no doubt that it was a deliberate and organised attempt, not by any means the first in history, to drive the Catholic Irish out of North-East Ulster, and the machinery that was being used was very largely the machinery of the Carsonite Army of 1914." That was what Mr. Dawson Bates had suggested and what Sir James Craig later approved of, when he spoke at a flag-unfurling ceremony in the shipyards to tell the men that he approved of the gallant action they had taken in the past.

All through the months that saw the truce between *Sinn*

Féin and the British government, the conference in London, the Anglo-Irish Treaty, the historic Treaty debate in Earlsfort Terrace in Dublin, the disagreement and the civil war, the rioting continued in North-East Ulster. That was, apparently, the only contribution that Belfast Unionism had to offer to the settlement of the Irish problem. It is tempting to follow the story of those months in detail, picking from the newspapers of the period and from the innumerable books that have already detailed that story. But that approach, besides running into volumes, would serve no good purpose and would provide neither instruction nor entertainment for readers who have had the newspapers of the last five years, innumerable paper-backed novels whose authors have sentimentally persisted in making the hero commit one or two cold-blooded murders, Hollywood films about Middle-West villages with a high percentage of paranoiacs. The world has grown so accustomed to the idea of outrage. Yet the story of the past of the bitter streets has considerable bearing on the future of Ireland.

(7)

The streets have been reasonably quiet now for the best part of ten years ; the 1935 outbreak being the culmination of a period of rioting that began when the bad times that followed the economic slump in 1929 seemed to be making towards a union of Protestant and Catholic in one common fight for the right to a livelihood. The troubles in Belfast have never been without their economic implications and it is especially interesting to consider what was happening there in 1930 and 1931, then to consider in that light some of the reasons given for the outbreak of rioting. For the streets of Belfast that had seen so many processions saw, under the shadow of the great misery that came on the world's industrial cities in the early nineteen-thirties, Catholic and Protestant workers march together, carrying not the banners of the Boyne but less colourful banners inscribed with the words : " We Want Bread."

" Sometimes their meetings were broken up by police

batons, and at one of them Captain White, son of General White of Ladysmith, was arrested. At the Police Court, head bandaged with a bloody rag, he figured in a violent scene when he tried to make a demonstration on behalf of the starving unemployed of the city. In a few days the great white Parliament Building at Stormont was to be opened by the Prince of Wales. The House of Commons met temporarily in the meantime at the City Hall. There a Labour M.P. seized the golden mace and hurled it at Lord Craigavon's feet when he was refused permission to raise the question of the plight of the starving people."*

That was in 1932. Within three years the union of the poor, the hungry, the unemployed, was broken; the Orange processions were again drumming along the streets; guns and bombs had taken the place of the old nineteenth-century rivets and cobblestones. Through those same streets a gun-carriage went with the coffin that held the remains of Lord Carson of Duncairn, watched with no great interest by men and women whose relatives had died like cattle on the Somme in 1916. But the men who had succeeded Carson could watch the pomp of his passing with a certain amount of shamefaced triumph, for they had made their protest against the alliance of the Catholic and Protestant poor that had three years before threatened their own political stability.

The protest was made in the usual manner, developed in the traditional way from the traditional beginnings, was inspired by the same inciting speeches that identified rebels with Papists, and Protestants with loyalists, that did not trouble to define the term loyalist or to say what exactly the rebels were supposed to be rebelling against. No writing about the six north-eastern counties is quite complete without a few snippets from speeches of that nature. For some reason or other the quotation of them is supposed to indicate that the person quoting is violently, and in the most partisan spirit possible, propagandizing for Eamon de Valera and the Pope of Rome. On almost every other subject a writer is allowed to quote fairly from docu-

* *Journalist's Diary*, by James J. Kelly (*Capuchin Annual*, Dublin, 1944).

mentary evidence without having his motives suspected and
his chances of appealing to both sides utterly ruined. But
there is a *naïveté* about the official Orange mind that considers
any use of the documentary evidence provided by itself as
inevitably hostile to itself. The last few years have provided,
for the philosophic mind that takes delight in contemplating
the fooleries and contradictions of mankind, the spectacle
of the Stormont government banning a certain publication
that consisted almost entirely of a statement of actual facts
and quotation of genuine documents. One leading statesman
leaped to his feet to protest against what he called the general
falsity of a publication which included several excerpts from
his own speeches. He declared then, that, at any rate, he
stood by every word he had said, by every word of his quoted
in the publication and he didn't care who knew it.

Of what use can discussion or reasonability be against the
blank solidity of a mind such as that man must possess, or
against the mind of the speaker, at a Protestant meeting
in the Ulster Hall, who, when speaking of the burden that
the 1935 pogrom had thrown on the ratepayer, said : " If
it cost a million a week to get rid of the Fenians it would
be worth it." When he said " Fenian " he meant " Catholic "
and did not, let us all hope, refer either to the great magic
adventures of Finn MacCool or to the more recent, but still
historic, adventures of James Stephens. Then there is the
interesting case of Sir Basil Brooke, who has long ago outshone
the familiarity with boycott with which Carson parried Joe
Devlin, and who could say in 1934 : " Many in the audience
employ Catholics but I have not one about my place. Catholics
are out to destroy Ulster with all their might and power " ;
and in 1935 : " It has been said that I was mainly responsible
through speeches for the recent riots, but I strongly deny
that I have ever attacked any man because of his religion."

Between the making of the two speeches that contained
those two passages the boys had been at it again. Twelve
people were killed. Orange apologists point out that the
majority of these, four out of seven, were not Catholics
but against this contention the author of the banned booklet
Orange Terror has some interesting suggestions to make. He

points out that there is no evidence to show that the deaths of the seven non-Catholics were caused by Catholics ; that " six of the seven were killed in the open, when rioting was in progress, with no evidence to show their killing was deliberate," not one of the six was killed in his own home or even in the street in which he lived; that " with regard to the seventh there is good reason for believing he was killed by non-Catholics because he spent a great amount of his leisure time with Catholics and showed sympathy with them." By way of contrast, apart from the three Catholics who were killed, there were twelve attempted murders of Catholics, in five instances when the victims were actually in their own homes. " One of the Catholics killed was set upon by a crowd of about fifty men as he was passing a corner with a lady, and so beaten that he died in hospital after three weeks of suffering."

Fifty people were wounded, more than two thousand Catholic people expelled from their homes, more than nineteen thousand pounds awarded as compensation for damages to property. Ninety-five per cent. of those who claimed damages were Catholics, a proportion of the other five per cent the Protestant landlords of Catholic tenants. The speeches had not made it obvious as to where a man's religion ended and his politics began, or whether the mere fact of a man being a Catholic was enough to justify criminal assault on his person or property, or whether guns or bombs were, at any rate, the weapons that civilised Irishmen should use against men who disagreed with them on the question of the future of Ireland and the promotion of good relations between Ireland and England.

The customary Inquiry did not follow the pogrom that came thus to an awful climax in 1935. It was asked for and agitated for, but because of the English pose of letting Stormont mind its own business, because of the reaction of certain radical English politicians towards the Catholic view on the struggle in Spain, even because of certain entanglements in the life of Catholic England, the Commission of Inquiry never came into being. The British Council For

Civil Liberties did issue a statement ably covering much
that was of importance in that period, and the report of the
Commission appointed by that Council should be read by
all men intrigued by the problem of Belfast and its bitter
streets.

It is all very wearisome and very perplexing : this parade
of riots and speeches and speeches and riots going back
beyond the making of the Border, beyond the long three-
tiered debate on the question of Home Rule, back to the
agrarian disturbances of the eighteenth century and the
gangs running in the night to burn houses and evict or murder
the people who lived in the houses. No country could be
proud of that chapter in its history. No movement should
be proud of that black undercurrent to its aspirations and
ideals. No citizens could congratulate themselves on the
uncouth, vicious thing that comes to life at intervals to burn
and kill and destroy. The remedy is in the power of the
young people of Belfast ; and there are signs that a minority
of those young people, Catholic and Protestant, are realising
their responsibility and their power. If you know the people
of those noisy, humpy streets, between the high cloud-
covered mountains and the flat arm of the sea, you will feel
among them the movement of ideas, new ideas, generous
ideas, constructive ideas ; as energetic as the inspiration
that built the factories, deepened the river, marked the black
water with the shadows of tall cranes and leaning gantries.
But these new ideas are more humane, more interested in
the things of the spirit that the big men of Belfast never seem
to have appreciated very well. Somewhere among them
may be the inspiration that will end forever the bitter legend.
Maybe, too, the last five years of cosmopolitanism may make
the air of Belfast a little more lenient to democratic lungs
that can settle differences by reasonable argument and without
the assistance of the Islandmen. For the whole world has
suffered and the whole world needs peace ; and the spirit
in the hearts of the young, and the spirit that is above and
around the souls of men, cries out for peace, for the burying
and forgetting of ancient differences.

CHAPTER IX

THE BORDER

" One of the greatest tragedies of Ireland is this—for some reason, some unaccountable reason—mind you I am not touching on politics or religion—but when football was getting some hold on the masses in the South of Ireland the ban was put on the game. If football had been allowed to spread, we in Ireland would not be a divided nation to-day."—*Sir Dawson Bates, Six-County Minister of Home Affairs, speaking at an Association Football Club Dinner in* 1936.

" We do not intend to have Lloyd George put a little red spot on the map of one corner of Ireland and call it part of England, as he does Gibraltar. We want a united Ireland. We have always said that Ulster would be given every guarantee."—*Michael Collins in* 1921.

(1)

POSSIBLY the first man to mention it in public parliamentary debate was a young Cornishman, a popular Liberal politician, Mr. Agar-Robartes. The party to which he belonged had, under the shadow of Gladstone, put forward a scheme of Home Rule as the solution for the ancient, annoying problem of what to do with the Irish. The majority of the Irish seemed to want the thing. A minority not only did not want it, but was very loudly saying that rather than accept Home Rule it would face red rebellion and civil war. Mr. Agar-Robartes and everybody else had a suspicion that the minority was so protestingly and outrageously violent because it depended on the support of very powerful elements in English political life. But there you were. That was the problem. The spirit of Gladstone could not be laid at rest without trouble, possibly in the north of Ireland, almost certainly in the House of Commons.

The protesting minority was strongly concentrated

geographically ; and the mind of the young Liberal politician saw a sensible and obvious solution in that accidental positioning. Draw a line. Give Home Rule to the people South of the line and West of the line. Let the minority in the North-East remain directly under the Imperial Parliament. The protest of that minority is based on some obscure and complicated argument where religion and politics intertwine confusedly, going backwards to drag in the wars of Rory O'Moore and Owen Roe O'Neill, the fall of James and the rise of William, the agrarian outrages and the faction-fights of the eighteenth century, the rebellion of 1798, and a dozen other things that no sensible twentieth-century politician can bother about. If the Irish must distinguish between Protestant and Catholic then draw a roughly-accurate line between the two denominations and let us have Peace In Our Time.

So on the eleventh day of June, 1912, Mr. Agar-Robartes stood up in the House of Commons and proposed an amendment to the Home Rule Bill. The four north-eastern counties of Antrim, Down, Armagh and Derry contained Protestant majorities and should on that account be excluded from the operation of the bill. There was nothing to convince Mr. Agar-Robartes that he was not solving but creating a problem.

Obviously the idea was not very original, so lacking in the individual thing that marks a great idea that there is now very little possibility of dating and attributing the first actual reference to the partition of Ireland. In spite of the amazing efforts to make Partition respectable by grafting it on to the wars of the great Gaelic heroic tales every man with a glimmer of sense knows that the idea could have had no existence previous to the debate on and the riots about the first Home Rule Bill. It was an outlawed and outcast idea, with no friends in either camp. To the Irish Nationalist it was a complete and definite denial of Ireland's claim to separate nationhood, an insult to the sentiment or the vision that saw the people of Ireland united and at peace, living on one island, surrounded by clear-cut coasts and the sea. To Unionists and Orangemen it was equally unacceptable. The Orange Grand Master in Belfast in 1893 was the Rev. R. R.

Kane. He considered that any man who talked of separate treatment for Ulster would be at home only in a lunatic asylum. The reason behind that statement was not nationalist sentiment, for the reverend Grand Master was only being solicitous for the Protestant minority in the South cut off from their co-religionists in the North nor, to do him justice, could he see why the Catholics of the South should be willing to abandon the Catholics of Ulster. The opinion of the famous William Johnston of Ballykilbeg would pass in any Orange Lodge as completely free from papistical leanings. That remarkable man, who offers such amazing comparisons and contrasts with Armour of Ballymoney, wrote_: " No man who would at any time support a half Union or be a party to the desertion of Irish loyalists outside Ulster would come back after a General Election as an M.P. for any Ulster constituency. . . . Disastrous effects would be produced if loyalists outside Ulster ever dreamt that they would be victims of that great betrayal. Let them be assured Ulster will take care of them. Lundy of Londonderry is dead. For him in politics there is no resurrection."

Logically Mr. Agar-Robartes should be burnt in effigy annually by the Orangemen of the six north-eastern counties. They honour Lundy in that way ; and the motives and details of Lundy's great betrayal are much more obscure than the motives and details of Mr. Agar-Robartes' proposal in the House of Commons. He talked of separate treatment for Ulster and should, in that, have qualified for immediate certification. He was responsible for selling the Protestants of twenty-six Irish counties into a slavery in which they have lived and prospered remarkably well.* He gave to

* Vol. III of the Twenty-Six County Census (1936) contains the following statistics of the proportions of vocational occupations held by members of the Protestant minority which constitutes 6.3% of the total male population of that area.

The Public Administration	6.9%
Commerce, Finance and Insurance	14.5%
The Professions	15.9%
The Railways	16.2%
Shipping and Harbour Officials	21.8%
Bank Officials	45%
Heads of Business Houses	50.8%
Commercial Travellers	30.2%

the Nationalist Catholics of six Irish counties the benefits of democratic government in a Protestant state for Protestant people.

(2)

Apart from all this puerile sarcasm, what actually happened was that this amending proposal offered a good ground for argument to the Unionist opposition. Edward Carson had no more love for the Partition idea than had Johnston of Ballykilbeg but he was astute enough to see that it was a stick strong enough to flay the life out of the whole conception of Home Rule as Asquith saw it and as John Redmond saw it. Between Castlereagh's Union and complete separation there was, said Carson, no alternative; Redmondite Home Rule and Mr. Agar-Robartes' exclusion of four counties were equal in daftness and in utter impracticability. The relation between the two was the relation between a powder-magazine and the inflammable something that would blow it to high heaven. For Edward Carson and the cause that he advocated that relationship was a great tactical benefit.

Carson's case was that if you were excluding anything, why only four counties? Tyrone and Fermanagh had then in 1912 and have now at this day Nationalist majorities, but he considered that it would be unfair to deny to those two counties the democratic benefits of exclusion from the Home Rule that the majority of their inhabitants wanted. Even if six counties were to be excluded by an amendment he made it clear that the Unionist party would not accept that exclusion as a final compromise or a final settlement. No compromise was possible. That was in 1912; and in a few years events in Europe and events in Ireland were to force Carson and the Ulster Unionists back on that identical compromise. It is interesting to keep a lucid recollection of their original position and their initial reaction to that proposed amendment. The Liberal Party had made a Home Rule Bill for one united Ireland, for neither the Liberal Party nor any other party had ever considered Ireland as anything other than a

unit ; a perplexing, disturbed, and possibly uncivilised unit, but still one island, one country, one people. There were different religions, different social classes, different political allegiances. The same was true of England ; and English was yet unmistakably English, and Irish was so unmistakably Irish, and the Home Rule Bill was unmistakably meant for all the Irish, because the best way to keep them quiet was to give them a show of liberty and let them settle their own differences, provided they kept the King's peace. Carson knew that. He knew that the Bill had come from the minds of civil-servants and politicians, that if a large area for which its fiscal and financial clauses had made allowance were suddenly withdrawn, then the Bill would perish. That was exactly what he wanted.

Mr. Lloyd George for his part couldn't see the Border. It was to be revealed to him a few years later in a moment of blinding vision ; but in 1912, while a subordinate position rebuked his amazing genius for taking sharp corners and facing both ways, he was able to say in the course of the Commons debate that the Cabinet had considered the proposal in all its bearings, but had finally decided that no geographical line could be drawn.

"Before you put forward a demand of that kind," said the man from Wales addressing himself (we suppose) to the man from Cornwall, "you should at any rate be clear and definite, and there should be an overwhelming demand for it. Is there a demand from the Protestants of those four counties, assuming now that Home Rule passes, that they should not go into it, or that they should save their skins, as it were, and just protect themselves, and that they should not go in to help at all in an Irish Parliament to protect the rest of the Protestants of Ireland ? What, therefore, is the demand of Ulster ? Not that she should be protected herself, not that she should have autonomy herself, but the right to veto autonomy to the rest of Ireland. That is an intolerable demand."

The next eight years were to produce some amazing changes : in the proposal put forward, in the attitude to that proposal adopted by different men and different parties. But

very few statements surpassed in lucid realism and unbiassed
exactitude that fragment from the mind of Mr. David Lloyd
George.

(3)

Somebody who didn't know much about it said that
John Redmond made his great mistake when he allowed
himself to suppose that Ireland was a nation. Yet a few
months before Mr. Agar-Robartes said his little say, Edward
Carson in the House of Commons came perilously close to
making the same mistake. Asquith had, Carson maintained,
based his case for Home Rule on the " demand " of the
Irish people ; he, Edward Carson, based his case against
Home Rule on the " good " of the Irish people. Passing over
his claim to understand what exactly was the " good " of
the entire Irish people, it is interesting to find him considering
that people as something integral, unified, apart. In the same
speech he admitted that he represented only a minority, but
that minority had " always been true to the United Kingdom."
He admitted also that the question was really a religious
question but it was " added to various other questions " ;
and the religious element was important because
" Protestantism has in history been looked upon as the
British Occupation in Ireland." Then as he, on his own
admission, saw the problem : there was the whole Irish people
demanding their own governmental institutions, and there
was a small British colony in Ireland, refusing to be affected
by the national sentiment of the country in which it found
itself, demanding exemption from the sway of these institu-
tions ; nor was there any self-determinative argument for the
giving of Home Rule to Irish nationalists that did not apply
equally to advocate a separate form of Home Rule for Irish
Unionists.

In the following year he made his first Partition proposal.
According to Lord Cushendun's excellent, but very official,
defence of the attitude of the Unionist minority, Carson's
proposed amendment to the Home Rule Bill asked for no
special privilege for " Ulster " except the privilege, claimed

as an inalienable right, of being allowed to remain part
of the United Kingdom, with representation at Westminster.
That proposal was " consistent with the uninterrupted demand
of Ulster to be let alone." There never had been, as even
Lord Cushendun must have known, any demand of the sort
on the part of the nine-county province of Ulster; and when
the soul of the thing that Carson spoke to was left alone
to develop in complete freedom from Papists and rebels,
the sheltering and enclosing wall was built only around a
portion of that province. The reasons for that were very
obvious. In a moment of exceptional penetration John
Redmond spoke of the possible future of Carson's proposal :
it " would create for all time a sharp internal, dividing line
between Irish Catholics and Irish Protestants." It would
" for all time mean the partition and disintegration of our
nation. To that we, as Irish nationalists, can never submit."
Winston Churchill hinted vaguely at the suitability of com-
promise and John Redmond replied that Ireland was a unit,
Ireland was an entity. For while the crevices of the Orange
mind were filled with memories of Enniskillen town fortifying
itself in the Williamite wars against the West and the South,
John Redmond's mind was radiant with a vision of all Irishmen
sitting down amicably at the same table. Anyway, to the
west of Enniskillen was Donegal, to the South of Enniskillen
were Cavan and Monaghan; three counties with nationalist
majorities, and Carson's proposal claimed the three for
Unionism. Enniskillen was in the county of Fermanagh, and
north of Fermanagh was Tyrone; two more nationalist
counties claimed also by Carson.

Bonar Law in that same year was confining the Unionist
demand to the four North-Eastern counties, with the possible
addition of Tyrone and one other, with, also, the option
for all the counties of being included at a later date under
the Home Rule government, always provided the counties
wished to be included, and so on. Nowadays after two
world wars it is very, very hard to believe that grown men,
placed by the strange will of Heaven in responsible positions,
could approach any problem with such complete ignorance
of details and background as Bonar Law and Asquith did

K

when one of them spoke in that way and the other pencilled down his egregious statements for future reference. Thirty or forty years afterwards it is, as any historian knows, very easy to be wise; and there is a cold possibility that even today men in governmental position, whether as a reward of ability or inherited money or sheer cheek, are sometimes not over-well informed on the problems of the governed. There was no inner self-examining eye to show the vendors of amending proposals that all the chopping-up and dividing and drawing of borders was evidence of something that they would have deplored in a German Kaiser or a German dictator. If the majority of the Irish people wanting Home Rule had been in one place, and the minority that shrank from the intelligent exercise of making their own laws in another place, then there might conceivably have been some sense in drawing a line to divide them, if they had all fairly agreed that division was the best solution for their problems. The Unionist publicists and speakers saw that point and painstakingly tried to convince everybody that it was not only possible but essential to draw a definite and decisive line. But it was not possible; and if the people living on this island would sit down for one day to think things over in reason and charity, they would soon find out that it was by no means essential.

(4)

By the summer of 1914 almost every imaginable form of partition proposal and idea for partition proposal had been exhibited in detail to show the world in years to come that the British statesmen of that period were really men of one nation with Edmund Lear and Lewis Carroll. Apart from the straightforward chopping and hacking of the normal partition proposal there were delectable federalistic ideas floating in the political atmosphere at that time. Mr. F. S. Oliver, a friend of Carson, was never tired of writing long personal letters about the benefits that the Empire stood to gain from a true system of federation; and Carson was sufficiently interested in the idea to put it forward, in a letter

to Lloyd George in 1918, as an alternative to Home Rule
for twenty-six counties with exclusion for six counties.
Winston Churchill flirted with a vision of local parliaments
for Scotland, Wales, London, the English Midlands, Yorkshire,
Lancashire. Possibly he reckoned that in the general orgy
of dividing and partitioning, the partition of Ireland would
pass without comment. Possibly he had taken as seriously
as the author intended them the ideas dressed up in the fantasy
called *The Napoleon of Notting Hill.* There was a great deal
of sense in those ideas ; and, to give due credit to F. S. Oliver
and to Winston Churchill, there was a great deal of sense
in the federalistic idea. It reacted against the bureaucratic
centralisation that has done more evil than good to many
modern states. But the proposed division in Ireland was not
intended to make towards better government by localising
certain powers and faculties. Ireland was divided in spirit
by the misfortune and misgovernment of the past ; and
really wise statesmen would have endeavoured to abolish
those divisions and to heal those ancient wounds. But the
statesmen of that period did the one thing needed to harden
and perpetuate those divisions, to keep the wounds open
and ulcerous. So far, in fact, was the actual partition of
Ireland opposed to the federalistic idea that among the most
active opponents of partition were many who advocated a
form of cantonal government for the four historic provinces
of Ireland. The idea has been advocated in recent years as
a possible solution for the evils created by partition.

Carson's 1913 proposal to exclude the whole nine counties
of Ulster became known, rather surgically, as the " clean
cut." In March, 1914, Asquith, moving the second reading
of the Home Rule Bill, put forward yet one more partition
proposal. The counties of Ulster were, individually, to be
given the power to vote themselves out of the jurisdiction
of the Home Rule Parliament for a period of six years. That
proposal of " county option " was about as near to common-
sense as the solution-finders of that time ever got ; but there
was a great deal of truth in Bonar Law's objection to the
qualifying time-limit of six years. He said it turned the
whole thing into nonsense ; and Carson, letting his imagination

get the better of him, called it " a sentence of death with
the stay of execution for six years." Carson's opinion was that
the time-limit clause had been added to make it impossible
for Ulster Unionists to accept the settlement, to show them
up as completely opposed to any compromise. The Liberal
mind was quite capable of that inanity, capable of it
even when it was plainly unnecessary ; for if any evidence
was needed of the irreconcilability of the Unionists of Ulster
it was scattered plentifully through the speeches of Edward
Carson. On the whole he regarded Asquith's proposal with
favour, welcomed the admission of the idea of exclusion,
said that he would submit it to a convention in Belfast
provided the condition imposing a time-limit was dropped.

About the same time John Redmond submitted to the
leaders of the Liberal government a memorandum that gave
the attitude of the Irish Nationalist Parliamentarians towards
the whole question of compromise and conciliating concessions.
To make peace between the conflicting elements, that
memorandum would have accepted the counties of Ulster
" standing out for three years by option." Another memor-
andum prepared by Joe Devlin outlined the position of the
Ulster Nationalists, and the man from Belfast put forward,
what he considered the real reason behind the parliamentary
demand for the exclusion of Ulster, in a statement made by
Mr. Austen Chamberlain that exclusion would be a " statutory
denial and negation of the national claim of Ireland." He
maintained that, although many Ulster Protestants had had
their fears excited about the possibility of discrimination
against them under a Home Rule administration, very few of
them had any intention of doing battle against the establish-
ment of that administration. The Nationalists were prepared to
offer every imaginable guarantee to these timid people, even
the guarantee of exclusion after ten years if the Unionist
members were dissatisfied with the treatment handed out to
them in an Irish parliament.

And so on and so forth : proposal after proposal, heated
parliamentary debates, eloquent public meetings, secret
conferences, public conferences like that held in Buckingham
Palace in 1914—an excellent example of the type of negotiation

that takes nobody nowhere, pencilled memoranda preserved among the papers of parliamentarians, memoranda prepared and presented to give information or to provoke discussion, all the imaginable and available political machinery employed to solve the problem created by the conflict between the insistent democratic demand of the Irish people and the material objections and atavistic dreads and hatreds of the north-eastern minority. The people as well as the parliamentarians had their opinions and their say. A consultation of newspaper files will give a very good idea of what the more publishable letters to editors had to add to the discussion. Mr. St. John Ervine's little volume of abuse of Carson has been frequently quoted in these pages. He wrote it in the period between the outbreak of the first world-war and the Easter Rising in Dublin when Irish parliamentary politics were comparatively quiet because John Redmond had taken to recruiting. It is worth quoting again at length because in it an Ulster Protestant, who could scarcely be described as being in the pay of the Catholic clergy, put quite forcibly what he then thought of the whole question of partition.

"When the last Home Rule controversy was at its height," he wrote, "some born fool proposed that Ulster should be politically detached from the rest of Ireland and politically attached to Scotland or the Isle of Man or some such place. He might as well have proposed that it should be physically detached. I have never yet met any Ulsterman to whom the proposal did not sound like a proposal to commit a horrible act of outrage."

And again: "There are not two Irelands and two kinds of Irishmen: there are four millions of Irish, men, women, and children, each of them varying from all the others, but all of them closely akin in their needs, and there is only one Ireland, whole and indivisible, a nation knit as all nations are, out of the incalculable dissimilarities and resemblances of its people into an imperishable unity."

The solid truth, that was so badly neglected in all that pantomime mimicry and mockery of proposing and memoranduming, has seldom been better expressed.

(5)

After 1916 the pantomime began again, rendered much more pantomimic by the remarkable capacity for duplicity displayed by Mr. Lloyd George. Duplicity may have been forced upon him by the awkwardness of the situation : the obvious justice—if democracy meant anything—of the long-deferred Nationalist hope ; the stubborn immovability of the Carsonite resistance ; the necessity for doing something immediately to catch the eye and please the heart of great America. But if the situation required duplicity then the gods provided the man for the situation ; and there is always the possibility that a little determined honesty might have had better and more permanent results. What he proposed was the immediate application of the Home Rule Act of 1914 to twenty-six Irish counties with the exclusion of the six counties of Antrim, Down, Armagh, Derry, Fermanagh and Tyrone. In the mind of John Redmond he managed to leave the impression that the exclusion was to be temporary ; while to Edward Carson he wrote the note containing a sentence that is frequently quoted and is well worth quoting : " We must make it clear that at the end of the provisional period Ulster does not, whether she wills it or not, merge in the rest of Ireland."

That sentence should, one would have thought, have placed David Lloyd George among the patron saints of Ulster Orangeism ; but for some reason or other Orange opinion has regarded him with as little favour as Nationalist opinion. That may be the inevitable fate of the man who tries to please both sides or deceive both sides. All reasonable Irishmen, Protestant or Catholic, would have been and would be grateful to the statesman who would show them their common interests and how to work for those interests. The Catholic Bishop of Derry, Most Rev. Dr. McHugh, let himself go in a statement about the " nefarious scheme " in which the chosen representatives of the people were prepared to " sell their brother Irishmen into slavery to secure a nominal freedom for a section of the people." The little dodges, the politic suggestings of something that was not true, the façade

rigged-up to impress American spectators : all these things were made obvious by parliamentary discussions and the comment of the public, and John Redmond, who had partially committed himself to something that—apparently— had not been meant, tactfully withdrew, and the scheme was abandoned. To that scheme sensible observers traced the eventual exclusion of six counties that took place after four years of disturbance and bloodshed ; and also in connection with that scheme the Ulster Unionist Council decided, after much heart-searching, to retreat to safer ground, to claim not nine counties but six counties. The account given by Lord Cushendun of the emotion displayed at the meeting, at which that decision was made, should nowadays give genuine amusement to young Irishmen of every religion and of every political allegiance. Strong men wept like the warlike fellow in the poem by Felicia Hemans. Shaken with grief the Unionists of the six counties abandoned to the wolves their brethren in Cavan, Monaghan and Donegal. Good statesman- ship demanded it. Edward Carson advised it. Lord Farnham, delegate for Cavan, came all the way from the fighting forces to make a speech that would have taken tears out of a drum. What it all meant in sober reality was that the Ulster Unionist Council had been shown the absurdity of its claim to speak for the province of Ulster. It could not control the nine counties of Ulster and if the wall of partition (to borrow a phrase from the novels of Mrs. Barclay—a poor second to the emotionalism of Lord Cushendun) had been built around nine counties, those nine counties would have voted them- selves back into a united Ireland before twelve months had passed. County option would have left less than half of Ulster to the Ulster Unionist Council, would have entailed more tearful and heartrending farewells. With six counties the good council felt that its hold was more secure. Nationalist areas had been included but they could, by manipulation, be dominated by the close Unionist organisation, by the con- centration of Unionist population in Belfast and the neighbour- hood. If the Nationalists of those six counties had foreseen the extent to which that manipulation and domination was to extend they would have sat and wept in a way that would

have made Lord Farnham's farewell look like an undergraduate's bottle-party. Lord Farnham and his friends went gallantly into the darkness of exile, to weep by the waters of Babylon and remember the Ulster Hall; and, as we never tire of saying, they have survived very well.

Lloyd George had not only discovered the real border for himself but he had helped the Ulster Unionist Council to find it, by way of the catharsis of an extremely difficult emotional crisis. The word of a fool goes to the end of the earth and the word of the poor Cornishman that Mr. St. John Ervine called a born fool had got at last as far as the labyrinthine mind of the Welshman. He was ready to tell the world about his conversion to the light; saying that while the government was ready to grant Home Rule to the parts of Ireland which unmistakably demanded it, he, Lloyd George, would never help to subject to Nationalist rule a minority " as alien in blood, in religious faith, in traditions, in outlook, from the rest of Ireland as the inhabitants of Fife or Aberdeen." It was not to his credit that a section of the world to which he solemnly addressed this piffle did actually know that at least two counties of the six to which he denied Home Rule unmistakably demanded it. Carson, according to the method that had served him so well in innumerable law-cases, was reducing the problem to its simplest elements, and discovering that it could all be compressed into two statements : (i) Ulster must be excluded, (ii) the Nationalist Party refused to consider any proposals on that basis. Compression can at times leave the compressor or simplifier staring idiotically at his own little narrow statement while other influences expand and develop unseen and unknown to him. That neat law-school simplification contrasts poorly with a statement published in the newspapers at that time, signed by three Catholic archbishops, fifteen Catholic bishops, three Protestant bishops, and by a considerable number of influential laymen. The men who signed that statement considered that the very thought " of our country partitioned and torn as a new Poland must be one of heartrending sorrow."

(6)

The day of sorrow was approaching and no parliamentary method could do anything to halt that approach. John Redmond lost his place in the hearts of the people he had once led because the people had grown weary of that profitless debating and lobbying, because startling events had given life to the new spirit. Then the Irish people went through days of bitterness and stress, days of unified resistance to a rule they did not want, to find themselves in the end confronted with the compromise that John Redmond had died repudiating. It came at the very height of the Black-and-Tan terror, under the appearance of the 1920 Government of Ireland Act. Because it retained the " clean cut " it became known as the Partition Act, with the idea of partition very much emphasised by the innovation that granted to the six counties the same form of Home Rule as it granted to the twenty-six. It included also one of those visions that appeared now and again in the course of the controversy : a thing called the Council of Ireland that was to provide seating accommodation for a number of legislators chosen equally from the parliaments in Belfast and in Dublin. The Orange minority was certainly not to be treated unfairly in that visionary assembly.

It remained a vision. That was, perhaps, a pity and a loss, for the idea of representatives of all-Ireland meeting in Ireland to discuss the affairs of Ireland was the idea that had always filled the minds of Nationalist Irishmen. Through some such council, meeting to discuss some urgent common interest, the way to unity may still be opened. It has still all the delightful possibilities and promises of a vision for it was never turned into a practical joke by one futile and farcical meeting ; that was the fate reserved for the parliament that Lloyd George had designed for the twenty-six counties. He considered that any scheme for the better government of Ireland, apart from the scheme of coercion and military terrorism that was older than Oliver Cromwell, must take into account three basic facts. The first was that three-fourths of the Irish people (the phraseology belongs to the estimable

work of Lord Cushendun) " were bitterly hostile, and were at heart rebels against the Crown and Government." Translated into common sense that meant that the bulk of the Irish people were guilty of a sentiment that Lord Cushendun would have admired in Mazzini or Louis Kossuth : they were conscious of their own nationality, they wished to express it through their own institutions. They were not enemies of Britain except in so far as Britain stood between them and their just claims. Those claims once granted, a dozen different overpowering reasons would have dictated friendship with Britain. The second basic fact was that : " Ulster was a complete contrast, which would make it an outrage to place her people under the rest of Ireland." Well, Lloyd George and even Lord Cushendun must have known that since Lord Farnham's farewell there was no longer any reason for misusing the name Ulster. The third basic fact was that : " No separation from the Empire could be tolerated, any attempt to force it would be fought as the United States had fought against secession." Any school-child could have destroyed that inane analogy by referring American readers, spectators and listeners to a more notable struggle waged not under Lincoln but under Washington.

No moth-eaten, three-legged stool ever maintained itself so precariously as the Partition Act did on those three absurdly inaccurate basic facts. On the eleventh day of November in the year 1920 the Bill became law ; and the spirits of the thousands of Irishmen who had died for small nations and for their own small nation were mocked and forgotten. Age may not have wearied them nor the years condemned, but the sullen fires of bigotry, the promises of politicians, had made their sacrifice as worthless as dust in the wind. All over the world men stood in silence remembering the dead, vaguely conscious that they were doing something that symbolised peace and honoured the heroic things that foolish plain men can do to restore peace, to preserve their homes and hearths, the casual, incidental things that make up their civilisation. And the great statesman of a great conquering nation drew this line across the fields of Ireland not certainly as a memorial and a sign of peace. It made no peace in the streets of Belfast.

It made no peace in Dublin or on the roads of the South; where anger would crackle in gunfire in the middle of a fair or at the corner of a street, where lorries of armed men went by in the night, where houses and even whole towns were burned by the uniformed upholders of law and loyalty and order. No peace: in the souls of Irishmen who went on remembering the accumulated injustice and slander, the criminal accusations of criminality, the recurring acts of coercion. That was twenty-five years ago. The line is still there; and in all those years it has never once meant peace.

Chapter X

THE SIX COUNTIES

" L'un des plus graves problèmes politiques irlandais est d'ordre géographique : c'est la separation, la " partition" de la Northern Ireland d'avec l'État libre d'Irlande. L'Irlande du Nord est communément désignée, mais à tort, sous le nom Ulster, ce qui contribue à obscurcir le sujet, parce que l'Irlande du Nord ne correspond point à la province d'Ulster et que le mot Ulster est une designation géographique et politique, precise en apparence, mais qu'on découvre être fort vague dès qu'on essaie de la définir."—" La Frontière de l'Ulster " par Y. M. Goblet, Paris, 1922—Extrait des Annales de Géographie.

"A rock of granite."—Lord Craigavon.

(1)

THE line was drawn then around six counties ; and two years later, when peace came back to Ireland and the amazing treaty was forced upon the Irish plenipotentiaries, the last golden vision of adjustment and compromise appeared in the shape of something called the Boundary Commission. Up to a point it followed the normal course of normal commissions appointed by governments to present reports on some branches of knowledge that the governments wish to know more about. The idea that inspired it was, possibly, a vague wish to find a boundary-line that would more accurately confine Nationalists to the south and Unionists to the north and east. The wish was neither strong nor gifted with any notable persevering power. It barely managed to collect a few members for the commission, to keep them talking over a period, to keep Nationalist hopes excited by the prospect of a revision of the obviously-inequitable dividing line. Towards the possibility of a revision not in their favour the men who were entrenching themselves in the Orange leader-

ship in the Six Counties reacted as they had previously been accustomed to react towards the possibility of Home Rule for all Ireland. Ulster, as they called it, became a rock of granite and neither commissions nor English acts of parliament nor the will of the people would clip away one inch of that hard substance. As for the men who were left as Nationalist leaders in the period following the tragedy of civil war they were ready to accept the line that was drawn as the easiest way to avoid the imposition of anything more unfair. The unfortunate Boundary Commission no longer merits the compliment that a detailed narration of its establishment and its aims would imply. Only a very small number of people still alive can know what exactly it talked about, for the report it submitted was never published. It changed nothing, modified nothing, improved nothing. It raised hopes that it did nothing, absolutely nothing, to satisfy; and in some vague and meaningless corner of chaos those shattered hopes were added to the great accumulation left behind by conventions and conferences, promises of plebiscites, councils of Ireland and cantonal assemblies. In spite of all these things the line was drawn to suit, not the wishes of the majority of the Irish people, but the wishes of that minority in Ulster and the perverted political notions of men who thought that frustrating the wishes of the Irish was a necessary part of imperial policy. The line was drawn thus in spite of the years of revolution, in spite of the new ideas that had swept aside John Redmond, in spite of the new methods that had replaced the worn-out constitutional appeal.

There is only one way of dealing intelligently with the complicated negotiations and ambiguous documents of that period, and that way involves a careful chronological relation of incident and quotation of statement. It has been done so frequently, even if not often with a cool lack of bias, that by sheer repetition both negotiations and documents seem to lose their importance. It is very difficult to strike on a new line of thought, almost impossible to come upon some hitherto unnoticed but important fact, impossible also to place known facts in a novel relationship that will reveal previously hidden meanings. There was a truce; and the

young Irishmen came down from the hills and hiding-places
to their homes, and the Crown forces moved in an unfamiliar
and uneasy peace. In Belfast there was a pogrom : no peace,
no truce. Some Irishmen crossed to London to discuss with
Lloyd George and the heads of the British Government :
" How the association of Ireland with the community of
nations known as the British Empire may best be reconciled
with Irish national aspirations." That was a fine formula,
but in practice it meant that the more powerful nation granted
just what it pleased to the less powerful, that " Ulster " was
still a rock of granite, that the pogrom did not stop, that over
the shoulders of the British statesmen the Irish visitors could
see the levelled gun. Great settlements are not made that
way and the only good thing about that settlement was a
hopeless ambiguity that, in calmer days, was to prove beneficial
to the weaker nation. Unfortunately those days were not
calm and the treaty that was to settle Ireland in peace provoked
a civil war.

For the purpose of this essay a little concentration on one
or two points combined with a general idea of their back-
ground is essential. The main obstacles in the way of a
generous and complete settlement were the question of the
future status of Ireland in relation to the British Government,
and the even more awkward question of the relation between
the Orange minority and the rest of the people of Ireland.
That minority looked with little favour on the progress of
any negotiations that might shake or diminish their position
under the 1920 Partition Act. An impartial and authoritative
commission sitting to discuss where exactly the border
should lie and how much of Ireland the Unionists should
be allowed to call " Ulster " threatened that position, brought
them face-to-face with the prospect of losing straightway the
two counties of Tyrone and Fermanagh. Lloyd George, who
relied on truth and evasion and half-assurances with a fine
impartiality, pronounced again on the question of those two
counties :

" There is no doubt, certainly since the Act of 1920, that
the majority of the people of the two counties prefer being
with the Southern neighbours to being in their Northern

Parliament. Take it either by constituency or by Poor Law Union, or, if you like, by counting heads, and you will find that the majority in these two counties prefer to be with their Southern neighbours—What does that mean? If Ulster is to remain a separate community, you can only by means of coercion keep them there, and although I am against the coercion of Ulster, I do not believe in Ulster coercing other units."

Such bewildering and dazzling handsprings were very typical of Mr. Lloyd George, typical of the whole negotiation. From one article of the Treaty and from private conversations Michael Collins was given to understand that the exact location of the dividing line should be decided by the wishes of the inhabitants. That meant a plebiscite; and, because of the inexorability of statistics that convinced even Lord Cushendun, a plebiscite must inevitably favour the Nationalist cause. Michael Collins was so sure of that, that the confidence of Craig was momentarily shaken; but Craig had no cause for anxiety. The astounding self-centredness that is a notable characteristic of the Orange mind preserved him from any temptation to respond to an opponent's generous gesture. When Collins recognised the Northern Parliament in the hope that Craig would meet him halfways in the cause of a united Ireland, the only response was the previously-quoted naïveté: that he, Craig, would never be the man to lead his people into a free state. Even if, in a moment of wild generosity Craig had gone out of his way to meet Collins, his progress would soon have been halted by the very terms of the treaty, that was, mind you, to give peace to Ireland. Wise politic heads, thinking imperially, had seen to that. Lord Birkenhead could write to Lord Balfour assuring him that Article Twelve of the Anglo-Irish treaty was only intended to ratify and confirm the Partition Act of 1920. The wall around the six counties was solid and safe, undisturbed by negotiation, unshaked by revolution. The fatuous Boundary Commission never once ran the risk of taking an inch from the stature of James Craig or a square-inch from the territory that he and his party had decided to dominate. For if a Unionist government could not make a success of nine

counties, no government of any sort could make a success out of four counties. Six was the mystic number : not too small to be economic, not large enough to give the Nationalist element a chance. The line remained, splitting Ireland with a spiritual wound more serious than any material division, marking the limit beyond which Irish friendship for England could not and cannot go. A few great Englishmen said the thing was folly, that another world-war would exhibit that folly to all men. But the politicians who drew the line murmured to themselves like some arcane incantation the words *Imperial Policy* ; and the thing was done.

<div align="center">(2)</div>

The Unionists of Ulster or of one portion of Ulster had a new leader. They had a new parliament all of their own. A king came to open that parliament and to make a speech. The old leader also made a speech that was his last will and testament to his followers. The two speeches merit consideration for their comment, prophetic comment, on the years that were to follow. In the Belfast City Hall, in which Edward Carson had signed the Covenant, King George V opened the first parliament that was to legislate for the six partitioned counties. He was confident that " the important matters entrusted to the control and guidance of the Northern Parliament would be managed with wisdom and with moderation, with fairness and with due regard to every faith and interest." He hoped that his coming to Ireland might be " the first step towards an end of strife amongst her people, whatever their race or creed." He felt assured that the men who composed this new parliament " would do their utmost to make it an instrument of happiness and good government for all parts of the community which they represented."

The parliament in question derived its right to existence from the frequently-referred-to Partition Act of 1920 ; and the men who framed that Act were scrupulously careful about the rights of religious minorities. That scrupulous care may have been an endeavour to protect the large Catholic minority confined against its will within the wall of partition, or it

may have been an echo of the unnecessary fear that a
Nationalist government would as its first piece of legislation
order the mass-massacre of every Protestant living within
its jurisdiction. For a section of the Colonial-Unionist element
in Ireland has always been haunted by the misty fears that
come like goblins out of guilty consciences and uneasy
memories of the unbalance of things in the past. Anyway,
the Act made definite statements about the treatment that
should be given to religious minorities : " In the exercise
of their powers to make laws under this Act neither the
Parliament of Southern Ireland nor the Parliament of Northern
Ireland shall make a law so as either directly or indirectly to
establish or endow any religion, or prohibit or restrict the
free exercise thereof, or give a preference, privilege, or
advantage, or impose any disability or disadvantage, on
account of religious belief or religious or ecclesiastical status."
And again : " In the exercise of power delegated to the Lord
Lieutenant in pursuance of this section (i.e. the section of the
Act dealing with executive authority) no preference, privilege
or advantage shall be given to, nor shall any disability or
disadvantage be imposed on any person on account of religious
belief, except where the nature of the case in which the power
is exercised itself involves the giving of such preference,
privilege or advantage or the imposing of such disability or
disadvantage."

All these sentiments were reinforced by a passage in what,
as far as Ulster Unionism was concerned, was the political
last will and testament of Edward Carson. He may as an
undergraduate have been a fervent enough Protestant to sing
hymns on the street. He may have been from an early age
a sworn Orangeman. He may have declared that Protestantism
had always been the religious belief of the British occupation
in Ireland, that it had on that account a definite political
significance. He may even, in moments of heat, have
harangued his followers in the traditional manner of Orange
leadership. But the number of those harangues was small
and, comparatively, their temperature was low. Not one of
them was so distinguished and definite as the parting advice
he gave to his followers : " From the outset let them see

L

that the Catholic minority have nothing to fear from the Protestant majority. Let them take care to win all that was best among those who had been opposed to them in the past : while maintaining intact their own religion, let them give the same rights to the religion of their neighbours."

With these wise warnings and with those precautions carefully inserted in an act of parliament the new divided Ireland began its new life twenty-odd years ago. Those years have managed to prove conclusively to anyone who had an intelligent interest in Irish affairs that the only people to keep Carson's advice were the Nationalist Irishmen who governed the Twenty-six Counties. There, the grudging and bitterness of the past were forgotten with almost miraculous swiftness ; and the inhabitants settled down to some realisation of common interests and common aims. Not completely, not utterly to the satisfaction of every single individual, for the havoc of centuries cannot be repaired in twenty years ; the walls that were built with such care and deliberation cannot too easily be gapped or flattened. There was and is a minority suffering terribly from that " nostalgia for lost domination," resentful of the power suddenly given to the democracy. But the majority of the Protestants living in the Twenty-six Counties would quite readily testify to the reality of the toleration they experience. Sometime within the last few years there was an incoherent outcry from the members of an Orange Lodge somewhere in Donegal asking the British parliament to deliver them from the body of this death but, since the good men were not certain about what they wanted deliverance from, the complaint may be disregarded. Then in March, 1944, in a pamphlet called *A Recognised Church : The Church of Ireland in Eire*, Professor W. B. Stanford of Trinity College, Dublin, talked, rather vaguely, of a political and economic pressure exerted by the Catholic majority on the Protestant minority. Professor Stanford's point-of-view is that of a Protestant Nationalist who wishes to encourage his co-religionists to think and act constructively and nationally. But he is hampered by a vague feeling that if the truth were told and if everything was as it should be Ireland would still be dominated by a minority in ascendancy, would still be, as John

Mitchel saw it, a pyramid balanced dizzily on its apex. When charges are made, some proof either in the shape of documents or in reliable testimony from authoritative witnesses, must be advanced to substantiate them. He gives no proof; and his actual charges boil down to some weary prognostications about the horrors that might possibly come to pass in some unspecified future. Consider this as a sample : " . . . suppose a Government (the present Government has been fair to us, I wish to make this clear, though I will not say the same for many actions of the local authorities in the country), suppose a Government were to decide to close or transfer some of our churches, or to send our children to schools contrary to our principles, or to introduce sectarian discrimination into taxation or public services, or to interfere with the ecclesiastical powers of our Bishops and Synods, or to introduce open propaganda against the Church of Ireland, or to try to separate us from our brothers in the North—then drastic action would be needed. Personally, I rather wish that such opportunity would arise that we might show our common loyalties openly and courageously. Persecution strengthens a true Church. Pressure and cold-shouldering, such as we have often to bear, are much more likely to weaken it."

Well, it is interesting to know how the poor professor feels about it. He is very very like the old man who said that he had had many troubles, most of which had never happened. This supposing and prognosticating, possibly, keep him awake at night while he shivers in the chill engendered by contact with the cold shoulders of his potential persecutors. Actually the most sensible Nationalists desire closer contact and better understanding with their Protestant neighbours because of the good that that contact and understanding can accomplish for the country. Most Protestants are quite aware of that desire and respond to it admirably. Nobody wishes to separate Professor Stanford from his brethren in the north except, perhaps, his brethren in the north and the relics of a very unimaginative school of English politicians. Nationalist Ireland has tried frantically for many years to make it possible for men like Professor Stanford to meet his brethren from

the north in an all-Ireland assembly to legislate for one contented, united Ireland. Nobody is in the least anxious to give Professor Stanford the crown of martyrdom for which he so ardently sighs. When the horror that comes in the air by night struck his brothers in the city of Belfast the fire-engines from Dublin went North over the border to help to alleviate the terror and suffering. Dublin offered hospitable refuge to the pitiable people flying from broken homes. Eamon de Valera asked the chief of the Dublin Fire Brigade to send every available engine. He said : " They are our people and their sorrows are our sorrows ; any help we give them is given whole-heartedly."

That is exactly what nationalist Ireland says to people like Professor Stanford and to his brothers in the North. There is no reason why they should not sleep in peace, live without fear of some future night of long knives and bloody blankets. If Professor Stanford had been a Catholic, born to the north-east of the Border, he might have been able to write a different type of pamphlet. He would not have had to rely on visions of a dreadful future. He could have filled his pages with quotations from documents, with photographs of documents, with accounts of incidents that could be verified from any newspaper-file. His reward would have been not the compliment of fair controversy but a term in gaol. In the silence of a cell he could have enjoyed the exquisite irony of knowing that a man in important position had not only admitted the charges made in that—hypothetical —pamphlet, but had spoken in favour of the very abuses the pamphlet had attacked. Perhaps Professor Stanford missed something when he was not born a six-county Catholic. He missed the joy—the martyrs had it—of being punished for telling the truth.

(3)

Such a pamphlet was actually written, almost contemporary with Professor Stanford's little effort, by a Belfast man who took the sensible precaution of concealing his identity under a pseudonym. The Northern government eventually banned

Orange Terror but made no attempt whatsoever to refute the points that the writer had made. The pamphlet was not so much made up of the author's statements as of statements made by northern politicians and Orange leaders, along with a collection of blunt unelaborated facts displaying how far the Northern Parliament had drifted from the spirit of King George's speech, from the regulations laid down in those clauses of the Act of 1920. Drifted is not the right word. The movement was much more of a drive than a drift, and it expressed itself in discrimination against Catholics in the giving of employment, in the withholding of any social or economic benefit that could possibly be withheld. It expressed itself in violently sectarian speeches made by men in responsible governmental position. It expressed itself in the riots that took place in Belfast in 1935 ; in the prevalence of political gerrymander as a means of weakening the Nationalist and Catholic voting power ; in unashamed, unfair treatment of the Catholics in the organisation of education ; in a dozen other ways in which a minority afflicted by the master race mentality can, finding themselves in positions of power, make life awkward for the neighbours.

No purpose could be effectively served by lengthy quotation to show how often men like James Craig, Sir Basil Brooke, Mr. J. M. Andrews, Sir E. M. Archdale, Sir Joseph Davison the Orange Grand Master, did say, in defiance of the Act of 1920, that the Six Counties constituted a Protestant state for a Protestant people, that no man should give employment to a Catholic because Catholics were ninety-nine per cent. disloyal, that they—the gentlemen named above—were first, foremost and before all things, Orangemen. No purpose could be effectively served by detailing statistics to show the injustice of the political gerrymandering of such places as Derry City, Omagh town, Newry town, where one Protestant vote is equal to two Catholic votes and in one case to 2.8 Catholic votes (rough calculations). Any man or woman who does not already know these things and who has any curiosity in that direction will have very little trouble in acquiring full and satisfactory information.

What interests us here is the spiritual thing that lives

somewhere behind incidents and details, speeches, drums and statistics. A common pro-Stormont argument says that no Catholic is victimised because he is a Catholic; but that every Catholic is a nationalist and every nationalist wants to put an end to the Stormont government, since nationalists are people who believe that Ireland is one nation. Now it is not true that a man, to whatever religious persuasion he may belong, who believes that Ireland is a nation must automatically commence to plot when and in what way Stormont must be destroyed. It is even farther from the truth to say that the Orange mind discriminates against Catholics only because of certain political doctrines that Catholics in the Six Counties are supposed to hold. In the August and September of 1944 a very good sample of what can happen to a Catholic because of his religion was provided when a Catholic was excluded from the mastership of the workhouse in Enniskillen, County Fermanagh. The man, who was the best-qualified applicant for the position, was neither a Fenian nor a Sinn Feiner nor a United Irishman—in the Orange mind all the types of Irish rebels move with little respect for chronology and less respect for reality. He was not a rebel against King and Empire. He was an ex-British soldier who had lost a leg in the African fighting, whose father had suffered wounds in the first world-war, whose claims were supported by the British Legion, whose qualifications were approved-of by the appropriate government ministry, but who was frustrated by the local Orange clique solely because of his religion.

That is one incident. The point it makes could be confirmed and reconfirmed by incident after incident, detail after detail, until there would be left no doubt that a considerable proportion of the spite and bitterness that makes life unpleasant in the six counties can be traced back in direct line to John Knox and John Calvin. The Orange mind is something more than conscious of the past; it does literally live in the past. Orange banners and posters and publicity can talk, in a way not now too common in western Europe, about preserving the principles of the Reformation, with startling emphasis on the principle of saying uncomplimentary things

about the Pope. Orangeism has nursed and preserved that
historic hostility to Rome until bitterness created for itself
images of bitterness, until the battles and victories, tragedies
and faction-fights in the story of Ireland were transformed
into one persistent, violent and ill-intentioned attack made
by the Catholic Church on the principles of civil and religious
liberty. The more extreme of the Scotch covenanters retiring
deeper and further into glens and forests came at last to
the place where the eye sees grotesque visions and the poor
human tongue speaks only in prophetic warning. By analogy :
the retirement of the Orange mind has made every event
in the development of Irish nationalism appear as the obvious
manifestation of some hostile, diabolic power. Historical
accuracy, documentary evidence, count for nothing in an
Orange Lodge. The hoary joke about the loyal Shankhill
man, who thought that the story of King William was part
of the Bible, has point and application. You will still find
the Ulster Orangemen believing that the Pope was responsible
for persecuting covenanters and dissenters. The fighting in
1641 is remembered as an organised Papist attempt to massacre
all the Protestants living in Ireland ; and no Orangeman would
dream of examining the evidence that covers that period,
the *actual* number killed, the political atmosphere and tempera-
ture of the time, the economic and material reasons that added
bitterness to the fighting. Scientific investigation has no
chance against the amazing faith and the powerful imagination
of the Ulster Orangeman. He accepts for proved and reliable
facts a series of fables that never comes anywhere near
impartial statement. He readily believes that his Catholic
neighbour is ready to despoil him, evict him, murder him,
and as a precaution he organises and arms and drills ; on a
few terrible occasions he has actually despoiled, evicted, even
murdered his Catholic neighbour.

All this isn't easy to understand. It has depth and darkness,
and has still that combination of stupidity and simplicity
that more than anything else baffles the investigator and
numbs the human intelligence. Samuel Johnson who under-
stood many things could not understand why two men, by
birth subject to the same mortal misery, could add to that

misery by hating each other ; and bigotry is just mass-hatred, unreasoning, unreasonable, unintelligent. When we use the word, we normally mean that the cause of that hatred has something to do with religious belief. That form of hate is certainly one of the influences that complicate and make difficult the problem of the partition of Ireland. It is one of the characteristics of the creed and methods of Ulster Unionism. It is happily not characteristic of the majority of Ulster Unionists ; and in that fact there is a germ of hope. Nor is it by any means the characteristic of the majority of Irish Nationalists, in Ulster or anywhere else. If the whole Protestant population of the Six Counties could be got to believe that last sentence a great breach would be made in the wall of Partition.

(4)

Still when a Stormont Protestant statesman says that Catholics are ninety-nine per cent. disloyal there is somewhere in his mind a tiny contact with fact that he has perverted, and exaggerated into a monstrous libel. He associates Catholicism with Nationalism because the majority of the Irish people are Catholics and the majority of the Irish people know that their country should be ruled as one united nation, because the chances of history or the providence of God associated Catholicism with the wish of the majority for independent self-government and made Protestantism— acknowledgment to Lord Carson of Duncairn—the religious belief of the British occupation in Ireland. He quite falsely implies that Catholic Irishmen wish to unseat King George, burn the Archbishop of Canterbury at the stake, depopulate the British Commonwealth of Nations. Any man within reach of fact knows that the implication is, at its best, rubbish; at its worst, calculated and organised falsehood ; knows, too, that nationalist Ireland wants genuine friendship with England, especially with an England that, under very trying circumstances, respected the right of nationalist-ruled Ireland (called because of a misunderstanding : *Eire*) to declare and maintain neutrality. Nationalist Ireland still maintains that

Irishmen from every part of Ireland, Protestant or Catholic, should find their common country a common interest. But the Orange mind has retreated from fact—the retreat has been made by other minds in England and Southern Ireland ; and in its retirement any perverted and exaggerated statement can pass for fact.

The Six-County nationalist is for many reasons no friend to the Stormont government. Mr. Lloyd George had, we have seen, rather a feeling that that would be the case. He knew that Tyrone and Fermanagh certainly did not belong under the Belfast administration, that keeping them there would mean incessant coercion. He wished to convince everybody that he did not want to see anybody coerced but he approved of the partition of Ireland and, indirectly, approved of the coercion he was so anxious to⁻ disavow. The Six-County nationalists had, in that way, a very miserable beginning in their new life. On the admission of the man mainly responsible for placing them under the Belfast regime, they did not belong there. With some justice they considered themselves abandoned by the men who were found on top when the nationalist movement crashed and collapsed in civil war, even though nationalists in the Twenty-six Counties felt very bitterly that abandonment.

That initial embitterment under the new order has not noticeably grown less in the years between 1925 and 1944. It has, if anything, increased and intensified because the Belfast politicians paid more respect to the twisted wisdom of Lloyd George than to that last magnanimous sentence from Edward Carson. If coercion was needed they could supply coercion, angry and inflamed with the fires of bigotry ; and against that steady application of pressure the hopes the Six-County nationalists had in the beginning gradually died. There was for a while a suspicion that the six-county experiment would end after a few years in a hopeless financial muddle, that a complete political revision and alteration would be necessary. There was even an ingenuous nationalist superstition that if Joe Devlin suddenly refused to appear in the Belfast parliament the unfortunate Orangemen would scarcely know how to draw their pay, that when Lord

Craigavon went to his eternal reward there would be a complete and final end to Orange bigotry. Mr. Seán Milroy, in an intelligent and informative little book, *The Case of Ulster*, written in 1922, showed conclusively that the economic position of the Six Counties was untenable. A thousand facts and long tables of figures came together to show how economically awkward the business of paying two governments would be for one small island. Reasonable statements from business-men explained the harm that partition would do their enterprises. The Chairman of the Great Northern Railway Company told of the difficulties facing that company because of the continued existence of a double line of customs-barriers. In 1925, according to Miss Dorothy Macardle :* " The economic condition of the country was deplorable. Partition, separating industrial centres from their agricultural hinterlands, breaking up transport systems, depressing trade by means of a Customs barrier and duplicating the costs of governmental departments and salaries, was proving economically disastrous to both the Free State and the North-East, and as time went by there seemed less and less prospect of partition being brought to an end."

Less and less prospect, yet the economic position was untenable. The government of the Six Counties survived artificially by the help of the British government because even Winston Churchill had come to regard the maintenance of partition as, God help us, Imperial policy. In 1925, almost four years after the birth of the Belfast government, the question of the grant-in-aid, that was life to that government, came up for discussion in the British House of Commons. Mr. Philip Snowden, an ex-Chancellor of the Exchequer, opposed the continuance of the grant. He said : " From the time of the passing of the Act of Parliament which conferred self-government upon Northern Ireland, the British Treasury has been subject to constant demands from the government of Ulster for illegal financial assistance from the British Exchequer. . . . The British Treasury have invariably resisted this demand until the pressure upon them by their political

* *The Irish Republic*, p. 918.

friends has become so strong that the Treasury were unable any longer to continue resistance." Captain Henry Harrison who quotes these sentences from *Hansard* (Col. 1,653 and Col. 1,654), in his book *Ulster and the British Empire*, 1939, points out that when Mr. Snowden said " illegal " he meant " inconsistent with provisions and terms of the Government of Ireland Act, 1920."

Mr. Winston Churchill as Chancellor of the Exchequer replied to Mr. Snowden and spoke in favour of the continuance of the grant, adding to his many notable statements on Irish affairs. He said : " For many years Ulster's repugnance to Home Rule denied Home Rule to the rest of the island which desired it so keenly, but in 1921 the attitude of Ulster changed. Ulster, not out of any wish on her own part, contrary to her inclinations and contrary to her interest, consented, in the Imperial interest, in the general interest, to accept a form of government which separated the administration of Ulster from the administration of Great Britain, and which established them a small community in the North of Ireland, with many difficulties, many embarrassments, and many perils which they had to face. I say that that was a great sacrifice on the part of Ulster, and no one who cares about the principle of pacification embodied in the Irish settlement ought ever to ignore or be forgetful of that great sacrifice. It has imposed hardships upon Ulster. They did not want any change, and were contented with the situation that existed . . . I say that, from this point of view, it seemed to me always that it should be a point of honour with the British Parliament to sustain and support the Ulster Government during their early, difficult years under the new conditions. That is exactly what we are doing."

There is fantasy enough in that statement to make one feel vaguely uneasy for Mr. Churchill who knew better than most men why and in what way " Ulster " exploited that repugnance to Home Rule. He knew, too, what Ulster was, the real Ulster ; and what proportion of the people of Ulster were afflicted with that repugnance, how it expressed itself, how it broke John Redmond whom Mr. Churchill admired. He knew exactly the sacrifice involved when " Ulster "

accepted the burden of self-government and as many national-
ists as could be dominated were penned behind the Border
to keep the whole fixture from collapsing within twelve
months. He knew, too, what peace that " principle of
pacification " had brought to Ireland. But there is truth
enough in that statement—because Mr. Churchill *does* under-
stand the situation—to show why the untenable economic
position has been held for more than twenty years, why
when so many Anglo-Irish difficulties were cleared up in
1938, Mr. Neville Chamberlain was not very anxious to talk
about partition. Incidentally all Irishmen and all Englishmen
should be grateful to the shade of Mr. Neville Chamberlain
for pointing the way to the higher wisdom when he said :
" But on our side we took the view that the question of
partition was not one for us ; it was one which must be
discussed between the Governments of Southern and Northern
Ireland."

But in 1938 there was no evidence that the two governments
were ready to come together to discuss common interests
and common aims. The men at Stormont were solidly and
suspiciously on the defensive* against any advances, friendly
or otherwise, on the part of the Dublin government ;
suspicious, also, of any negotiation between the Dublin
government and the British government. While Mr. Neville
Chamberlain was washing his hands of the whole business,
and Mr. de Valera, speaking for the vast majority of the
people of Ireland, declared that no settlement would be final
and complete unless the partition problem was dealt with,
Sir Basil Brooke, then Minister for Agriculture in the six-
county government, was proclaiming in the traditional
fashion : " We have received definite assurances of the

* The self-defence complex of Ulster Unionism and notably of Ulster
Orangeism has frequently been mentioned in these pages. On Wednesday,
11th October, 1944, Professor Savory, Unionist member for Queen's University,
Belfast, protested "defensively" in the House of Commons against the
possibility of Partition being mentioned at a post-war peace conference. " We
never are the aggressors," said Professor Savory, and his words need no
comment. ".We always stand upon the defensive. But when our very existence
is at stake, when our whole constitutional position is being attacked, we must
make use of what opportunities this House provides us in order to reply.
Otherwise our silence would be misunderstood."

safety of our position from the British government, and
we have no reason to believe that they will let us down."
 The broad back of the British government did not let
them down. They were supported when their position was
a hopeless financial muddle. They were supported in spite
of the blatantly obvious coercion of the Nationalist-Catholic
minority, in spite of the disgraceful Belfast pogrom of 1935
and the disgraceful speeches that preceded it, in spite of the
wish of an ever-increasing majority of the Irish people to
smash the last barrier holding Ireland and England from
genuine friendship and co-operation. Then, a little more
than twelve months after Sir Basil Brooke testified to the
solidity of Stormont, the German troops crossed the Polish
border and those years of " Imperial policy " had an inevitable
result.

(5)

 Sir Basil Brooke would maintain that that Imperial policy
was more than justified by the events of the last five years.
The publicity efforts of the Stormont government have been
directed to prove that this time it is " Ulster," not Ireland,
that is the one bright spot, the one part of Ireland devoted
to the prosecution of a war for human liberty and the rights
of minorities, the place where loyal men hold a bridgehead
of communication between Great Britain and America.
Nothing has been neglected that could serve to stamp that
idea into the minds of the thousands in England and America
who know nothing about the past of Ireland and nothing
about the present of Ireland, who scarcely know where the
place is. The process has been ably, if accidentally, assisted
by some of the more yellow American and English papers, by
articles ranging from the appalling fantasticalities named
collectively by the title " *Poison Pen*," to the weak inaccuracies
of Mr. Beverley Baxter and the weary meditations of Mr.
Osbert Lancaster. If the impression could be created that, in
this war, the Stormont government has finally proved that
its labours, and the separation of the area it governs, are
indispensable to the welfare of Britain and the British

Commonwealth of Nations, then the Stormont government would, justifiably, be very well pleased. Actually, the efforts of Unionist publicists to push this point home give the impression that there is always a certain amount of foreboding that the question of the partition of Ireland will again come up for debate. That will inevitably happen ; for any arrangement so obviously artificial, so obviously the result of political accidents and unreasonable prejudices, cannot be permanently immune from criticism. And every man in any way interested should struggle hard to realise that future attempts to settle the Irish problem would not be ingratitude to a loyal, war-torn minority. It would be a genuine attempt to correct the errors of the past that we have, sketchily, reviewed. For the belligerency of the six Irish counties and the neutrality of the other twenty-six, are the unavoidable results of those errors. Most Irishmen and many Englishmen knew what exactly neutrality meant : the history behind it, the fact that it symbolised the Irish resolve to be independent of England first and friendly with her afterwards, the moral courage needed to hold steadily and conscientiously to the declared neutrality. Above all there was the fact, amazing to most Irishmen, that under circumstances of dreadful difficulty Britain respected Irish neutrality. When that realisation sinks in, it may do more to correct those errors than would twenty years of negotiation.

Now what exactly did belligerency mean for the six counties dominated by Stormont ? Apart from the bustle of war-work that relieved the Belfast administration of a perplexing unemployment problem, apart from the movement of troops that went with the global catastrophe like the rim of a restless tide, there was the question of the conscription of man-power for military service. The Six-County area ruled from Stormont was not conscripted. The forbearance or the good sense of the government of Britain did, in that, pay a definite compliment to Irish national sentiment, and every man who wished to see the establishment of solid, satisfactory Anglo-Irish relations, was gratified. Yet it was remarkable and illuminating that the men at Stormont could not command the complete, unified allegiance of the people that, according

to the legend of " Ulster," they were supposed to rule. If the objections to conscription had even been solely Nationalist objections, then there was nothing to prevent the young able-bodied men of Unionist belief from subjecting themselves to conscription for real military service, as distinguished from the sort of home-defence that was quite safe, quite unnecessary, and arranged on a basis of sectarian discrimination. Everybody knows, too, the large numbers of young Catholic Irishmen who materially assisted Great Britain in the years of war and fighting. Their countrymen may have various opinions on the rightness or wrongness of their giving that assistance. At any rate those young men were not conscripted, nor were they obliged to fight because their leaders had been in the past blessed with much imperial favour. The history of the last five years contains other awkward little incidents that reveal with embarrassing clearness the illogicalities, the denials of right and reason, on which the Stormont government bases its policy.

The neutrality of the majority of Irishmen, the motives behind it, the justification for it, the strict conscientiousness with which it was maintained ; all these things were reasonably publicised in March, 1944, by an incident and an exchange of diplomatic Notes that is now part of the uneasy history of five terrible years. *March of Time* news-cameramen made quite sure that everybody would see and hear about it when they screened it with laudable impartiality in their documentary on *The Irish Question*. But far and from the furthest coasts is the price of the American cameraman who will make a documentary of the official Orange mind, showing the effect on it of the second European war, whether or not the prospect of mankind in agony has taught it the desirability of peace and charity. When the guns began the drums stopped. Now drums are not in themselves objectionable things, but in north-east Ireland the noise of drums has very frequently been a prelude to the noise of the guns. After the war the drums may, they almost certainly will, return. The men who beat them have the power of deciding whether the rhythm will send the neighbours dancing in joyful procession or whether they will sound the awful sound that means the

continuance and perpetuation of hatred and division. So
many things in the world have changed. So many things
have been tumbled, destroyed, torn up by the roots. So
many values have been lost and forgotten. So many accepted
principles and beliefs have lost their influence on the minds
of men. It would be ironic and very pitiable if this were one
of the few things to stand unchanged : this old bitterness,
distilled and preserved for centuries, drawing its strength
from unbalanced ideas on the past and twisted visions of the
future ; carried on, into the years when the world will be
hungry for peace, to the sullen noise of drums, the flapping
of banners and the wearing of sashes.

At the end of five years of war there are hopeful signs ;
and other signs indicating that the unphotogenic mind of
Orangeism remains as it has always been. The wounded
soldier returns to his home to find that a job or the tenancy
of a house is denied him because he is a Catholic. In Strabane,
County Tyrone, the Orange minority advocates the abolition
of a town-council, that has done its job satisfactorily for
years, and its replacement by a Stormont-appointed Com-
missioner ; because Strabane has always been too
predominantly nationalist to be gerrymandered, and a town
administered according to the will of its nationalist majority
is too much for any Orange stomach. The United Protestant
Committee meets in Belfast to disapprove of Mr. Churchill's
audience with the Pope ; to disapprove, also, of the niggard-
liness of the Stormont government in the matter of residence-
permits. That niggardliness, says the bold committee, is an
injustice to Protestants south of the Border who would other-
wise run for refuge to the Six-County haven of democracy.
Nationalists in that area find that that same power of giving
or withholding the written permission to live in a place
has actually been added to the armoury of sectarian or
politico-sectarian discrimination. Sir Basil Brooke in a speech
in the London Guildhall makes fantastic parallels with
Scandinavia, the Low Countries, the Iberian peninsula, to
prove that the partition solution has respectable precedents.
He recognises the right to neutrality of the Twenty-six Coun-
ties, arguing that the neutrality goes to prove the steady drift

of those counties away from England, in contrast to the Six Counties of which he is Prime Minister. Those Six Counties, he claims, incline every day to become more and more part of England; and we are left with the amazing fantasy of an Ireland split into two pieces, one sailing determinedly towards the English Lake District, the other drifting aimlessly and treasonably, a peril to shipping, over the western ocean.

Sir Basil Brooke will never know, at least he will never admit, that an independent Ireland where everybody spoke Gaelic, wore kilts, and played or listened to the harp and told each other, in regular instalments, the Fenian saga, could offer to Britain more genuine and valuable friendship than this broken, discontented thing that doesn't even know how to name its separate fragments. He would naturally never admit that he is not really the captain of the fantastic ship that he sees voyaging to Cumberland. The ship never sailed, held up by that coercion and inevitable mutiny that Lloyd George saw and, apparently, approved of. But there are other people who know these things and are prepared to shout them from the housetops; and they are not all in the Twenty-six Counties nor are they all Nationalists and Catholics. They may be young men trying to write or old men preparing to die, but they have in common the knowledge that the division and line, whose origin we have filled some pages considering, has not been good for Ireland or for Britain. They have in common the desire for settlement, appeasement, a solution that will consider justly the aspirations of every party. They have in common with all mankind the desire for that peace in which homes are built, in which the great energy of men goes to adorn the earth that God has given to men, to make beautiful the roads and the streets, to make the fields fertile and blossoming, to fill the little transiency of life with song and neighbourliness and words spoken in charity.

M

CHAPTER XI

THE VOICE OF STORMONT

" I need hardly mention the persecution that is going on even at the present day in ' Northern ' Ireland."—*The Archbishop of Westminster, Most Rev. Dr. Griffin.*

" At a meeting of the County Down Grand Orange Lodge the Imperial Grand Master, Sir Joseph Davison, said the statement was a ' scandalous disgrace ' and challenged the Archbishop (of Westminster) and Cardinal MacRory ' to bring forward one concrete case of persecution by the Protestants of the Six Counties.' "—" *The Derry Journal,*" *Monday, Nov.* 13, 1944.

(1)

THE government of the six north-eastern counties of Ireland meets in a great oblong building on the high ground south of the Lagan and Belfast Lough, on the same slope and in the same neighbourhood as Craigavon where Carson spoke in 1911. To the left of the building is the tomb of Lord Craigavon who began his political career as Captain James Craig. Down the slope from the main door is the statue of Lord Duncairn who began his political career as Mr. Edward Carson. It is a reasonably good statue, catching Carson in an oratorical pose ; and underneath it is written for some reason or other *Dum Spiro Spero.* - Modern Belfast has built itself all over that slope with a pleasant semi-detached suburbanity that offers a pleasing contrast to the black, busy centre of the city, with the noisy, smoky shipyards, the gaunt cranes and gantries. All *that* is down below in the valley on the shores of the lough and the edge of the Lagan, and beyond the water is the straight side of Cave Hill, and behind Cave Hill the beautiful county of Antrim. The name of the place is Stormont ; and the oblong building is a very large one for such a small state.

The two quotations that head this chapter offer the key to some interesting information on the mentality and methods of the men who, in that large building, make up the government of that small state. In the first quotation the English Catholic Archbishop of Westminster mentioned the state of affairs existing in the six partitioned counties as affording one more example of the persecution of men because of their religion. In the second quotation Sir Joseph Davison, Imperial Grand Master of the Orange Order, denied that statement, challenged the English Archbishop and Cardinal MacRory, Primate of All-Ireland, to produce evidence to show that in the Six Counties any Catholic had ever been persecuted, victimised, discriminated against because of his religion. That was a plain, blunt, valiant challenge, ably seconded by Mr. Hugh Minford, a Unionist member of the Stormont Parliament when he said : " It is a damnable and scandalous statement against the people, who, in this Government's career, never attempted to persecute a man because of his religion. No man in ' Northern ' Ireland is denied civil or religious liberty." Men who speak like that are obviously very sure of themselves, plainly convinced of the justice of their cause, quite certain that no man alive will be able to advance any evidence to show that their valour was just windy bluff.

Earlier in the same year, to be exact on Tuesday, 25th January, Sir Joseph Davison, Mr. Minford and any other person interested had the opportunity of refuting a documented attack on conditions under Stormont rule. That documented attack, the pamphlet *Orange Terror*, has been mentioned already in these pages, but in relation to the two aforementioned quotations it is worth considering briefly what the contents of that pamphlet were, worth recalling from the obscurity of newspaper files and parliamentary reports some of the gems of political wisdom contained in the debate that followed the banning of the publication. For the men who prohibited the circulation of that pamphlet were in their position of power because of the Carsonite agitation and the circumstances that attended that agitation. The pamphlet was a concise, effectively documented attack on the conditions made possible

by that agitation, by that partitioning compromise, a portrait of the present resulting from the past that these pages have reviewed.

(2)

Orange Terror first appeared as a symposium of articles in *The Capuchin Annual* of 1943, under the title *The Real Case Against Partition.* The leading article in the symposium was written under the name *Ultach* which means *Ulsterman.* Later on the writer was reproached with that concealing of his own name; but any impartial critic will realise that a man may write under a pseudonym for any one of a dozen different honourable reasons, and the critic who knows anything about life in the Six Counties will admit that honourable prudence might possibly force anonymity on anyone writing an attack on Stormont governmental method. The main article was followed by a series of comments written by the Bishop of Down and Connor, the Most Rev. Dr. Mageean ; by Eleanor, Lady Yarrow, Mr. John Nugent, George Noble Count Plunkett, Madame Maud Gonne MacBride, Mr. Maurice Walsh, Mr. D. L. Kelleher, Miss Gertrude Gaffney, Senator David L. Robinson, Count Michael de la Bédoyère, Mr. Thomas Collins, Captain Denis Ireland, Senator Magennis, Mr. Éamon Donnelly, M.P., Mr. Ernest Blythe, Mr. T. J. Campbell, K.C., M.P. ; Mr. Darach Connolly, Mr. John Carson Tozer, and finally by the editors of *The Capuchin Annual*, Fathers Gerald and Senan, O.F.M. Cap. The natural result of a symposium is the revealing of a variety of opinions ; but one would want to disagree very violently with the writers of that symposium to accuse them of mere conspiracy to disturb the peace and destroy civil order. That was exactly what they were accused of when the symposium, published in pamphlet form, was, after considerable delay, banned by the Stormont government. Their names alone, the positions they occupied, the work they had done in the past should have been enough to protect them against that accusation. They stood against very different backgrounds, spoke from varied experience, differed in several points, but were unanimous in agreeing that the persecution, the existence of which

is denied by Sir Joseph Davison, did actually exist. Behind
that persecution they saw the incongruous line that has
straggled across the map of Ireland for the last score of
years, they saw the division that had made that line.

The writer of the main article was plainly stating the
case against the partition. of Ireland, putting his argument
on the solidest foundation : the fact that partition made
possible the persecution of the Catholic religious minority
in the Six Counties. No essay on the subject of partition
could be quite complete without giving some consideration
to the reality of that persecution ; and one convenient
way of doing that considering is by reading through the
pages of *Orange Terror*—always provided that you do not
live in the Six Counties.

The author, although he opened his article with some
reminiscence, was not concerned with his own impressions
and feelings. He had eyes only for documents, statistics,
recorded statements, all those hard, verifiable things that
even the most sceptical investigator will accept as " concrete "
proof. Even the introductory reminiscence was a piece of
hard fact : a flash-back to the grey days of the 1920 pogrom
when the author's father, although ultra-conservative in
politics, was victimised, beggared, driven out of business
solely because he was a Catholic. Then coming swiftly down
to more modern times he gives us some intimate sketches
of the incessant police-raids that are an important part of
the social life of modern Belfast, along with the challenging
for identification-cards and the searching of pockets for
guns that may enliven the moments of any young Catholic
man when he is walking home from the pictures. Any and
every Catholic is a suspect. His house may be raided, he
may be stopped and searched on the street, he may without
accusation, trial or sentence be interned for indefinite periods.
Sir Joseph Davison would possibly say that internment and
the application of a Special Powers Act were just the normal
reaction of government to the existence of an underground
political organisation. But then no effort has ever been made
in the majority of cases to prove in court that the persons
interned were really members of any illegal organisation.

" Note that all this," writes *Ultach*, " is direct intimidation, discrimination and provocation by the authorities. Imagine it happening in England. Read the comparatively trivial and petty complaints with which Herbert Morrison, the British Home Secretary, is bombarded (in the midst of war) about interference with individual liberty in England—and meditate for a moment. . . . Northern Ireland, so far as Britain is concerned with it, is Mr. Morrison's bailiwick. What I have described (i.e. searching, raiding, internment) all happens in Northern Ireland even in peace conditions. It is a necessary and inevitable feature of the one-party State."

That reference to the one-party State is imbedded in the author's thesis : that the system of government by coercion, of admitting in times of peace that a Special Powers Act is necessary for the preservation of the state, bears striking similarities to various forms of totalitarianism, past and present. It is an interesting point and even those who disagree very violently will find it very difficult to reconcile various aspects of life in the Six Counties with anything other than an extreme form of authoritarianism.

The author backed up his thesis with quotation after quotation, instance after instance, with statistics showing, for example, the working of political gerrymander in the Six Counties, with photographic reproduction of various official documents showing how discrimination does exist, with statements made in public by government ministers and prominent Orangemen, with statistics showing the number of Catholics evicted during the pogrom of 1935. Now it is not the business of these pages to cover again the ground that has already been sufficiently well covered. The pamphlet is of interest here because of the reactions it caused in that great house from which the little state is controlled, the things that that series of quotations—mostly from official documents—provoked Stormont ministers to say. For the men who banned that pamphlet and made those statements have so much to do with the solving of the problem that it is worth while striving to understand how their minds work. The best way to do that is to read *Orange Terror* carefully, to follow on by reading the official report of the

debate in the Northern Senate for Tuesday, January 25, 1944, the reports of the debate in the Northern Commons for Wednesday, February 2, and Wednesday, February 9, of the same year. If you have lived in the Six Counties you will not be surprised. If you have never lived in the Six Counties you may say, as one man said : " I would like to *see* one of these men."

(3)

In the upper house of the Northern government, then, on the date in January mentioned above, Senator McLaughlin, a Nationalist, asked a question about the banning of *Orange Terror*. He wanted to know why the circulation of the publication had been prohibited ; whether the facts that it contained had or had not been collected from official documents ; " whether any reply to it was possible, and, if so, could the new Propaganda Department under the supervision of Mr. Cooper not have issued one ; whether the English censor had issued any order against the publication ; and whether thousands of copies have been sold and circulated amongst all classes in Great Britain." Senator Browne then pointed out that a Protestant clergyman, the Dean of Belfast, was of the opinion that the publication should be widely circulated particularly in Orange Lodges because it was " such a ludicrous piece of gross misrepresentations and glaring falsehoods that its reading was likely to be useful . . . its circulation should be encouraged as evidence of the deceptions to which opponents have to resort, and as a revelation of the methods of the campaign against Northern Protestants." Another senator made some wandering, and, I fear, comic comparisons between the banning of *Orange Terror* and the banning of *Lady Chatterley's Lover*. He was not quite certain about the authorship of the latter volume.

That ended the first round of the discussion, with nothing said that really called for comment except the facility with which the daring dean referred to the quotation of statements and photographing of documents as " gross misrepresentations," " glaring falsehoods," and " deceptions." At any

rate the Leader of the House, Rev. Professor Corkey, replied to the questions that had been asked. Anything of note in his reply was compressed into one sentence : " Some of the statements in the book may have been gleaned from Government or official sources, but nevertheless the publication in its entirety is definitely considered to be prejudicial to the preservation of the peace in Northern Ireland." The Rev. Professor said also that it " would be beneath the dignity of any Department to attempt to reply to the scurrilous articles which it (i.e. the pamphlet) contains." Beneath the dignity ? Professor Corkey did not, naturally, say that the statements that " may " have been gleaned from official sources were indubitably the important and prominent portions of the booklet, nor did he point out exactly why lengthy quotation from the statements of Stormont leaders should point the way to public disorder, except by following the precedent created in the years before the pogrom of 1935.

Answering Professor Corkey, Senator McAllister pointed out that the answer given to the series of questions had been a poor enough effort, that it would scarcely be beneath the dignity " of a Government office and a Government official of this parochial Parliament of Northern Ireland to reply to a document published by a body widely known throughout almost the entire world, and respected in every place except Northern Ireland." Senator McAllister pointed out the anomaly in the attitude of Dean Kerr who had made a general statement advising the free circulation of the pamphlet and insisting on the facility with which a reply could be written. But neither Dean Kerr nor anybody else connected with him had written the reply. Professor Corkey had not given any reply, neither to the accusations contained in the pamphlet nor to the questions asked by Senator McLaughlin, because Professor Corkey knew quite well that he would be in no position to sustain an argument, for " all the statements and figures in the book were compiled from official records of the Government." According to Senator McAllister the real reason for the banning of the pamphlet was that it contained " an absolute condemnation of the partisanship displayed by the Northern Government and the destruction of democracy

in their midst, and of the biassed legislation and adminis-
tration of the Government." The banning had been an
effort to "prevent people in Northern Ireland, and the
visitors who are here at the present time, ascertaining the
true position of the minority under the Government of
Northern Ireland."

The next speaker was Sir Joseph Davison, the challenging
Grand Master, and what he said is worth, not analysing
for there is nothing to analyse, but objective, philosophic
contemplation. He said he had read the book. Fair enough !
He said the book was full of statements given without any
proof whatever. Once again it is worth remembering that,
apart from some reflections and recollections made by the
author, the more important statements and statistics came
from very official sources. Sir Joseph pointed out that Senator
McAllister had mentioned the MacMahon murders, but
that neither Senator McAllister nor the author of *Orange Terror*
had mentioned "that quite a large number of policemen
had been shot in the city of Belfast in the exercise of
their duty, and no person has come forward to give evidence
against the murderers." Now policemen have been shot
in the streets of Belfast, but a moment's consideration
and even the most casual acquaintance with life in
those streets would show that they were not knocked-off
in " large numbers " while directing the traffic or investigating
dog-licences. The policemen who were killed, outside
pogrom periods, were few in numbers and, as a general
rule, were actively engaged in following up the misguided
political activities of some young men ; and some of these
young men and youths were actually brought to trial and
executed. Now no man with a feeling for public order will
do anything but regret those shootings ; he will also regret
the miserable background of social and political disorder
that was behind those shootings. If he is a man with a head
as well as a man with a heart he will examine that background
until he comes upon the wretched contradiction that has been
the subject of this book. He will also discover the Grand
Masterish absurdity of mentioning those shootings in one
paragraph with atrocities like the murder of the MacMahon

family, and he will wonder did Sir Joseph Davison really not recognise the absurdity. Possibly, Sir Joseph Davison didn't, for the next passage in the debate seems to hint that Sir Joseph Davison wouldn't recognise an absurdity, not even if it were pointed out to him. Only exact quotation could do that passage full justice.

Sir Joseph Davison : " I would like to know if either Senator McLaughlin or Senator McAllister can give me any information with regard to how this Capuchin Press became possessed of a document issued by the County Grand Lodge of Belfast over my name some years ago."

Mr. McAllister : " What was that document ? "

Sir Joseph Davison : " It is a document sent out by the County Grand Orange Lodge of Belfast to its members, and reproduced from photographs in the book referred to."

Mr. McLaughlin : " What does it state ? "

Sir Joseph Davison : " The document only stated that we object to our members supporting Roman Catholic publicans in the city of Belfast, and that we would take action against our members if they did so. I am not ashamed of that."

Now here is the relevant quotation from the reproduction of the photograph of the document and, passing over the naïve spider-to-the-fly inquiry as to how and when it was photographed, it is worth comparing with the " only stated " motif in Sir Joseph Davison's defence. Under the heading of *Offences Against Sobriety* the Grand Lodge of Ireland passed the following resolution, to which Joseph Davison as Grand Master and J. A. Barlowe as Grand Secretary added the sanction of their names : " That any member of the Orange Institution found frequenting Roman Catholic public-houses is guilty of conduct unbecoming an Orangeman, and a charge to that effect may be brought against him and dealt with according to our laws." I give the idea gratuitously to Mr. Michael Burt who could certainly, on the lines of *The Case of the Fast Young Lady*, write a brilliant murder story about an apostate loyal man hounded to his death because of the bottle of bass or guinness lowered in a papistical and idolatrous house. Poor Sir Joseph should be warned that some day a

humorous writer in search of copy will come upon the official report of the Stormont debates.

After that it is easy to understand how Sir Joseph Davison can throw challenges at an archbishop and a cardinal. Either he doesn't know any better, or he just doesn't care. At any rate he went on speaking : " There are also in this book reproductions of speeches made many years ago. Many years ago I was speaking in County Armagh on the infiltration of persons from Southern Ireland. That speech, or part of it, is reproduced, stripped of its context. My statement then—and I am not going back on it today—was for Protestants to employ Protestants. That is one of the things that is reproduced in this book. There are also some old statements made by the late Lord Craigavon, by our present Prime Minister (i.e. Sir Basil Brooke), and by the Right Hon. J. M. Andrews when he was Prime Minister. In regard to all these statements there is no proof given."

Let us, please, make a serious, determined effort to get all this clear. Does Sir Joseph Davison or does he not wish to deny these statements ? He complains that his own little gem has been torn from its setting. Here, I daresay, is the quotation in question :* " When will the Protestant employers of Northern Ireland recognise their duty to their Protestant brothers and sisters and employ them to the exclusion of Roman Catholics ? It is time Protestant employers realised that whenever a Roman Catholic is brought into their employment it means one Protestant vote less. It is our duty to pass the word along from this great demonstration and I suggest the slogan should be : ' Protestants, employ Protestants.' " *August*, 1933.

Now if that passage was quoted for any purpose it was to show that Sir Joseph Davison wanted Protestants to employ Protestants to the exclusion of Catholics, that he recommended sectarian discrimination in the giving of employment. Sir Joseph Davison admits that that is exactly what he wants, yet he complains that he has been unfairly quoted. He also complains that " in regard to all these statements there is

* See *Orange Terror*, p. 14.

no proof given." What proof can be given beyond the dates on which the statements were made and the testimony of the newspaper files of the period, and the knowledge, shared by every man and woman and child who knows anything about the business, that the statements were made. But there you are !

(4)

After that it is obvious how much time could be wasted bothering about the illogical and incoherent things that come spasmodically from the loyal lips of the Grand Master. For instance, when he claims that the trouble on the 12th July, 1935—part of the anti-Catholic riots of that year—began when an attack was made on an Orange procession he is, to put it very mildly, not an impartial witness because according to his own account he was heading the procession. When he says that murders as atrocious as the massacre of the MacMahon family have taken place since in Belfast, that possible witnesses were terrorised into keeping quiet, and when he implies that those atrocities were perpetrated by Catholics, he is talking what most people know to be, at best, arrant nonsense. When he says that the account given by the author of *Orange Terror* of the victimisation of his father *may* be true but that really the author should have signed his name, then he is saying something that a Fiji islander would recognise as uproariously funny. For if that account *may* be true then Sir Joseph Davison has admitted that serious victimisation *may* take place in the Six Counties ; and if the father, whose politics were conservative, suffered victimisation then the son might be well advised to leave anonymous an attack on the system that had victimised his father. When Sir Joseph Davison flings a challenge to the four winds of heaven he does not really mean that he wishes to engage in debate on the question as to whether there is or is not persecution in the Six Counties. He is only whistling his way past the graveyard, talking loudly in the hope that his words may be heard in England and America by men who have not the leisure nor the opportunity to go behind the ludicrous headline façade of his challenge.

When he had said his little say in that Stormont senatorial debate a nationalist member had the last word : " With regard to the articles that are printed in this book, we welcome the Dean of Belfast's expression of opinion that the book should not have been banned. No ill-will is intended, and only the true facts are stated. If they can be denied let them be denied, as well as any documents that are alleged to be untrue."

Sir Joseph Davison didn't answer that challenge.

(5)

The matter was discussed in the Stormont House of Commons on Tuesday, February 8th, 1944. Now it may seem disproportionate to consider in detail the debate on the banning of one solitary pamphlet ; but that pamphlet—once again—was a concise, documented account of the methods of coercion that Mr. Lloyd George had foretold, and the debate itself gave some valuable information on governmental methods in the Six Counties, some valuable insight into the characters of the men who make up that government.

Mr. T. J. Campbell, K.C., M.P., introduced the question in the Stormont Commons. He said of the pamphlet : " When you look at its pages it does strike you with amazement that any banning took place at all. It has a map of Ireland. It indicates on that map by shadings the areas of this country for and against partition—29,821 square miles against, and 2,526 square miles for. Is that another reason for banning a book of this kind ? It indicates that even in this area of Northern Ireland the majority, judged by square miles, is against partition, almost 100,000 being in that category."

Mr. Campbell wondered was the inclusion of the little exhortation to sobriety among loyal men one of the reasons for the banning. Or the fact that it included a " facsimile of the introduction card of the Ministry of Labour in which was written in one word why employment was refused to a Catholic worker—' *Religion.*' " Was it banned because it gave " an account of the riots which have disgraced Belfast from cycle to cycle, and of the educational difficulties and dis-

abilities of the Catholic minority." And óne more fragment
from the speech made by Mr. Campbell is well worth quoting :
" I charge the Government with seeking to drive young
Irishmen into the ways of desperation, to be there entrapped
by *agents provocateurs* and spies and consigned to penal servi-
tude. I charge them with doing so in order to break the
Nationalist spirit in this area. If this booklet tends to create
dissatisfaction, the American Declaration of Independence
tends tenfold more."

Later on, the Unionist Mr. Lowry took exception to that
reference to the Declaration of Independence, because
apparently a whole lot of people came northwards over the
Border to find freedom, because, according to Mr. Lowry,
they couldn't find any at home. Now both Mr. Lowry and
Sir Joseph Davison (when one of them was not busy keeping
loyal men out of papist pubs, and the other not suggesting
that the Portrush Orange Hall should be fumigated because
it had been used as a chapel for Catholic American soldiers)
have fallen back on the immigration of working-men into the
Six Counties as evidence of the fact that these men are rushing
from slavery into freedom, from darkness to the light. It is
not well to think poorly of the intellect that God has given
to any man, and we can only hope that Sir Joseph and Mr.
Lowry know that the movement of working-men can be
simply and easily explained. The explanation, which is purely
economic, would carry a footnote on the question of residence
permits, pointing out how the granting or withholding of
permission to live in a place has been turned into another
means of sectarian discrimination. Mr. Lowry said he had
never " seen so many unblushing mendacities gathered into
such a short compass." Mr. Beattie wisely suggested that every
member in the house should be supplied with a copy of the
publication so that they might know what all the talk was
about. Then the debate drifted on to the consideration of
some entertainment expenses granted to some minister. Very
interesting to everybody upwards from the cub-reporter
presenting his first expenses docket. But not at all exceptional,
and by no means vital.

(6)

For that little footnote I am indebted to the text of *Orange Terror*, to the men who spoke in the debate, to the Hansard reporters. It should justify its own inclusion. For in any attempt to reach a solution for the whole problem the facts contained in that booklet and the minds displayed in that debate must be seriously considered. The prospect does not exactly fill one with hope. I know that there are a thousand things upon which I could agree with the average Ulster Protestant, because I have lived with Ulster Protestants in an Ulster town. But I am not quite so certain about a man like Sir Joseph Davison. If, with an intelligent Ulster Protestant, I were to review the mistakes of the past and the contradictions of the present we would at least agree that there was a problem to be solved, that goodwill could solve it. Sir Joseph Davison must know all about the problem, but he knows little and cares less about goodwill, nor does he seem very anxious to find a solution.

POSTSCRIPT

" An Ireland in fragments nobody cares about. A unified Ireland alone
can be happy and prosperous. To the British Commonwealth group
and to Britain itself Ireland would readily become friendly, but it is
only in freedom that friendship could come."—*Letter written in* 1921
by Eamon de Valera to General Smuts.

(1)

As for solutions : there never yet was a problem, apart from
the strictly mathematical, that had not at least half-a-dozen.
This problem is made up by the actions and reactions of
various groups of men, variously influenced by a past that
gives them different ways of looking at the present. Every
one of those groups knows that there is a problem, although
it may appear differently to different men : figures to the
mathematician and the man of business, discord to the man
of music or the poet, obscure fears to the superstitious.

There is for instance the violent young man who would
solve things by the gun, although the world in which we
live is a pretty woeful monument to the truth that the gun
is a poor enough instrument with which to solve anything.
Personally, if I were given the choice to-morrow between
the continuance of partition and a one-government Ireland
ruling the Protestants of Ulster against *their* will, I would
choose a partitioned Ireland. That may seem the last and
thinnest thing in milk and water, but it is really wise, wide-
visioned politics. For the partition of a nation is not done
with when a few wooden huts are knocked down. That
would not unite me with the men from Sandy Row, any more
than the fact of those huts standing erect cuts off a man in
Ballydehob, County Cork, from a man in Ballycastle, County
Antrim. Sir Basil Brooke says that the Border does not make
differences, that it recognises differences. The spirit of Wolfe

Tone would agree, would say even that the Border accentuates differences, and possibly for a purpose. The majority of Irishmen want to do away with those differences or at least to find a compromise that will, instead of making them greater, smooth the rough places and make the crooked ways straight. Partition will end automatically when all the people that compose the nation find, after the disputes of centuries, some common ground in the muddled, complicated present. They may find that common ground in the solution of an unemployment problem that will weigh on the whole country, more particularly on the six partitioned counties, when the war ends. Mr. Denis Ireland, among others, thinks that a Dublin government could remove the Border by sweeping economic and financial reforms that would open up a golden prospect (no pun intended) to the shy men in the North-East. Another man holds that there will be " no solution of the ' Ulster ' problem, no removal of partition until the power of the Orange party to poison and embitter the people is broken." Yet another suggests that the oppressed Catholics and the dissatisfied Protestants of the Six Counties should get together, and asks for a Nationalist party that shall be Nationalist and not sectarian. Somebody else suggests a comprehensive, intensive and persevering campaign to tell the English and American world the truth, the whole truth, and so on.

It is encouraging to find Irishmen of all creeds really thinking their way towards some solution, although at times the results of their thoughts may not be remarkable for wisdom. They compare favourably with Sir Basil Brooke who is, apparently, quite content that the Border should continue to mark and accentuate differences. It is encouraging to find men founding beneficial, non-political organisations that can live in Belfast or Dublin or Cork, that can overleap barriers that are not and never have been beneficial.

A certain modesty and a certain pride prevent me from putting forward my own pet solution ; modesty, because it seems presumptuous to offer a cut-and-dried theory to deal with the reality that has baffled so many abler men ; pride, because of a desire to avoid mixing in the company of the

poor people who, day after day, solve all the problems of
God's universe in letters to the editors of newspapers or in
other more elaborate publications. There are many men
anxious to find a solution who are also in positions to do
something about it when it is found. These pages may do
them the service of setting some people considering the
origins of the queer artificiality that we have come dangerously
near to accepting as something founded on a sort of half-
reason. Chesterton said that the man who wanted to destroy
abuses should first consider their origins and discover that
every abuse was really some useful thing gone to degeneracy
and decay. Similarly the man who has come to the dangerous
place where he may accept for truth the thing that is artificial
and a fake, should turn aside to that same consideration of
origins, to the discovery of the sandy and shaky foundations
on which the thing has been built.

(2)

Even the dead past is a thing that can cause disputes and
differences, and the search for a solution in the present only
reminds one wearyingly that there is a problem to be solved.
It is pleasant and easy to go into the future, to the place where
the yellow houses were on the terrace and the grey houses
on the street, to find the men from the terrace and the men
from the street marching together in jubilee to one song and
one tune, with one common purpose. The drums are the
drums of joy and the banners and sashes are starred with the
symbols of unity. East in Belfast the great ships come and
go, the workers walk to the factories in the cool morning,
the trams roll and rock on the hilly streets ; but the rivets
and cobblestones are forever in their places ; hunted work-
men, exploding processions, evicted families, broken homes,
are only memories, unhappy memories. And south in
Dublin . . .

It is a great vision, a very great vision, and one must not
destroy it by the hard touch of the detail that cries out all
the time for fact, only fact. So many Irishmen, so many men
of Ulster have seen that vision that it must really represent
something more important than an individual illusion.

AUTHORITIES

THIS volume, as most men of discernment will have noticed, has no scholastic pretensions, and, for that reason, any great display of footnotes, references, cross-references, has been avoided. The reader is thus spared some tedium and, frankly, so is the writer. But certain authorities have been used, not abused: that is, quotations have been given fairly and as fully as possible, ideas have been represented as the writers apparently meant them to be represented. If the reader is prevented by native caution from accepting that statement he can turn, at least, to the following works:

(1) The 3-vol. *Life of Carson.* Vol. I by Edward Marjoribanks; Vols. 2 and 3 by Ian Colvin. (Gollancz.)

(2) *Sir Edward Carson, Ulster Leader.* Jean V. Bates. (Introduction by Rt. Hon. A. J. Balfour, foreword by Lt.-Col. Sir J. Craig), 1921.

(3) *Sir Edward Carson and the Ulster Movement.* St. John Ervine, 1915.

(4) *Ulster's Stand for Union.* Ronald McNeill (Lord Cushendun). (John Murray, 1922.)

(5) *Not an Inch.* Hugh Shearman. (Faber.)

(6) *The Birth of Ulster.* Cyril Falls. (Methuen, 1936.)

(7) *Orangeism in Ireland and Throughout the Empire.* (2 vols.) By a Member of the Order (R. Sibbett). (London: Thynne.)

(8) *A Recognised Church—The Church of Ireland in Eire.* W. B. Stanford, M.A., Litt.D. (A.P.C.K.: Dublin and Belfast, 1944.)

(9) *The Life of John Redmond.* Denis Gwynn. (Harrap.)

(10) *The Irish Republic.* Dorothy Macardle. (Gollancz.)

(11) *The Case of Ulster.* Sean Milroy, T.D. (Talbot Press, 1922.)

(12) *Ulster and the British Empire,* 1939: *Help or Hindrance?* Henry Harrison, O.B.E., M.C.

(13) *Handbook of the Ulster Question.* (Dublin Stationery Office, 1923.)

(14) *The Victory of Sinn Féin.* P. S. O'Hegarty. (Talbot Press, 1924.)

(15) *What Sinn Féin Stands For.* A. de Blacam. (Mellifont Press, Dublin, 1921.)

(16) *The Evolution of Sinn Féin.* R. M. Henry. (Talbot Press.)

(17) *The Irish Labour Movement.* W. P. Ryan. (Talbot Press, 1919.)

(18) *Eamon de Valera.* M. J. MacManus. (Talbot Press, 1944.)

(19) *Constance Markievicz.* Sean O'Faolain. (Cape, 1934.)

(20) *A Servant of the Queen.* Maud Gonne MacBride. (Gollancz.)

(21) *The Black North.* A. de Blacam. (Gill, 1942.)

(22) *Fifty Years of Ulster* (1890-1940). T. J. Campbell. (*Irish News,* 1941.)

(23) *Orange Terror.* "Ultach." (Capuchin Periodicals, Dublin, 1943.)

(24) *Partition.* A lecture by J. J. O'Kelly, .i. "Sceilg." (Sinn Féin Standing Committee, Dublin, 1940.)

(25) *Stepping-Stones*. A lecture by J. J. O'Kelly. (Irish Book Bureau, Dublin, 1939.)

(26) *Eamon De Valera Doesn't See it Through*. Denis Ireland. (Forum Press, Cork, 1941.)

(27) *Churchill Can Unite Ireland*. Jim Phelan. (Gollancz, 1940.)

(28) *Ireland—Atlantic Gateway*. Jim Phelan. (The Bodley Head, 1941.)

The above list is not only incomplete but insignificant, and it is put down not as a pretence to erudition or as a half-hearted proof that the author knows something about the subject, but as a gesture of gratitude to writers and works that have been useful. Among the works that the list does not mention but that have also proved useful are the writings of Pearse, James Connolly, Arthur Griffith, and a dozen others who added to the literature of the resurgence ; there are the newspaper files that cover the period ; there are the innumerable pamphlets, including everything from speeches by Edward Carson, to *La Frontière de l'Ulster* by Y. M. Goblet, from *Britain and Ireland* by Nicholas Mansergh to an extract from the American Journal of International Law, *The Irish Boundary Question* by Manley O. Hudson.

Lastly some personal acknowledgments to Mr. Kevin Nowlan and to another friend whose suggestions were very valuable, whose knowledge of the whole question is profound, but who prefers to remain anonymous.

INDEX

A.

Abercorn, Duke of : 44.
Agar-Robartes : his Partition Proposal, 131.
Aldermen of Skinner's Row, The : 61.
Andrews, J. M. : 157.
Andrews, The Right Honourable Thomas : 17.
Apprentice Boys of Derry, The : 61.
Archdale, Sir E. M. : 157.
Armour of Ballymoney : 54.
Asquith, Liberal Prime Minister : 23 ; 43 ; 44 ; 50 ; 86 ; '97 ; proposes
 " county option," 139.

B.

Balfour, Arthur : 32.
Balmoral : 24.
Barlowe, J. A. : 178.
Bates, Jean, V. : 94.
Baxter, Beverley : 101 ; 165.
Beattie, Mr. J. : 182.
Belloc, Hilaire : 57.
Biggar, J. G. : 74.
Birkenhead, Lord. (F. E. Smith) : 24 ; 92 ; 151.
Blenheim : 24.
Blythe, Ernest : 172.
Bonar Law : 24 ; 48 ; encourages Carsonite resistance, 122 ; adopts Partition,
 137.
Bonnivert : 112.
Boundary Commission, The : 148 ; 151.
Boyne Society, The : 61.
Britannic Society, The : 61.
Brooke, Sir Basil : " Employ no Catholics," 128 ; 157 ; 164 ; 165 ; 168 ;
 169 ; 184 ; 185.
Browne, Senator : 175.
Buckingham Palace Conference : 140.
Bullock, Shan : 68.
Burke, Edmund : 34.
Burt, Michael : 178.
Butt, Isaac : 74.

C.

Campbell, T. J. : 172 ; 181 ; 182.
Capuchin Annual, The : 172.
Cardinal MacRory : 171.

U.

Ulster Covenant, The : 46 ; 53-54 ; Ulster Day, 54.
Ulster Hall, The : 49.
Ulster Liberal Association, The : 49.
Ulster Unionist Council, The : 24 ; 44 ; 51.
Ulster Volunteer Force, The : 45 ; 46 ; 51-52 ; 84 ; as the Ulster Division,
 89 ; 96 ; 98 ; discipline of, 122.
Union, Act of : 64 ; 76 seq.

V.

Victimisation of Catholics : 158.

W.

Walsh, Archbishop of Dublin : 41.
Walsh, Maurice : 172.
War of Independence, The : 106.
Watson, William : 110.
White, Captain : arrested in Belfast labour march, 127.
Wilde, Oscar : 29.
William of Orange : 60 ; 61.
Wilson, Sir Henry : 84 ; organises special police, 125.

Y.

Yarrow, Eleanor, Lady
Yeats, W. B. : 36 ; 98 ; " Letters To The New Island," 108.